NIPPON MODERN

NIPPON MODERN

Japanese Cinema of the 1920s and 1930s

Mitsuyo Wada-Marciano

University of Hawai'i Press
Honolulu

13 12 11 10 09 08 6 5 4 3 2 1

Library of Congress Cataloging-in-Publication Data

Wada-Marciano, Mitsuyo.
 Nippon modern : Japanese cinema of the 1920s and 1930s / Mitsuyo
Wada-Marciano.
 p. cm.
 Includes bibliographical references and index.
 ISBN 978-0-8248-3182-0 (hardcover : alk. paper)—ISBN 978-0-8248-3240-7
(softcover : alk. paper)
 1. Motion pictures—Japan—History. I. Title.
 PN1993.5.J3W33 2008
 791.430952'09042—dc22
 2007032533

University of Hawai'i Press books are printed on
acid-free paper and meet the guidelines for permanence
and durability of the Council on Library Resources

Designed by University of Hawai'i Press Production staff
Printed by The Maple-Vail Book Manufacturing Group

Contents

Preface and Acknowledgments

MY INTEREST in this project on Japanese cinema in the 1920s and 1930s has a personal side connected with my father. In 1992, my father passed away rather unexpectedly at the age of sixty-one. He was born in 1931, when Shochiku Kamata films reigned in Japan. With his death I sensed that I had also lost an experiential link with the Japanese past, and I pondered how such links with cultural experience remain so volatile and elusive. One day I experienced an unforgettable moment while watching a Shochiku Kamata film on video with my mother. Although I have already forgotten which film it was, I clearly remember her saying, "Wow! It's so nostalgic!" But of course it was impossible for her to have seen the film in its original release. And strangely enough, I also had the sense of nostalgia. It occurred to me then that this feeling of nostalgia surrounding film might lead me to an understanding of the past and perhaps of my father's life. I was curious as to how the films were able to retain their nostalgic power and whether it stemmed from a specific cultural formation or a more universal sense of the poetic quality of life's ephemera. Thus, the sense of nostalgia comprising a cultural memory is actually a key aspect of this project and a rather personal one as well. With the death of Atsumi Kiyoshi, the star of the quintessentially nostalgic Tora-san series, in 1996, and the recent closing of Shochiku's last full production studios in Ofuna in 1999, Shochiku's films have merged even further with the past, existing now only in acts of elegiac recovery. There is also a lot at stake here when one considers the issue of the intrinsic qualities of the filmic experience versus the more personalized commodification of the filmic image on video and DVD—that is, nostalgia reminds us of questions surrounding the structure of cinema, which always requires a viewing subject. Indeed, postmodern claims concerning the end of history have a self-fulfilling quality in that the new visual technologies

allow us a simulation of the earlier experience without its underlying cultural context. The difficulty in understanding recent history lies in our tendency to conflate the nostalgia we experience in the present with the experience of the past to which the film first belonged.

I am grateful to numerous individuals whose support was invaluable while I worked on this book. Dudley Andrew inspired me with his elegant work, and during times of uncertainty, I found, by recalling his calm demeanor in problem solving, that somehow this quality was then "on loan" to me. Mitsuhiro Yoshimoto has shown me how to be a critical thinker through his own insightful work. Stephen Vlastos nurtured me with his generosity throughout my graduate career. I am also grateful for the suggestions and openhanded support from Anne Donadey and Tonglin Lu, as well as Taylor Atkins, Ellen Hammond, Yukiko Hatasa, Thomas H. Rohlich, and Steven Unger during my years at the University of Iowa. I am indebted to the friends who were with me then while I was wrestling with the early stages of this book. I want to thank Ernesto Acevedo-Munoz, Jung-Bong Choi, Tetsuya Fujiwara, Aaron Gerow, Chris Gerteis, Junko Kobayashi, Aaron Han Joon Magnan-Park, Aya Matsushima, Aminta I. Perez, Michael Raine, Satomi Saito, Kumiko Sato, Junko Tanaka, and Patricia Welch. I am deeply fortunate to have benefited from the expertise of some of the most brilliant scholars of film and Japanese studies. I owe great thanks to Joseph L. Anderson, Joanne Bernardi, William Burton, Darrell W. Davis, Andrew Gordon, Tom Gunning, Yoshikuni Igarashi, Abé Mark Nornes, and Scott Nygren. I was also buoyed by a lot of people's encouragement in the process of refining the book. I thank Rachel DiNitto, Sarah Frederick, Hideaki and Masumi Fujiki, Hosea Hirata, Charles and Rei Inouye, Kyoko Kagawa, Kyun Hyun Kim, Daisuke Miyao, Anna Roselen, Catherine Russell, Julian Stringer, Augusto Tallino, Roland B. Tolentino, Xueping Zhang, Zhang Zhen, and my colleagues at the School for Studies in Art and Culture at Carleton University.

During the years of research in Japan, I met magnificent people who gave me support intellectually and as friends. I am well aware that *Nippon Modern* would not have reached completion without their generosity. They include Sharon Hayashi, Iwamoto Kenji, Kanazawa Junko and Satoshi, Izuno Chita, Akira Mizuta Lippit, Sasagawa Keiko, and Shimura Miyoko at Waseda University; Kitada Akihiro, Nogami Gen, Uryu Yoshinori, and Yoshimi Shun'ya at Tokyo University; Isoya Kumiko, Kobayashi Fukuko, and other members of the Cinema and Gender Studies Group at Ochanomizu University; Monma Takashi, Saito Ayako, Yomota Inuhiko, and other members of the Japanese Cinema Studies Group at Meiji Gakuin University; and Aoyama Masaru, Fujii Jinshi, Ishida Minori, Itakura Fumiaki, and Kato Mikiro at Kyoto University.

Numerous talented and knowledgeable archivists generously helped navigate my countless searches for films and related written materials. I thank Irie Yoshiro, Okajima Hisashi, Saiki Tomonori (currently at the Agency of Cultural Affairs), and Tochigi Akira of the National Film Center; Gibo Motoko and Moriwaki Kiyotaka of the Museum of Kyoto; Takehisa Ryuichi of the Archives of Toei Film Village; and Wachi Yukiko of the Kawakita Memorial Film Institute. I am also enormously indebted to Makino Mamoru, Ota Yoneo, Sazaki Yoriaki, and, most of all, Hamanaka Asae and Masaki, who graciously took me in as a family member during my research year in Tokyo.

The Japan Foundation Doctoral Fellowship allowed me to conduct a solid year of research in Tokyo. The Asian Library Grant for Japanese Studies at the University of Michigan supported me in subsequent research on journals and literature. The Seashore Dissertation-Year Fellowship, T. Anne Cleary International Dissertation Research Award, and Center for Asian and Pacific Dissertation Research Grants from the University of Iowa aided the completion of the primary work for this book. Internal grants from both Tufts University and Carleton University made possible the final research for the book. I have been very blessed to work with my editors, Patricia Crosby, Keith Leber, and Bojana Ristich, at the University of Hawai'i Press. Their professionalism and assertiveness kept me on the right track.

Finally, I thank my family in both Japan and North America. Whenever I return to Japan, my mother always welcomes me home and gives me strong encouragement. The Japanese version of this book is for her. Shirley Marciano has also supported me emotionally and financially. Daniel Marciano, my best friend, supporter, and beloved husband, has always been there as a critical reader. We had a son, Nicola, at the last stage of this book project. His presence has brought laughter, sleepless nights, and a new perspective on all things.

Note on Transliteration

THROUGHOUT the book, I have omitted the macron, which typically indicates long vowels in romanized Japanese words. I did so for the sake of consistency over what I see as a selective and often arbitrary use of the diacritic.

I have also followed the practice of writing Japanese names with the family name preceding the given name; for Japanese who reside and publish their work outside Japan, the given name appears first, as in my own case.

Translations from Japanese are all mine unless otherwise indicated.

Introduction

If recognition is the beginning of a history, Japanese film history literally started in 1951 outside of Japan, when Kurosawa Akira's *Rashomon* (1950) won first prize at the 1951 Venice Film Festival. From that time on, a few Japanese filmmakers have been recognized via international festivals, and countless books on those filmmakers have been dedicated to analyzing their works. Kurosawa, Mizoguchi Kenji, Ozu Yasujiro, and Oshima Nagisa are all considered great Japanese directors, and their works have shaped perceptions of Japanese film history. Highly regarded scholarly works on the cinema, such as Donald Kirihara's book on Mizoguchi, David Bordwell's work on Ozu, and numerous books on Kurosawa, have reinforced notions of historical classicism around these auteurs.[1]

The practice of auteurism has been the norm in studies of national cinemas such as those of Latin America, China, and Iran, as well as Japan. Of course, a book on film may ignore film canon and simply present a chronological history, pointing out objective facts and names; however, this type of historical overview often takes a subordinate role to the study of canonical filmmakers. It is ironic that these great filmmakers have propelled a history of Japanese cinema while, at the same time, the incessant focus on auteurs has narrowed the scope of that history. The auteur narrative has configured the rest of Japanese film history as either a preparatory stage for the classic auteur period or a post-auteur residue.

Often termed the "golden age" of Japanese cinema for its zenith of production, the cinema in the late 1920s and early 1930s has seldom been explored outside the works of these canonical directors, and indeed the films from the period are mostly unavailable with subtitles.[2] It is not simply that one cannot see these films, but it is also the case that the dominant narrative of Japa-

nese film history has been structured around the auteurs. Yet before Kurosawa worked as a director for the first time in 1943, the standards for filmmaking were already established, and the industry's modes of production, distribution, and exhibition were fully systematized. When Ozu first gained recognition as an up-and-coming director with *I Was Born, But . . .* (*Umarete wa mita keredo*, 1932), the film's genre, a distinctly local form of middle-class film (*shoshimin eiga*), was already prevalent. The challenge of this volume is to acquaint the reader with Japanese cinema in the 1920s and 1930s without relegating the films of this period as mere prefigurations in the historical narrative of the established auteurs.

Classical Japanese Cinema

In order to free ourselves from the already existing canons of Japanese film history, we need to find another way to view and analyze the cinema. It is therefore worth raising the question of alternative norms. David Bordwell and his colleagues define Hollywood cinema as "a distinct mode of film practice with its own cinematic style and industrial conditions of existence" and describe classical Hollywood cinema as "Hollywood filmmaking from 1917–60 . . . a coherent system whereby aesthetic norms and the mode of film production reinforced one another."[3] I view the 1920s and 1930s as a time when the cinema's aesthetic norms and the modes of film production, distribution, and exhibition were established. This book frames the period from 1920 to 1936 as the foundation of a "classical Japanese cinema."

We ought not, however, equate "classical Japanese cinema" with a "classical Hollywood cinema," which is, for the most part, a theoretical construct used to articulate Hollywood's film history. Bordwell clarifies the latter as "not reducible to an oeuvre (the films of Frank Capra), a genre (the Western), or an economic category (RKO studios films). It is an altogether different category, cutting across careers, genres, and studios. It is, more simply, a context."[4] In the case of Japanese cinema, on the other hand, film practice, especially in this period, was heavily dependent on the force of each studio, with its "trademark" film styles and genres. This tradition would continue until the end of the studio production period in the 1970s.

Film genre figures prominently in this study, both as a historical resource for social practices and as a critical methodology. Film genres are structures for the flow of texts from industry to audience, and they are ideological in that they build consensus within the spectatorial experience. To nurture loyal audiences, the Japanese cinema developed its own genre system, necessarily distinct from Hollywood in its subject identities and subgenre categori-

zation, influenced by Kabuki theater.[5] Thus the distinct genres of the period also carry a record of the subtle negotiations with the dominating presence of Hollywood cinema. Because of this high cultural specificity, in a critical sense historicizing genre in Japanese cinema frees us from the ontological traps of both formalist and auteur analyses. Genre also allows us to de-center the predominance of classical Hollywood cinema as the comparative norm and shift focus from canonical film as artistic expression to film as social practice—that is, the continuity of subject identity, community expectations, or the ways that cinema particularized a vernacular form of modernity. Rather than map the whole genre system of the period, I shall focus on the genres that highlight modern subject identity and contain the discourses of Japanese modernity.

It is indispensable to look at individual studios and their practices in order to configure the heterogeneous norms of the Japanese national cinema. I shall focus on the preeminent studio of the 1920s and 1930s, Shochiku Kamata, and examine how the studio established norms for a classical Japanese cinema. The Shochiku company name literally means "pine" and "bamboo," characters that originated from its founding brothers' first names, Matsutaro and Takejiro. The company originally owned and operated Kabuki theaters, and it expanded into film in 1920, when the cinema first showed indications of profitability. Shochiku located its studio in Kamata, on the outskirts of Tokyo, and the studio adapted the Hollywood production process, star system, and distribution practices. In order to learn such business practices, Shochiku sent its managers to Hollywood and even hired a Japanese cameraman, Henry Kotani (1887–1972), who was working in Hollywood at that time. As the company's history indicates, Shochiku's films were produced within a context of cultural hybridity, the melding of external influences with the internal necessity for capital gain. The fact that Shochiku's films coexisted with Hollywood and other foreign films in the Japanese domestic market makes the classical Japanese cinema similar to, but at the same time different from, Hollywood, and this cross-cultural aspect has always been the reason that Japanese cinema has been analyzed in comparison with Hollywood cinema. To be sure, classical Japanese cinema cannot be discussed without accounting for the influence of Hollywood—and even other European cinemas—but it still needs to be articulated as a coherent aesthetic mode with practices of its own.

The early cinema offered the attraction of a modern Western technology wedded to a preoccupation with locality, traditional culture, and current events. Film production in Japan began in 1889, when a *benshi* (a film commentator for silent film) produced films with scenes of different districts in Tokyo and geisha dance performances. This "sightseeing film" was gradually refined and started to include theatrical plays from *shinpa* ("new school" theater; see chapter 4) and Kabuki, sumo wrestling, and wartime documentaries on

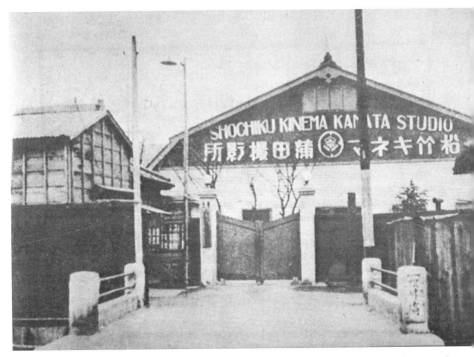

Founded in 1920 in the outlying Tokyo suburbs, the Shochiku Kamata Studio dominated the Japanese film industry until it moved to Ofuna in 1936. From Oba Masatoshi et al., eds., *Film Center 85: Nihon eigashi kenkyu 3, Kamata eiga no sekai 1921–1936* (Tokyo: Tokyo Kokuritsu Kindai Bijutsukan, 1986).

(for example) the Northern Chinese Incident in 1900 and the Russo-Japanese War in 1904. Indeed, the string of wars of this period and the need for news stories contributed to both the development of this early Japanese cinema and the assertion of national identity through the cinema. Tokyo became the center of film production; the film industry gradually stabilized, with studios investing in production facilities such as the first glass-roofed studio, built in 1909. The early film companies were launched by importing foreign films, which they continued to distribute even after they began producing their own films. In 1912, four Japanese importing and distributing companies merged and founded Nikkatsu, which later became the main rival to Shochiku. By the end of 1920, five main film companies, including Shochiku, were competing amid new pressures for technological innovation in the cinema.

One of the reasons I highlight the strong tie between Shochiku Kamata films and a classical Japanese cinema is that Shochiku was the only studio that continued production in Tokyo throughout this period of early development

of the Japanese film industry. As many Japanese historians have indicated, the historical, economic, and cultural divisions caused by the Great Kanto Earthquake in September 1923 were far-reaching, especially in the case of the Japanese film industry. All of the film studios located in the Tokyo area were completely destroyed except for Shochiku Kamata; the rest of the studios relocated to the west: Kyoto, Osaka, and Kobe. The Shochiku Kamata Studio was the only production facility in Tokyo during 1923–1934, until Nikkatsu returned to Tokyo, by which time the classical Japanese cinema was fully established in terms of its modes and practices. Despite the fact that multiple film studios existed during the period, Shochiku became the most prolific and influential studio for the creation of the "modern" cinema.

This is not to suggest that Shochiku alone represents the cinematic embodiment of modernity during this period, and I shall address examples from other studios, notably Nikkatsu. However, the material connection between the capital, Tokyo, and Shochiku Kamata's brand of *gendaigeki* (contemporary film) is indispensable to grasp the historical basis for the cinema's reciprocal relationship with the cultural modernity that fully bloomed in Tokyo during the period. My goal is to examine the classical Japanese cinema, especially in the 1920s and 1930s, as the expressive visual media of Japanese modernity.

In historically specific ways, modern Japan is distinct from other countries by the degree to which it has been politically, economically, and culturally centripetal to its urban capital, Tokyo, especially since the Meiji period (1868–1912), when the capital was permanently transferred to Tokyo. As "Hollywood" now stands for not only the location of the various studios in southern California, but also for the whole American film industry, so Tokyo's ties to the process and development of Japanese film production cannot be overemphasized. The division of the production system into broad genre categories of *jidaigeki* (period film) and *gendaigeki* was well established in the 1920s and 1930s. The former was often practiced in western Japan, and the latter was developed and reached its fruition with Shochiku's production in Tokyo. Film itself carried the imprint of the culture's imagined division into old (Kyoto) and new (Tokyo) geographies and forms, the historical cognition of a modern present. Thus Tokyo, and by extension Shochiku, became both the center of modern film production and the cultural hub of Japanese modernity itself.

Cinema and the Japanese Modern

In this volume I hope to reveal how modernity was expressed in the popular cinema of Japan in the 1920s and early 1930s. In 1914, from the time of its par-

ticipation in World War I, Japan's negotiations with the geopolitical hegemony of the West intensified, and its economic ties with the West grew after the war. With the development of heavy industry, fueled by Japan's economic success as a munitions supplier during the war, the transformation from an agricultural to an urban industrial economy accelerated. The migration of labor from farm to city led to the growth of a consumer population, and the new urban classes sought mass entertainments. The Japanese film industry began to embrace as well as compete with Western cinemas, producing and distributing its own films to negotiate its own place in the Japanese market. The industry gradually addressed the new classes of labor with self-reflexive subjects and narratives, the typically displaced scenarios resembling the new urban dwellers' migration to the city. Images of middle-class office workers and blue-collar proletarians were disseminated from Tokyo through various art forms, literature, and the mass media, such as magazines, newspapers, radio, records, and film, and this popular culture made possible the sudden appearance and rapid proliferation of the modern consumer as subject in Japan. In filmic depictions of the typical *sarariman,* the salaried office worker, for instance, there are intimations of a provisional "guidebook" for the modern subject, an attempt to model consensus among the Japanese audience.

I view the classical Japanese cinema of this period as expressing a distinct vision of Japanese modernity. The cinema presents both the performative and experiential aspects of modernity's transformations. As I shall elaborate, the modern, performative aspect is frequently enacted as an overt display of nationalistic pride, such as in Japan's participation in international events (war, trade, exhibitions, and the Olympic games), or in the cinema's conspicuous appropriation of Hollywood, as when Ozu, for example, in *Woman of Tokyo* (*Tokyo no on'na,* 1934) lifts a sequence from Ernst Lubitsch's work, an act that signifies both homage and Ozu's "mastering the master."[6] Such film-within-a-film devices created a sophisticated and distinctly modern form of spectatorship, wherein the viewers could relish the intertextual references to other films as well as the satire of their own experience as moviegoers. The spectatorial regime that such devices inculcated also had a postcolonial dimension: it mitigated the sense of shame over the hybrid origins of Japanese film culture and offered consolation through a modern sensibility that beckoned the viewer's participation. I shall also look at the experiential side in the cinema's depiction of modern space and its signified transformations of the urban landscape and the social institutions of company and family, as well as the more interior realms of female subjectivity. My interest is in the cultural subject at the center of such transformations. Simply put, I consider the ways in which modern

Japanese subjectivity was materialized by the Japanese themselves through cinema.

As in Masao Miyoshi's concept of "Japanese modern" and Miriam Hansen's "vernacular modernism," the recent tendency of modernity studies is to see modernity in the particular context of a nation-state and its culture.[7] *Nippon Modern* captures the Japanese modern specifically through the classical Japanese cinema. Historically the concept of modernity in Japan represented a split set of characteristics, one side shaped by the European Enlightenment, the other by the newness of a consumer culture. In Japanese these are termed *kindaishugi* and *modanizumu* respectively, and while this volume deals largely with the latter, the idea of Japanese modernity as fragmentary and provisional is central to the discussion throughout.

The issue of modernity in Japan remains charged even now—dangerously so in the view of Masao Miyoshi and H. D. Harootunian—because it conjures up the unresolved issues of Japanese imperialism and nationalism stemming from the World War II period.[8] As Yoshikuni Igarashi points out, "postwar Japan's relation to its past is filled with tension."[9] The country's war memory became "the absent presence," and the past was "signified and forgotten through the mediation of history."[10] The postwar view of that past and the cultural modernity that flourished in the 1920s and 1930s also became distorted in this process, subsumed under the militarism that followed or misconstrued as merely surface Westernization. The lack of attention to pre–World War II Japanese film history is, in my view, a consequence of Japan's problem with the past. Critical issues of Japanese film history, such as the formal continuity between pre- and post–World War II cinema and the successive practice of internal norms remain unexplored, a condition that is also due to the national sentiment of this division caused by the war.

Japan's collective amnesia toward the pre–World War II period was abetted during the American occupation, with the postwar narrative of America bringing "true" democracy and modernity to Japan at last. In the postwar constitutional debate, for instance, the American view prevailed that the Meiji constitution was incompatible with the development of a genuine democratic government, in contrast to the Japanese contention that the constitution needed only mending.[11] The American assertion was supported by an ideological view of the past, in which the pre–World War II period was branded as insufficiently democratic or modern. In the postwar period, the visible evidence of Japanese modernity in ruins combined with emotional and ideological impulses to deny that such modernity had ever existed in the first place. In effect, cinema, culture, and Japanese modernity in the 1920s and 1930s were all

amputated from the historical current. The repression of wartime memories became as well a tactic for the postwar acceptance of defeat and the subsequent push to rebuild the country. The view that Japan was never truly modern before the war became a mantra for the reconciliation of Japan's new role as a vassal of the U.S. occupation. The fragmented subjectivity of the Japanese, between their being accomplices of the West and subjects of their own narratives, was thoroughly imprinted on the postwar culture. In my conclusion, I offer further elaboration on this condition of Japanese modernity through my discussion of the "self-reinvention" of the film critic Tsumura Hideo (1907–1985).

As Elise K. Tipton and John Clark write, "Japanese modern art of the 1910s and 1920s is frequently misconceived as derivative, a view which may too easily recognize only the transfer of European modernist forms of discourse . . . and not see the way these were varied and developed by their articulation in Japan."[12] Such misconceptions of the culture of the Taisho period (1912–1926) have been prevalent not only outside Japan, but also among the Japanese themselves. *Ero guro nansensu* (the erotic, the grotesque, and nonsense), the pulp expressions of the modern urban culture, typically describe the Taisho period, and the extreme Westernization of that epoch has often been cast as trivial and transient. This fixed historical conception of the period's modern culture, especially the value-laden perception of lightness and a lack of content in the culture, needs to be reexamined in order to fully grasp Japanese modernity itself and the cinema of the 1920s and 1930s.

In general, the Japanese culture of the Taisho period, which was highly exposed to Western modernity, has been confined as a devaluated cultural epoch—neither traditional nor really modern, but only "derivative"; this label was also applied to the Japanese cinema. Curiously, this depiction parallels a recent resurgence of Japanese exceptionalism in the postmodern discourse: since Japanese modernity was insufficient, belated, and incomplete, the Japanese have therefore been able to embrace the postmodern condition of eclecticism much earlier and faster than other countries in the world. Indeed, much of the postwar debate over Japanese subjectivity can be seen in this context as confirming the ideological assumption of Japanese modernity as historically dubious and then wondering from where and out of what to begin constructing an authentic version. The playwright and critic Fukuda Tsuneari, for instance, wrote an essay on Japanese modernity in 1947 in which he asserted that authentic modernity never existed in Japan. His essay also discusses the Japanese uncertainty in the postwar period over how to establish a starting point for Japanese modern history.[13] As these examples indicate, the issue of Japanese modernity has always been tied to the politics of national identity in wartime and in peace.

Cinema and Visual Community

I believe it is worthwhile to search the ruins for what remains of the pre–World War II period's modern culture, especially the classical Japanese cinema, though not as another exercise in rescuing national self-esteem. The classical films offer a record of the reciprocal, reflexive relations between Japanese modernity and culture and the central contradictions of modernity's transformative power over community. Moreover, the filmic record reveals how the cinema maintains national identity through the inculcation of what I term the "visual community."

The cinema is a fundamental paradox, a modern technological apparatus that is concomitant with the larger fracturing effects of modernization—which are as a rule destructive to local communities and traditions—as well as a mode for assimilating spectators into a visual and national community. Thus, on the one hand, Shochiku's dissemination throughout Japan of images of urban Tokyo neighborhoods closely paralleled the development of modernization from urban center to rural periphery, with the resultant erasure of local identities within a homogenizing mass culture. On the other hand, the films' evocation of middle-class communities strengthened a Japanese sense of national identity.

The quality of cinema as a herald of both global and local forces is evident in the transformation of national sentiment from a highly modernized, Westernized social condition to one of nationalistic militarism. During the 1920s a prototypical *taishu shakai* (mass society) came into being in Japan through rapid industrialization and urbanization. Sociologist Tsutsui Kiyotada indicates that the *heijunka* (mitigation of class differences) was promoted in the period by mass production and consumption, the development of mass communications, and the diffusion of higher education, all of which were aspects of Japan's overall modernization. However, this entire *heijunka* process also led Japanese society toward a period of nationalism and centralization that culminated in the 1940s: "In the interwar period from the 1920s to 1940s, I can conclude that *heijunka*, nationalism, and the centralization of powers progressed side by side with the practical bases of *heijunka* such as mass production, mass communication, and the popularization of modern concepts. From the viewpoint of popular sociology, it is a matter of due course that the already leveled mass can easily be conducted in the direction of centralized authority."[14] Underlying Tsutsui's assumption that the masses, having gone through a process of *heijunka* within the larger process of modernization, naturally head toward nationalism is a fundamentally mechanistic view of mass communication. What needs elaboration here is how a society that has been thor-

oughly exposed to Westernized values, technology, and thought can so readily conform to nationalistic identity and community.

If the cinema has a role in furthering nationalism, how does it pursue this role? Specifically, how does it delineate and maintain the boundaries of nation and national identity in the face of the leveling power of modernization? Etienne Balibar has elaborated on the ways in which language and race form an ideological buttress to maintain the continuity of national identity: "[Language and race] constitute two ways of rooting historical populations in a fact of 'nature,' but also two ways of giving a meaning to their continued existence, of transcending its contingency." [15] While Balibar shows that language is the most concrete common mechanism for creating ethnicity or the ideal national community, my interest is in how the cinematic image and narrative work via this same process to similarly constitute what and who is Japanese. In contrast with the language model, the cinema's expression of unified national culture is more openly ambivalent, since any pretense of cultural exclusivity in Japanese cinema is always in conflict with the cinema's Western origins, as evinced in the assimilation of Hollywood narrative and stylistic modes. However, as with the language mechanism, cinema also delineates national boundaries, through (for example) critical discourses and theatrical distribution, distinguishing films and their venues by national origins, as expressed in the terms *hoga* (Japanese film) and *yoga* (Western film). Moreover, Japanese cinema internalized the processes Balibar describes through a self-ascribed division between the self and the Other. We can read the critical reception of Japanese cinema's imitation of Hollywood techniques at different historical moments with regard to the cinema's creation of national identity. In the late 1930s, for instance, Japanese film criticism's typical contrast between "high" Hollywood and "low" Japanese cinema gradually receded, and "monumental Japaneseness" was foregrounded.[16]

Balibar describes writers, journalists, politicians, and others as "translators" because they "speak the language of the 'people' in a way that seems all the more natural for the very degree of distinction they thereby bring to it." [17] I see filmmakers as translators as well, since they depict as "natural" the image of their community and they internally translate between different levels of image according to standards of how Japanese national identity is constituted. In this sense, the filmmakers are translators of the images to a larger visual community.

A language community needs to be subtended by a common race because of the language's inherent plasticity and its potential for permeating the community's borders. The nostalgic image of a fictive ethnic community always appears when small communities are fading or in crisis, and Balibar describes how a racial community works to reinforce the ethnic community: "The race

community dissolves social inequalities in an even more ambivalent 'similarity.' . . . The ideal of a racial community makes its appearance when the frontiers of kinship dissolve at the level of the clan, the neighborhood community and, theoretically at least, the social class, to be imaginarily transferred to the threshold of nationality. . . . The racial community has a tendency to represent itself as one big family or as the common envelope of family relations."[18] The classical Japanese cinema of the prewar period can be said to present both visual similarities and an equivalence between the racial community and the concentric social spheres of family, neighborhood, company, and nation within, for instance, the genre of the middle-class film, which became prevalent in the 1930s.

I shall argue that the sense of nostalgia, which has always accompanied these films, can be explained by such relations. Nostalgia arises in both the image of community, such as *furusato* (hometown), and from the community's disintegration in a process that was well under way even during the films' initial release. Cinema aided the equivalence of racial and social identities by bringing the notion of *heijunka* to the mode of exhibition. The affordable ticket attracted mass audiences, and the mechanism's reproducibility allowed many movie theaters to screen the same films. This version of class equality, however, does not on its own explain how cinema integrated cultural subjects within a national community. The answers lie in the ways that the classical Japanese cinema created a fictive Japanese national identity, a visual community formed through its spectatorial regime and the nostalgic visual aesthetic.

Embodying the Modern

In this volume I shall explore how Japanese modernity took shape in the film culture of the 1920s and 1930s. While the Meiji government had opened Japan to Western imperial regimes, adapting their bureaucratic, military, and state practices, it was in the interwar period that modernity in popular culture became ubiquitous in Japan's urban architecture, literature, fashion, advertising, popular music, and cinema. The reconstruction of Tokyo following the 1923 earthquake highlighted the extent of the cultural transformation. The film industry, especially Shochiku, embraced the reconfigured space so as to create a visible expression of modernity, influenced by the West yet constructed for local needs. Japanese modernity influenced Japan's national cinema, just as the cinema also inspired and embodied modernity itself. Its power to reconfigure space and time into a provisional reality made the cinema the perfect embodiment of Japanese modernity. The images it offered of middle-class life—

salaried men, modern girls, college students, and nuclear families—shot on locations in Tokyo as it underwent reconstruction, became affirmations of the audience's own imaginary tableau of modern life. I shall focus on six aspects of the cinema that envelop the on-screen and off-screen worlds of the Japanese modern in popular culture: Tokyo urban space, the middle-class film, modern sports, the woman's film, Shochiku Kamata film style, and historical discourses in film criticism.

Chapter 1 focuses on the intertextual links between the social project of Tokyo's development and actual film texts. I uncover how historical subjects produced a distinctly modern sense of space, which both served and shaped a new urban middle class and its values. The cinema evolved during a decade of explosive urban development following both the devastation of the Great Kanto Earthquake and a substantial migration into Tokyo. The government's plan to reconfigure the city and its surroundings led to the huge expansion of Tokyo to its current size. The modernization of the city space occurred simultaneously with the filmmakers' creation of images of a new modern city, and their depictions shared a reciprocal relation with the emergence of the new middle class of urban dwellers. I shall explore how a cinematic version of reconfigured space redefined urban dwellers as middle class in order to both manage the increased population and address a mass audience. Implicit in my thesis is the idea that interpreting such representations of space in the classical Japanese cinema in the 1920s and 1930s can reveal conflicts in the social reorganization of the period, specifically in terms of a capitalist incorporation of public space. Two central spaces for the urban middle class, "hometown" and "domestic space," are focused on through examinations of *Izu Dancer* (*Izu no odoriko*, dir. Gosho Heinosuke, 1933) and *Everynight Dreams* (*Yogoto no yume,* dir. Naruse Mikio, 1933), among other films.

Chapter 2 examines the local genre, the "middle-class film," which is not only a formative genre in the classical Japanese cinema of the 1920s and 1930s, but is also a foundation for the Japanese melodramatic tradition of *homu dorama,* a term that became synonymous with television family melodramas in the postwar period. I approach the middle-class film genre as a critical term and a historical cultural currency, a system of expectations and conventions that circulates among industry, text, and subject. The Japanese term *shoshimin eiga* was pervasive in the popular culture and film critiques of 1930s Japan. The films depict the newly emerging modern subject, the salaried man, and his middle-class family, and the films often present a self-reflexive stance on modern society and experience. Although these films were about a specific class, they appealed to a broad cross-section of social classes, thus helping, in effect, to create a modern national subject. While the films became associated with their trademark cheerful narratives, there are darker undercurrents,

such as a veiled critique of capitalism's extended reach, in particular the reflection of company hierarchy on daily life. Thus the middle-class films suggest a split within the Japanese national subject between the call to modernize and contradictory longings for the mythic cohesion of the past. I explore this rupture in two ways: the politics of genre in Japan's national cinema and the creation of a modern national subject in two films by Ozu Yasujiro, *Tokyo Chorus* (*Tokyo no gassho*, 1931) and *I Was Born, But*. . . . The latter, for example, deploys a comical sequence in which the salaried man's young sons witness his public humiliation via a homemade film screened at his boss's house. The film-within-a-film sequence lays bare the dystopian contradictions of modern life—the irreconcilable rift between the office worker's public and private selves—and it presents a commentary on the modern spectatorial experience itself. My closing discussion of the middle-class film explores how notions of Japanese genre have been molded in cross-cultural misunderstandings within Western film scholarship, as well as the culturally specific use of genre appropriation in Japan.

Chapter 3 focuses on the filmic image of the idealized, athletic Japanese body, which was created under the direct influence of the 1920s Hollywood college comedies, such as *The Freshman* (dirs. Fred C. Newmeyer and Sam Taylor, 1925) and *College* (dirs. James W. Home and Buster Keaton, 1927), starring Harold Lloyd and Buster Keaton respectively. I analyze the hybrid and idealized body, which national ideological discourses construed as a tangible confirmation of Japan as a modern nation. While the 1928 Amsterdam Olympics established Japanese singularity with the spectacle of small Japanese bodies competing against the West, in films that followed the Japanese body would be depicted as already Westernized and modern, erasing the visible inferiority implicit in earlier comparisons to the West. By elaborating on how the body compensated for Japanese anxiety toward modernization, I view the image of the body in its dual forms, on screen and in the star persona off screen, specifically in the case of the star Suzuki Denmei (1900–1985) and his film *Why Do the Youth Cry?* (*Wakamono yo naze naku ka,* dir. Ushihara Kiyohiko, 1930). My analysis of the film reveals the ideological underpinnings of the film's harnessing of the star's idealized body to national imperatives on both the visual and narrative levels.

In similar terms, my discussion of the woman's film in chapter 4 analyzes how the cinema embodied the very forces that it at least ideologically sought to delimit and naturalize. I view the cinema's reenactment of the transformative experience of the Japanese encounter with the West specifically by focusing on depictions of *moga,* modern girl figures. This chapter explores how latent Japanese anxieties over modernization are made visible through representations of this figure in critical discourse and film. While the modern girl's dan-

gerous persona was often controlled within the frame of consumerism—thus mitigating the threat of an emerging female subjectivity—what sort of female identifications did the woman's film allow? I frame this question within the overarching problem of a cross-cultural analysis of female spectatorship and the woman's film. This chapter also offers an account of the inherently political nature of the woman's film by focusing on the construction of Japanese female subjectivity. The use of the modern girl figure in the films that I discuss—*A Burden of Life* (*Jinsei no onimotsu*, dir. Gosho Heinosuke, 1935) and *Woman of Tokyo*—demonstrates how the Japanese woman's film created an imagined female subjectivity as a visible reenactment of Japanese anxiety over the transformative aspects of modernity. In contrast with the "monumental style" films of 1939–1942 examined by Darrell William Davis, which attempted to erase the Western origins of cinema in an appeal to mythic narratives and "traditional" aesthetics, the woman's film of the 1930s was overtly modern in constructing a contemporary consumer subject and more subtly reflective of national consciousness in limiting its embrace of both Western aesthetics and values by confining its female characters to a feminized domestic space.

Chapter 5 offers an account of the relationship between modern mass culture and nationalism through an analysis of the cinema's reflexivity toward the moviegoing experience itself. In this context, I elaborate on Shochiku's "Kamata style," the foundation for the classical Japanese cinema, as the performative expression of Japanese modernity. Further, my analysis in this chapter of the oeuvre of the director Shimazu Yasujiro (1897–1945), especially his *My Neighbor, Miss Yae* (*Tonari no Yae-chan,* 1934), explores the relations between film style and cultural formations in Japanese society. As an early contributor to the national style, Shimazu made films that focused on the dynamic of modernity in Tokyo neighborhood life. Often overlooked, his films were influential in shaping the postwar *homu dorama*.

My conclusion deals with the role that film criticism played in the discourses of Japanese modern subjectivity, traced from the nationalist turn toward exceptionalism to the postwar acceptance of Japan as a vassal of the United States. In particular, I discuss the work of Tsumura Hideo, whose various conversions—from prewar liberal journalist to wartime ultranationalist to postwar aesthete of Hollywood cinema—offer a parable for the contested nature of Japanese modernity itself.

The Creation of Modern Space

S pace as a conceptual term has been theorized by many scholars, although there exists no consensus about its most productive use in critical writing.[1] In film studies, most writing has focused on space as a form in the filmic text often in relation to narrative, without a connection to the space "outside" the screen. "Space and Narrative in the Films of Ozu," by Kristin Thompson and David Bordwell, is typical in its primary focus on Ozu's use of specific spatial devices.[2] For example, the authors' formalist approach examines how space in Ozu's films contends with narrative logic, and they compare this space with that of classical Hollywood cinema, in which space typically serves the narrative. In their view, the filmic space in Ozu's films is autonomous in its defiance of classical narrative economy. Thompson and Bordwell first declare Ozu a "modernist" because of his fundamental challenge to the classical norm in the mid-1970s.[3] Bordwell later refines Noël Burch's concept of "intrinsic norms" as "the premises 'locked in' the moment the film starts" and "involv[ing] all aspects of materials and form," revising the earlier affirmation of Ozu's "transgressiveness."[4] Bordwell writes: "Ozu's style is undeniably unusual, yet his films pose no drastic problems of narrative comprehension, so their use of style does not fit that current concept of 'transgressiveness' that is supposed to oppose the classical film's 'transparency.'"[5]

In their article, Thompson and Bordwell introduce the term "intermediate spaces"—"a short series of shots of landscapes, empty rooms, or other actionless spaces"—as evidence of Ozu's singularity.[6] Intermediate spaces in their view are somewhat disorienting for a spectator since they do not follow the economics of establishing shots in Hollywood narrative. As Bordwell describes in his later work, "[the intermediate spaces'] peculiarities have at-

tracted critical attention."[7] Arguing against Noël Burch's comparative reading of intermediate spaces as situated between "the dramaturgy of Western cinema" and "the Japanese poetic tradition," Bordwell states, "We want more. We want to explain, in a historically plausible way, how these strategies came to be as they are."[8] He continues: "Our intrinsic analysis thus becomes an indispensable methodological step, since it reveals an overall system of narrative that must be explained in its concrete and dynamic totality."[9]

In his essay on "narrative space" in the mid-1970s, Stephen Heath points out that although Thompson and Bordwell differentiate Ozu's spatial devices from the classical regimen of establishing shots, they do not examine the former in relation to the larger activity of the films.[10] Heath expresses a need for locating the question of "space in film" beyond formal limits to encompass the realm of reception, how a film takes place. Heath's concept, film as "narrative space," emphasizes a phenomenological reading of the relation between text and viewing subject, and he writes: "Film is not a sum of images but a temporal form," and "movement is not just perceived in itself but localized in space. . . . The spectator is not just responsive to what is moving but also to what stays in place and the perception of movement supposes fixed frames."[11] The point of Heath's argument is that "[Ozu's filmic] system is effectively different from that of Hollywood, which it can serve to contrast, but the question of its effective functioning, its critical activity, *in the films* is not posed. . . . The description of the autonomy [of Ozu's shots] tends to avoid consideration of its activity outside of formal limits."[12]

In this regard, Bordwell later extends his "intrinsic analysis" with some cultural contexts within the methodological frame of "a historical poetics." In *Ozu and the Poetics of Cinema,* he even indicates the possible dynamics between the spectator and the filmic space: "To some extent Ozu could assume that his viewer's prior knowledge would unify his transition."[13] Bordwell offers Japanese poetry and three Hollywood filmmakers as historical factors "both proximate and pertinent to Ozu" and that would have likely informed Ozu's spectator as well.[14] Here I repeat Bordwell's utterance: "We want more." In this chapter, I shall focus on filmic space in a more material sense to indicate other possibilities for the activity between the spectator and the film text.

My primary appreciation for Ozu's films is formed within this cinematic association with "spaces," and this experience is possibly shared with the national sentiment toward Shochiku Kamata films. More specifically, one can relate Ozu's films to the works of other interwar directors, with which they share a range of spatial deployments, as well as to the broader mesh of popular culture, their references to things "outside" the screen. In the films of Gosho Heinosuke (1902–1981), Naruse Mikio (1905–1969), Shimizu Hiroshi

(1903–1966), and Shimazu Yasujiro, for instance, we find similar adaptations of empty filmic spaces with the quality of a temporal and spatial pause. To be sure, these shots are not often of the same duration or refinement as in Ozu's case, nor are they always empty of narrative potential, as when characters enter an empty room. Nevertheless, these filmmakers' frequent use of landscapes and actionless spaces is evidence of a vernacular genre system, a norm established in the period's Japanese cinema, in which the repetition of stylistic techniques and images formed patterns of filmmaking and spectatorship. As a cultural subject, the Japanese had already established such cinematic vernacular norms and knowledge within the flux of various influences from other cultures, along with their own invention of a sense of newness in the interwar period. Japanese modernity was an accumulation of these norms within the larger mesh of culture.

When the activity of a film is placed in this cultural context, the accented filmic spaces start revealing other cultural codes and meanings, intertextualized with the period's popular culture and history. Such codes and meanings are often lost in the singular appeal of film critics to Hollywood norms. Examining how these interwar films circulated cultural knowledge with the spectators' cultural norms—of what is modern and what has value as commodity—allows us to formulate a historical account of the relation between space and "modernity." Indeed, the spaces in these films made Japanese modernity literally perceptible to the film audiences in the period.

It is worth noting how often Japanese audiences in the interwar period went to see movies as a measure of their level of receptivity to genre and cultural codes. According to *The Annual Records of Cinema in 1930,* the average Japanese went to the cinema at least once every two months; of course the numbers were much higher in cities with more access to movie theaters and a variety of films.[15] The frequent use of intertextualized filmic techniques such as intermediate spaces oriented the cinema's audiences to recognize both the narrative cues and the genres to which the films belonged. Deploying the term "intermediate spaces," then, might be misleading in this regard since, contrary to Bordwell's view, audiences probably did not view the spaces as "not informative on causal or temporal grounds."[16] Then how did they view those spaces? Following the films' genre signatures and their familiar use of spaces, I argue that the historical audience was steeped in the visual juxtaposition of spaces, a practice in which seemingly different genres supported an increasingly urban, middle-class form of spectatorship.

As cultural production, the cinema in particular enacted modernity's characteristic collision of spaces and temporalities, the spectacle of the unfamiliar and exotic juxtaposed with the everyday. Distant spaces were now

brought suddenly within reach of the filmgoer. Indeed, the cinema frequently mimicked the visual spectacle of an increasingly popular middle-class form of leisure travel, with shots of rural locales often framed by a window on a moving bus or train. In this chapter, I shall analyze the cinema's ability to articulate the spatial disruptions of modernity. Especially for Japanese cinema after the 1923 earthquake, urban space became the cinema's crucial iconography, one that expressed Japanese modernity's contradictory impulses toward rationality and the equality of classes, as well as insufficiency and displacement.

Cinema and the City

We can view the interwar Japanese cinema as a site, an actual space for the convergence of popular culture and the transformation of the city, Tokyo. In both imaginary and material terms, film production was inextricable from Tokyo urban space, especially in the case of the Shochiku Kamata studio, with its emerging dominance of the 1920s Japanese film industry. From 1923 to 1934, Shochiku was the only major studio remaining in Tokyo. The dislocating effects of the 1923 Great Kanto Earthquake directly determined the mapping of the Japanese film industry. Nikkatsu relocated to Kyoto after the earthquake and could not return to Tokyo until 1934. Shochiku Kamata filmmakers exploited the singular advantage of their urban Tokyo location by intertextualizing many actual scenes of the city in their films. Such images of urbanity were disseminated throughout the nation, in both city and countryside, and they confirmed popular notions among the Japanese of how the modern city space should appear. Many of the filmmakers also developed a complex interdependence between the Tokyo space of their films and the collective imaginary of urban life in their various film genres. They incorporated their own experiences of dislocation and the neighborhood "town" into the settings and narratives of the films.

The period's cinema was created during a decade of explosive urban development following both a substantial population influx into Tokyo after World War I and the devastation of the earthquake. It should be noted that this urban development was largely under the control of the Japanese government—that is, the modernization of urban space in Tokyo was directly tied to national planning and interests. The Meiji policy of *fukoku kyohei* (enhancing the wealth and military strength of the country) supported the process of spatial modernization.[17] The government's plan to reconfigure the city and its surroundings after the earthquake led to the huge expansion of Tokyo to its current size, subsuming five counties and eighty-two towns in 1932 and two

more towns in 1936, eventually elevating its status to *dai-Tokyo* (metropolis Tokyo), a slogan of the period for the restoration of the capital.[18] The revitalization of Tokyo literally became synonymous with the revitalization of the nation and Japanese modernity. As Japanese industrialization began under the Meiji government's direction, the spatial planning of Japanese modernity was also structured within top-down government control. Spatial development in Tokyo was most significant in three areas: major roads and rail systems (for the better transportation of raw materials and workers), parks (as shelters in case of natural disaster or fire), and residential areas (for the growing population of middle-class office workers). The complete destruction of the city and its ensuing transformation had the practical benefit of creating sufficient space for this new social class, with little of the class conflict that typically accompanied stages of modernity in the West.

The middle-class salaried men, as the newly risen modern subjects, became the ubiquitous image of capitalist expansion, and that image is reflected in the popular culture of the time. For example, many of the interwar films in the middle-class film genre are set in outlying Tokyo suburbs, the new areas for the growing class; they depict empty fields with low-density population yet with the first signs of encroaching development—new sewer pipes, telephone poles, and railroad lines in the background, the visible conduits of the city's relentless outward expansion. As the term for the new middle-class residence, *bunka jutaku* (culture house), suggests, the Taisho government's rebuilding effort was also tied up with a cultural project to rationalize urban space toward a more equitable and hence stable class structure. Without a major class struggle, as there had been in Western countries, the new urban subject was depicted and given form through the media—newspapers, magazines, popular music, radio, and cinema. The cinema's version of reconfigured space redefined urban dwellers as middle class and assimilated the increased population within a mass audience.[19] Implicit in my thesis is the idea that such representations of space can elaborate for us the cinema's role in the social reorganization of the period—that is, the construction of Japanese modernity itself.

Roland Barthes, in *Empire of Signs,* describes Tokyo as possessing an empty center, in reference to the Imperial Palace as the once powerful ideological center of Japan.[20] In contrast, the city space in interwar popular culture reveals a markedly different discourse of Tokyo, with the figure of an increasingly ubiquitous middle class at the center of the city. My focus on the intertextual links between the city of Tokyo, which became the center of Japanese modernity, and the urban spaces created in the cinema aims to uncover how historical subjects produced a modern space filled with the experiences and desires of a new urban middle class. I argue that cinema did not simply re-

flect transformations of the period, such as the development of the modern city, but that it was rather an active agent in modernity's envelopment of other spaces and temporalities, imagined within urban everyday life. To this end, I discuss the interwar films that contain distinct spatial expressions of domesticity in the burgeoning suburbs of Tokyo's outlying districts, nostalgia within the form of pastoral utopia, and liminality in the harbor's exotic, criminal dystopia. Many films of the period demonstrate spaces that carry the modern gaze of the contemporary audience as urban consumer. These images are not mere reflections of social development within the opposing binary models of traditional/modern and domestic/foreign; rather the interwar films may offer competing images for the audience's desires, images that support a national collective identity.

Everyday Domesticity for the Middle Class

The process of modernization is constituted at various levels: socioeconomic planning of industrialization, democratization of the political system, and cultural modernization, such as rationalism. In the case of Japanese modernity, from its inception the state prioritized industrialization over other aspects. Japan's industrialization began in the late 1880s and recorded gains coinciding with a series of wars (with China and Russia, and World War I). The significant distinction of Japanese modernity from Western variants is the profound unevenness of its emphasis on industrialization and the fundamental character of its top-down operation. As the sociologist Tominaga Ken'ichi writes, "In the case of countries with belated modernization, there is no alternative to a top-down, government-initiated economic plan. Japan's intended industrialization was the first of its kind among non-Western countries."[21]

This top-down aspect required a significant modification in that the goals of industrialization (and modernization itself) were couched in the rhetoric of a national project. The Japanese government and the *zaibatsu* plutocracy, the major industrialists that promoted the process of industrialization from its start, touted economic development for the nation-state and discouraged profits solely for the individual. This "adaptation" of modernity as a national project was made possible through Japan's familiarity with the pre-Meiji social system: the social hierarchy of *shi-no-ko-sho,* which placed the samurai class at the top as political administrators and the merchants, despite their wealth, at the bottom, located the political as the most significant order over the economic value system. The resulting unevenness caused various conflicts that the Japanese government could not resolve and that finally led the nation

to its military expansionism with the Fifteen Years' War and culminated in World War II.[22] As the government promoted industrialization, the inequities between the urban and rural economies became unsolvable. Farmers, who had received few of the benefits of industrialization, grew increasingly hostile toward modernization; as a result, there were intermittent eruptions of violence such as the rice riots (*kome sodo*) in the 1910s and political assassinations in the 1930s. Tominaga concludes that the prewar fascism of the military originated from the xenophobic nationalist sentiments of Japanese soldiers, the majority of whom were from poor agricultural communities.[23]

In the modern workplace, similar contradictions caused by the unevenness of Japanese modernity were seen in the melding of Western corporate rationalism with feudal ethics emphasizing familial allegiance. The ensuing transformations in the nature of work, home, and class identity hastily constructed a modern subject in the urban middle class that was marked by the disparities of Japanese modernity. Indeed, many of the middle-class films play with the gap between the superficially modern Western appearance of the salaried man and his infantilized subject position at work under the boss, the "feudal father."

While the term "middle class" was used to promptly solidify the new classes of labor, the classification itself in interwar Japan remains ambiguous as less of a quantifiable reality than as class rhetoric indicating how people saw themselves. When the Japanese word *shoshimin* started to be used for "middle class" in the 1920s, it was actually a literal translation from *petite bourgeoisie,* the stratum of the bourgeoisie having the least wealth and lowest social status. However, the subdivisions of "petite" or "lower" were not systematically formulated. Ubiquitous terms such as *chusan kaikyu, churyu shakai, chukanso, taishu,* and *shoshimin* (middle class, middle-class society, middle level of society, general public, and *petite bourgeoisie* respectively) were used without any strict distinction to depict the rising urban white-collar workers. As Jordan Sand indicates, the Japanese middle class "needs to be understood not as a simple social reality but as a discursive construct, and a highly contingent one."[24] The Japanese middle class resists definition with either Marx's two-class system of capitalist and proletariat or the typical tripartite system of upper, middle, and lower. Yet even with its characteristic imprecision, the language of class reflected the social transformation from Meiji's largely bureaucratic formulation to a more tenuous private corporate structure in the 1920s. The sociologist Minami Hiroshi points out that three criteria can be used for the Japanese middle class: income, occupation, and educational background.[25] However, these criteria are historically contingent and transformed radically with economic growth. Compared with the Meiji period, the middle class in

the interwar period had changed occupations from government officials, servicemen, and educators to office workers in privatized companies. The change was due to the contingency that these companies, such as the banking business, started paying significantly more than the civil service, and many highly educated graduates sought positions in the private sector.[26]

Minami states that the middle class was critically divided into high and low strata after the economic depression in 1929, and the lower middle class slipped closer to the working class. The new urban middle class became the subject of the middle-class film genre. The films, with their focus on the office worker and his family, appeared right after the devastation of the Kanto earthquake and reflected the economic constraints of the period in their production values. Starting with the comedies *Father* (*Otosan*, 1923) and *Sunday* (*Nichiyobi*, 1924), both directed by Shimazu Yasujiro, the middle-class film genre expressed the singularity of the urban nuclear family. By analyzing the film genre, we can see how this new middle-class cultural subject was constructed amid the characteristic unevenness of Japanese modernity to support a national reconfiguration of urban space for capitalist production.

Both the middle-class subjects and the films about them were thoroughly tied to the social conditions and value system of interwar Japan. In the late 1920s and early 1930s, with the rise of the socially progressive *keiko eiga* (tendency film genre), the middle-class genre also began to emphasize a critical treatment of its white-collar subjects, frequently offering an ambivalent view of modern life. Compared with the tendency films, however, the middle-class films lacked the overt politics of a broad social critique, revealing instead the predicament of the modern Japanese subject at the level of the individual and the new formation of family. While the tendency film genre was censored by the state and lasted for just a short period, many of the middle-class films could evade the state's political control. The former typically deployed polarized Marxist views of the exploiting and the exploited, but the latter rather focused on the autonomous individual, and in terms of spaces, it highlighted those in between the private and public realms as an expression of the fundamental unevenness of Japanese modernity. Most significant, the middle-class film genre revealed how the domestic space of family life was subordinated to modernity's reorganization of production. For instance, the genre presents the office worker subject's frequent predicament as a failed attempt to retain his authority at home even as he becomes a cog in the workplace. Hence, the larger social structure embodied in the public sphere of the workplace extends even to the private sphere, the domestic space. As the private domestic space was idealized as a suburban refuge, a fetishized object for consumption, the aims of public and private spheres became increasingly entwined. That is, the

private domestic space and the nuclear family became the basic units of management for the national goals of industrial production.

While the middle-class films were produced in various studios, Shochiku developed them as one of its hallmark genres. Naruse's *Flunky, Work Hard!* (*Koshiben ganbare*, 1931), Ozu's *I Was Born, But . . .* , and Shimizu's *Hero in Tokyo* (*Tokyo no eiyu*, 1935) were all commercial and critical successes, and the first Japanese talkie film, Gosho's *The Neighbor's Wife and Mine* (*Madamu to nyobo*, 1931) also deployed the genre subject. Overall, the middle-class films' criticism was not laid out as direct commentary on the failings of capitalism but more subtly reflected social economic disparities in Japanese modernity. These films deployed archetypal spaces for everyday middle-class life, such as the suburban development home for the middle-class family, the father's urban office, and the empty lot of the children's playground.

The middle-class film genre offers the reassuring narrative of middle-class life persevering in the face of economic hardship. The central spaces of this genre contain a dichotomy of private and public spheres, specifically the domestic family space and the office space of the father figure. The films legitimize middle-class life in the modest size of the family's home and the suburban location, and they further emphasize the father's salaried-man status in the morning commute to work. *Tokyo Chorus,* locates a threat to middle-class stability in the class differences of the unregulated space of city streets. In one sequence the leading character (Okada Tokihiko) goes downtown in search of a job. The long establishing shots provide the mise-en-scène of the depression period and space of Tokyo. Numerous vagrants are sitting on the sidewalk as cars pass behind them. There is a shot of a factory's chimney, followed by a medium shot of two vagrants and a close-up of cigarette butts wrapped with newspaper in their hands. Okada appears and extinguishes his cigarette before entering a building. One of the vagrants immediately picks up the butt, relighting it as he says, "The world has changed if even that gentleman needs to come here." The audience is informed by a sign reading "Employment Office" that the leading character has come to the building to find a job. The scene identifies the threats of financial instability and temporary slippage of class distinctions on city streets; both the bums and the protagonist are unemployed, and the "shared" cigarette butt presents a symbolic tie between them. However, the film never shows that these two classes are united, nor does it offer more than an indirect critique of the government. On the other hand, the film reassures and soothes the middle-class audience by identifying it with the protagonist, who is in the end saved by his former teacher and provided with a new job. In the face of pervasive anxiety over the increasingly tenuous status of class distinctions, the film offers refuge in the communal ties of the hometown

and the past. The warm domesticity of the salaried man's home, the former teacher's family-run restaurant, and the nostalgic high school affiliations provide the intimacy that connects the salaried man, and the audience as well, to the good old days.

The Invention of the Hometown as Nostalgic Space

In his analysis of 1920s Tokyo, sociologist Yoshimi Shun'ya presents two different urban spaces, Asakusa and Ginza, defining them as the *kakyo kukan* (hometown space) and the *mirai kukan* (future space) respectively.[27] Briefly, the two represent distinct spaces within the city: Asakusa represents the informal and local, a mix of classes in the atmosphere of the hometown; Ginza represents the modern, status-conscious world of commodity fetishism in imitation of Western culture—"futuristic" in its overt longing to be on par with the West. As a representation of the premodern interpolated within the modern, Yoshimi's Asakusa in particular offers a suitable framework for my discussion of the nostalgia imbedded in filmic images of the country space.

Applying the Asakusa and Ginza models here reveals the split nature of Japanese modernity in regard to urban space. The two spaces represent quite different modern experiences, yet both are subsumed within the urban landscape and indeed within the popular imaginary, most notably through consumerism. While Asakusa offers Tokyo residents local goods, cheap restaurants, and recreation in the form of live performance and movies, Ginza's version of public space and popular culture is geared toward middle- and upper-class Westernized sensibilities in the form of cafés and department stores.[28] Unlike the scattered open spaces of the Asakusa marketplace, the Ginza space is tightly structured by the dictates of top-down urban planning. Ginza's form of consumption has less of the participatory, communal aspect of Asakusa. Ginza window-shopping is based on a more private act of subject identification; individuals actualize themselves through such looking and buying.[29] Evidence of the connection between such consumerism and Japanese modernity abounds: 19 percent of women walking on Ginza streets wore Western clothes in 1933, and the increasing affordability of ready-made suits encouraged businessmen to adopt Western-style clothes. After a huge fire in the Shirokiya department store in 1932 claimed the lives of a number of women shoppers (who, out of modesty, refused to jump down to the firemen's trampolines), the sale of Western pantaloons increased dramatically.[30]

Such accelerated Westernization coexisted with the urban dwellers' love of the countryside; it was represented throughout the mass media, including

films such as *Izu Dancer*. Indeed, the twin longings for a localized imagined "home" and a city space offering a more expansive "customized" identity can be seen as inextricable with Japanese modernity itself. Historian Narita Ryuichi asserts that the idea of "hometown" first appeared in the 1880s in Japan, and the concept gained popular currency with the development of industry and urban planning, especially in the 1920s and early 1930s.[31] In 1926, the folklorist Yanagita Kunio highlighted the social transformation and indicated that the most significant alteration from Meiji to Taisho was the increasing centralization of economic and cultural power in Tokyo: "In both the countryside and the remote islands, residents already observe the cultural norms and average living standards that have extended from urban city life during the Taisho period."[32] At the same time, the urban dwellers' nostalgic longing for their hometown reflected the dislocation of the growing class of Tokyo migrants, who, in the words of sociologist Mita Munesuke, were marked by "the polarization of one's space identity."[33] Mita presents this split as the result of the leading force of Japanese modernity, *risshin shusse shugi* (careerism, or the goal of establishing oneself and advancing in the world), rooted in the Meiji period's merit system of achievement and the ensuing centralization of Tokyo as the site for bureaucratic advancement.

By manipulating this polarization in the nostalgic recollection of hometown memories, film, popular music, and novels worked to integrate and manage the vast number of recent migrants to Tokyo. The song "Hometown" (Furusato, composed in 1914), designated for the elementary schools by the Ministry of Education, initiated children to urban middle-class values with the following lyrics: "The mountain where I chased after rabbits, the river where I caught little carp, I am still recalling my dreams, the hometown that I cannot ever forget." In "Literature of the Lost Home" (1933) Kobayashi Hideo laments being born in Tokyo and not having his own hometown: "Listening to him [Takii Kosaku, another writer and Kobayashi's close friend in the period] then describe the fullness of his heart, how [when] gazing upon such mountain roads a stream of childhood memories came welling up within him, I keenly felt that the 'hometown' exists beyond my comprehension. It is not so much that I do not know the hometown as I do not understand the notion of a 'birthplace,' or a 'first home,' or a 'second home'—indeed, what home of any kind in fact is. Where there is no memory, there is no home."[34] As these sentimental longings for the hometown indicate, the gentrified concept of hometown provided inspiration for the production of a popular culture that served and incorporated the new middle class as a mass audience within the urban space.

The interwar films made good use of this nostalgic space in the 1920s and 1930s, soothing middle-class anxieties in a period of intense social change

during the restructuring of capitalist production. Directors such as Ozu, Shimizu, Naruse, and Gosho reiterated the nostalgic creation of the imagined hometown. In *The Only Son* (*Hitori musuko*, dir. Ozu Yasujiro, 1937), a mother in Shinshu visits her son working in Tokyo; *Mr. Thank You* (*Arigato-san*, dir. Shimizu Hiroshi, 1936) depicts the bus driver protagonist rescuing a country girl en route to Tokyo; *Wife! Be like a Rose!* (*Tsuma yo bara no yoni*, dir. Naruse Mikio, 1935) has an urban entrepreneur choosing his new family in the country over his family in Tokyo.[35] Even in recent times, the hugely popular Tora-san film series (from 1969 to 1997) by Yamada Yoji has evoked hometown, the space of nostalgia, as the central figure, Kuruma Torajiro, is depicted in a comical mismatch with the social formations of late capitalism. In this case, the hometown is not simply located in the country, where urban cultural standards have long since become prevalent, but rather the series presents *shitamachi* (the urban downtown neighborhood) as a symbolic locale of a preserved "good old days" and the warm community signified by Torajiro himself.

Izu Dancer uses nostalgia in its images of rural locale and its narrative structure—a journey from Tokyo to the countryside based on the narrator's recollections. Kawabata Yasunari's novel *Izu Dancer* has since demonstrated its value as cultural currency, having been adapted into five other film versions, but Gosho's film has always been evaluated as *wakamono eiga no koten* (the classic youth film), and many film critics have praised it as the best of the various versions.[36]

Izu Dancer concerns a Tokyo college student, Mizuhara, and his trip to the Izu area (located in Shizuoka prefecture, famous as a tourist attraction for its hot springs), where he befriends a troupe of street performers and becomes enamored with a young dancer, Kaoru. At the end of the short trip, he returns to Tokyo, and the dancer sees him off at the harbor with tears.

Most Japanese film critics have pointed out how realistic Gosho's film is, especially in its depiction of the street performers' low social status. For example, the film critic Sato Tadao writes, "At the beginning of the Showa period, the social status of the First High School [present-day Tokyo University] was the most elite of the elites. The street dancers, on the other hand, belonged to a class that was always held in contempt by people. . . . In this film, Gosho depicted their social class differences in specific ways and showed the heartrending love caused by those differences."[37]

American film scholars as well, such as Arthur Nolletti Jr., view the issue of class differences among these characters as central to an analysis of the film. In short, Nolletti points out that Gosho's film diverges from the novel by embellishing the love story and adding a subplot and new characters. The sub-

plot focuses on the film's materialist theme and makes the issue of class more complex. Nolletti concludes, "The real obstacle [to Mizuhara and Kaoru's union] is social class."[38] He adds: "Viewed one way, Gosho and [the screenplay writer] Fushimi's change of Kaoru and Eikichi's [Kaoru's brother] class [compared to the novel] might seem to be a case of backpedaling on the part of the filmmakers. Viewed another way, this change carries a decided sting, implying that nothing short of a miracle—which is exactly what Zenbei [one of the new characters willing to become Kaoru's benefactor] is performing—could make inroads on social strictures regarding class."[39] What might be missing from Sato's socially conventional view and Nolletti's thoughtful but narrative-oriented reading is the fact that this adaptation is indeed the transformation from word to image. The construction of space as nostalgia that attracts the contemporary audience needs to be considered in this process of adaptation.

In this light, the film's emphasis is no longer simply on the class differences of the lovers but rather on their experience of traveling and the scenery surrounding them. The circuitous route of the student's tour of Izu and the return to Tokyo is depicted in the film with the manipulation of space and nostalgia. The class differences are ultimately mitigated in the film compared with Kawabata's novel, and the characters themselves are described as thoroughly modern in their language, their sense of individuality, and their unfailing cheerfulness. The film avoids a melodramatic ending and detaches from the novel's *shishosetsu* (I-novel) formula of deploying the author's or the protagonist's subjective viewpoint. Gosho changed the terms of the romantic breakup between the student and dancer by his addition to the narrative of another prospective suitor, for whom the student willingly steps aside. *Izu Dancer* invents a country space appealing to the nostalgia of city dwellers, and by obscuring class differences, the film legitimizes the sensibility of its middle-class audiences.

Placed in the context of other films of the period, *Izu Dancer*'s deployment of space can be seen as less a reflection of actual life in the countryside than an intentionally created nostalgic space. Produced during the same period as *Izu Dancer*, Gosho's other film, *Love of Tokyo* (*Koi no Tokyo*, 1932), celebrates the renewal of the metropolis of Tokyo, and the film was nothing but a hymn to urban space. Clearly both films serve the same audience by foregrounding middle-class values. The same audience could have also viewed other films, produced in the same period, that specifically highlighted urban spaces, such as Tokyo in Ozu's *Woman of Tokyo* and Yokohama in Shimizu's *Japanese Girls of the Harbor* (*Minato no Nihon musume*, 1933). In comparison with these films about cities, Gosho created country space through an extensive use of location scenes in *Izu Dancer*; it is noteworthy that his nostalgic depiction of

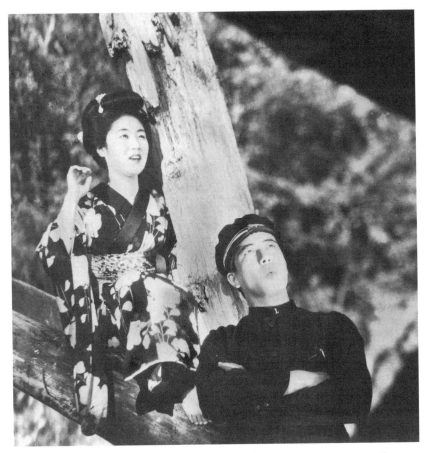

Izu Dancer (dir. Gosho Heinosuke, 1933). The film is less concerned with class differences than it is with the manipulation of space and nostalgia. The Izu dancer (Tanaka Kinuyo), on the left, spends time with her new friend, the university student (Obinata Den). Courtesy of Kawakita Memorial Film Institute.

the country (untainted by modernization) aims at the same audience as the other films in the period.

The nostalgic country space in *Izu Dancer* is far more central to the film than was the Izu countryside in Kawabata's original story. Gosho indeed transformed various aspects of the original novel. He changed Mizuhara's motivation for the journey from internal alienation to simply an excursion—the character travels to relax after exams—and he reduced the novel's attention to subjectivity in favor of atmosphere or space. The film is structured around the experience of travel for pleasure, typically associated with city dwellers,

encouraging the audience to identify with the character and experience the scenery with him. Almost half of the film's shots include the scenery of the Izu area.[40] Gosho himself reminisced that "It was not easy to scout enough good locations for the film in the areas of Amagi, Shimoda, and Yugano even thirty-four or thirty-five years ago, so we had to go far away to Bessho in Shinshu and the background of *Snow Country* [*Yuki guni*] in Joetsu."[41] Gosho, thus, made a conscious attempt to create *a perfect nostalgic space* in the film with his well-chosen scenery.[42]

Gosho's film foregrounded the concept of hometown and highlighted the experience of traveling itself, transforming the novel's individual act of traveling by Mizuhara to the collective experience of viewing pastoral scenery, in which the characters reflect the modern gaze of the urban consumer, the city dwellers' "excursion" into nostalgic country space. This process of adaptation itself needs to be analyzed within the historical context here. Eric Cazdyn interprets the *eiga-ka* (adaptation from literature to film) in the 1930s Japanese cinema as the result of the film industry's participation in the war effort dur-

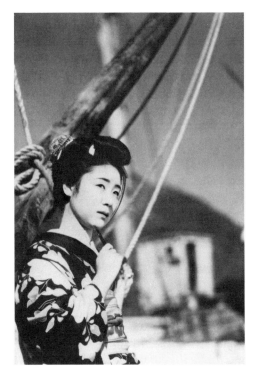

Izu Dancer (dir. Gosho Heinosuke, 1933). Gosho has carefully excised all modern elements from the harbor location to realize the perfect nostalgic space. Courtesy of Kawakita Memorial Film Institute.

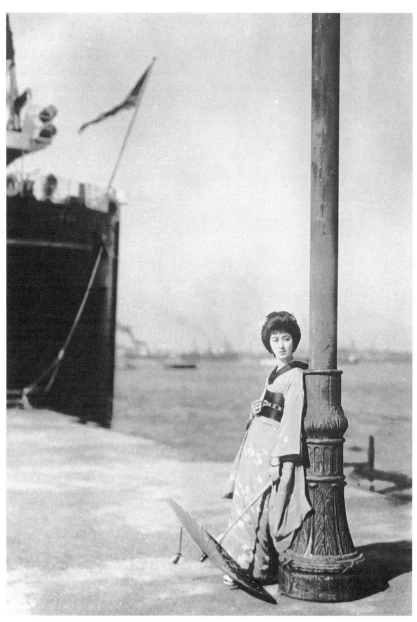

Japanese Girls of the Harbor (dir. Shimizu Hiroshi, 1933). The woman at the harbor. Gosho's creation of the nostalgic harbor space in *Izu Dancer* can be seen more clearly when compared with this film's harbor scene. Courtesy of Kawakita Memorial Film Institute.

ing Japan's Fifteen Years' War: "This first important *eiga-ka* movement corresponded to the most significant ideological return to 'origins' that modern Japan had yet to experience. . . . The early 1930s marked the moment in which film would need to straighten itself out and become an equal partner in advancing the war effort."[43] While I see the parallel of the *eiga-ka* movement's act of returning to "origins" in the adaptation of *Izu Dancer* since the film's country space represents nothing but the urban spectator's nostalgic longing toward the hometown "origin," I also find Cazdyn's interpretation exclusive and overdetermined. First, this specific case of *eiga-ka* by Gosho does not deploy an ontological privileging of literature over film—as I have indicated, the film transforms the original story on both the levels of plot and mise-en-scène. In particular, the film subordinates word to image in the visual stimulation of its landscape scenes. Moreover, in the context of popular culture in the early 1930s, the act of returning to "origins," symbolized by the nostalgic hometown, can also be read as an attraction for the modern consumer, an object for tourism, rather than the ideological rise of militarism. The analysis of popular culture must always be examined within the system of commodification—that is, popular cinema was and will be produced for profit. Much is made of how the profit motive often runs counter to creating art in the cinema, yet the economic imperative has its upside: what makes money does not always coalesce with the goals of the state—particularly the escapism that often characterizes wartime cinema. Thus, at least some part of the cinema's attractions always escapes the ideological control of meaning.

Izu Dancer's deployment of the attractions of countryside tourism can be best understood in the historical economic leveling of leisure travel from upper-class recreation to middle-class consumption. The consumer "excursion" in the prewar period reached its peak in the 1930s. With the government policies for enhancing the wealth and military strength of the country (*fukoku kyohei*) and promoting industry (*shokusan kogyo*), the Japanese railroads had developed dramatically in the first three decades of the century. Various local railroads were nationalized and streamlined in 1903, and Japan built the most efficient railroad system in the world, one that could even embrace military requirements at any time without changing the regular train schedule. With the technological development and popularization of public transportation, leisure travel to such destinations as hot springs resorts, summer houses, and beaches was no longer limited to the upper class but became accessible to middle-class urban dwellers by the 1920s. Evidence of this changing demographic can be seen in the promotion of *shuyu-ken* (travel tickets for sightseeing) in 1925 and the launch of the super express train Tsubame (Swallow), a bullet train running between Tokyo and Kobe, in 1930. The national railroad

advertised the dramatically shortened running time of the Tsubame (from 11 hours and 40 minutes to 8 hours and 20 minutes)—which literally made modernity's idiosyncratic experience of speed and consumption prevalent in modern life—until 1940, when, in support of the war effort, it eliminated the promotion of tourism.[44] Sightseeing buses also became popular with the development of the auto industry. One of the most famous hot springs, Beppu, for instance, started deploying periodic sightseeing buses in 1927. The planner of the tourist resort Aburaya Kumahachi in Kyushu even presented ideas for developing the whole Kyushu area as a resort in the late 1920s, such as creating a Kyushu national park and highways across the area.[45]

While the shots of mountains, rivers, and country roads in *Izu Dancer* may be considered excessive and inefficient within the narrative practice of classical Hollywood cinema, they supported the economics of popular culture familiar to the 1930s Japanese audience. The scenes represented space constructed for the new urban consumer, and as such, they included and legitimized middle-class sensibilities in the modern public space of the cinema. In this sense, the nostalgia imbedded in the country space demonstrates the film's support of an external protocol by which the audience of the period constructed meaning from the film's coded significations.

Liminal Space with the Other

The *ankokugai eiga* (underworld film) appeared in the early 1930s as a new genre, and it offered contested spaces in which reality and imagination, ordinary life and crime, domestic space and "foreign" space directly interacted. These films presented a more complex and dynamic view of social space, characterized by liminality and allowing for greater autonomy in its location at the margins of national identity, a threshold to the outside. There was fluidity in ethnicity, such that Japanese were shown in parity with Westerners, with English names, and visibly familiar with Western customs, such as smoking a pipe, drinking beer, or living in an apartment furnished with Western furniture. In this liminal space, the Japanese identity was presented as connected with the outside, yet the encounter with the foreign was not depicted as threatening since the whole liminal space was closed off from people's everyday lives throughout narrative development. While the expression *mukokuseki* (statelessness) has often been used for culturally mixed genres, such as action films since the 1950s, the denationalized identity was already evident in this underworld film genre in the interwar period.[46] The genre's films reveal the Japanese intention of imitating Hollywood cinema and Western iconography, yet they

present their own spatial and narrative logic, which does not necessarily match with Hollywood's.

The period's underworld themes and images were not solely the subjects of cinema. Interwar popular culture was fully engaged with alternative identities—the underworld of street gangs, longshoremen, dance hall girls, barmaids, prostitutes, and urban strollers, flâneurs and flâneuses in the urban space. Clearly the images cannot be interpreted simply as a reflection of Westernization or an imitation of the West; rather they were molded for the Japanese consumers' own desires. Apart from Hollywood's influence, it is worth examining the resonance from print media in the films' symbolic liminality, "exotic" spaces, and the mobilized gaze of the city dweller.

Many of the urban figures in film closely resembled literary characters, such as those, for example, in Kawabata Yasunari's novel *The Asakusa Crimson Gang* (*Asakusa kurenaidan,* 1929–1930) and many of Edogawa Rampo's detective novels.[47] The crime and mystery genre appeared on the Japanese literary scene in the 1920s with the emergence of magazines such as *Shin seinen* (New Youth, 1920–1950). The appearance of the popular detective genre and the writings of Edogawa Rampo (many of whose works appeared in *Shin seinen*) can be located in the social phenomenon of the public fascination with sensational crime.[48] In many of these novels, urban crimes are solved by a detective/*flâneur* who is intimately familiar with the city streets, so that the location becomes entwined with criminal acts and deviancy. The detective Akechi Kogoro in Edogawa's novels, for instance, is a typical *flâneur* in the newly rebuilt Tokyo. In this version of urban space, there is no longer a clear division between ordinary people and abnormal criminals. The anonymity of the modern city fostered actual psychotic crimes, and readers consumed crime stories as a symbolic tableau of urban space. Newspapers reporting sensational crimes, along with various magazines, such as *Hanzai kagaku* (Criminal Science), *Hanzai koron* (Crime Debate), and *Tantei shosetsu* (Detective Novels), established the genre of criminal journalism.[49] Translated literature, such as the French urban novel *Ouvert la nuit* (Open All Night, 1922), by Paul Morand, presented new expressions for urban space and underworld culture in Japanese literature.[50] Readers desired the experience of *flânerie* in Anne Friedberg's sense—"a social and textual construct for a mobilized visual" that could be situated as a vernacular urban phenomenon linked to the new aesthetic of reception in reading literature and viewing films.[51] These modern urban consumers' experience in the vernacular culture emerged as the reified form of Japanese modernity configured within Japanese historical and cultural contingencies, such as the urban city's geographical transformation. The rapid expansion of the capital after the Kanto Earthquake produced a city with alternative economies and

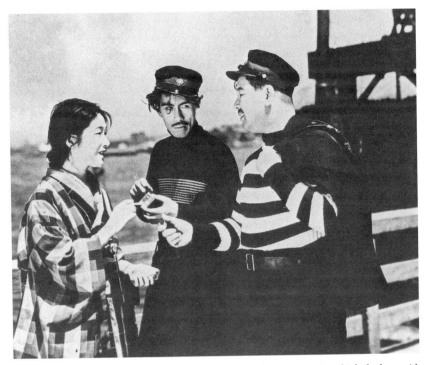

Everynight Dreams (dir. Naruse Mikio, 1933) begins with a sequence in which the barmaid Omitsu (Kurishima Sumiko) begs a cigarette from the sailors. Yokohama harbor, the gateway to all things foreign, becomes linked with the image of a fallen woman. Courtesy of Kawakita Memorial Film Institute.

identities, even foreign ones; the city changed so relentlessly that it contained spaces that were at once unfamiliar and alluring to the imagination.

Many of the crime films, such as *First Steps Ashore* (*Joriku daiippo*, dir. Shimazu Yasujiro, 1932), *Everynight Dreams,* and *Japanese Girls of the Harbor,* unfolded these cultural contingencies by centering on the seedy dockside spaces of Yokohama harbor. Like the downtown Ginza district, Yokohama harbor was used as an indicator of a modern urban space; however, the harbor space, detached from the city dweller's everyday life, would offer mobilization to the audience's gaze and represent the more symbolic, imaginary locale for the foreign. The depictions of Yokohama often included images of foreigners and foreign cultures, which embodied a different foreignness from Ginza's luxury shops in that they represented the transient, heterogeneous population of outlaw space—that is, a liminal space to the "other" side of Japan.

This image of Yokohama as the conduit of cultural flows from outside Ja-

pan remained prominent in the popular imaginary even as the actual harbor city and its openness to the foreign were superceded by a national regulatory structure. Here one can see the triangular reciprocity between Yokohama as a place, its image via the media, and its historical geopolitical transformation. Writing on Yokohama and Tokyo's geopolitical structure, Yoshimi explains the transformation of the capital from before 1914 to after. In 1914, when the Tokyo railway station, now the central hub in Japan, was constructed, the Ginza district, then the center of consumption of Western goods and images, started strengthening its ties with the domestic rather than the foreign. Before 1914, the central rail line from Yokohama to Ginza was connected via Shinbashi: foreigners and Western goods arrived at Yokohama harbor and were then transported to Shinbashi station by railroad; after that, many of the foreigners went to the foreign settlement in Tsukiji (near Shinbashi), and the imported Western goods went to the Ginza shopping district. After 1914, Ginza was directly connected to the newly built Tokyo station, circumventing Shinbashi, and it became tied to the Imperial Palace via Tokyo station's Marunouchi central exit; consequently the station users faced the direction of the Imperial Palace. For Yoshimi, the pre-1914 Ginza-Yokohama cultural-geographic pipeline of Western goods and foreigners was replaced by the post-1914 nationalistic triumvirate of Ginza, Tokyo station, and the Imperial Palace, and Yokohama was left on the margins, literally and symbolically, of Japanese geopolitics as simply a harbor port.[52]

With the geopolitical turn in 1914, as Yoshimi described, the image of Yokohama was transposed in the popular imaginary, where it functioned as a "medium" for the Japanese connection with the West. In the interwar period, Yokohama became the Japanese liminal space, supporting the illusion of Japan's internationality, the notion that we are at the same time connected with the outside and protected from it, since the harbor space stood as both threshold and secure breakwater, guarding the nation from unknown threats outside. The lyrics to a popular 1921 children's song, "Red Shoes" (*Akai kutsu*), clearly captured the popular imaginary about Yokohama: "A girl wearing red shoes was taken by a foreigner. She was taken abroad by boat from the Yokohama harbor." Despite the intimated threat of kidnapping, the song's theme would have been received more ambivalently since rags-to-riches tales of adventure abroad were common in the period. The song is indeterminate regarding the displacement of the girl, be it out of envy or pity. In this sense, the cinema also functioned as a liminal space—for instance, exhibiting Hollywood's influence in the process of adaptation while limiting spectatorial identifications with fallen characters to the harbor. My comparison of *The Docks of New*

York (United States, dir. Josef Von Sternberg, 1928) and its Japanese version, *First Steps Ashore*, will further explore how adaptation mediates the Western influence in Japanese cinema.

The harbor space in the aforementioned underworld film genre is circumscribed by foreignness more so than by the infrequent presence of actual foreigners. For example, in the early sequence of *First Steps Ashore*, barmaids await the arrival of foreigners and foreign ship crews to their bars; however, the foreigners exist in a curiously absent form in this and many other films of the period. This absent existence of the foreigner or actual foreignness (foreign locale, authentic foreign goods, Western-style furniture, etc.) occurs on various levels of the film. The film's use of foreign atmosphere creates the harbor space as a liminal site for *imagined* Otherness, a "border" of national boundaries. The Western-style furniture and conveniences in the modest living quarters of the prostitutes in the film work as temporal signifiers that only meet with the Japanese audience's increasing knowledge about how the West (*seiyo*) appears via the media (books, magazines, and films), but that audience has only a limited experience, if any, of actual foreigners or life abroad. The often mentioned Western iconographies in Ozu's films, such as Hollywood film posters, English newspapers, and graffiti on the walls of a gang's seedy dive in *Walk Cheerfully* (*Hogarakani ayume*, 1930), are the best examples of this sort of indicator. Ozu continued using the signifiers of foreignness in the postwar period, but their meanings obviously changed from imaginary to experiential, and like the Coca-Cola sign foregrounded in *Late Spring* (*Banshun*, 1949), such images are shown as already partialized within the Japanese vernacular culture.

The "absent existence" of foreignness often occurs in the process of adaptation. *First Steps Ashore* is an adaptation of *The Docks of New York*, though the film credits do not indicate this. It is hard to imagine that the director of *First Steps Ashore*, Shimazu Yasujiro, intended to hide the film's source from the audience, since *The Docks of New York* was one of the best received Hollywood films of the time in Japan. In 1929 it was named the best foreign film of the year by the film magazine *Kinema junpo* (Movie Times, 1920–present). Such free adaptations were so commonplace that it was often the case that their sources were unacknowledged, reflecting the assumption of Hollywood's prominence in film and its absence as a potential spectator of the Japanese films. Conversely, filmmakers would sometimes falsely credit a film's narrative source to a foreign-sounding author in order to give their film the imagined cachet of higher production values. Examples of this practice include Ozu's *I Was Born, But . . .* , *Dragnet Girl* (*Hijosen no on'na*, 1933), and *Passing Fancy* (*Dekigokoro*, 1933)—all written by a fictional James Maki.

First Steps Ashore starts with a sequence in the dark engine room of a ship; in the sequence the film carefully imitates the aesthetic of *The Docks of New York*. It differs from the latter in the spatial setting: the engine stokers are working before taking their "first steps ashore" at Yokohama Bay. The film's narrative has the protagonist, the stoker Sakata (Oka Joji), rescuing a drowning woman from the sea. After attending her all night, he and the suicidal woman, Sato (Mizutani Yoshie), develop a romantic interest in each other. Later they are attacked by gangsters, and Sakata kills one of them by accident. At the end of the film, the police arrest him, whereupon Sakata reveals his feelings to Sato for the first time: "You can just think that I'll be at sea for a while."

As noted, film itself worked as a liminal space from the global influence of Hollywood cinema in the period. *First Steps Ashore* conveyed the Hollywood influences, such as the visually similar sequence in the engine room, and at the same time, it transformed the influences within the conventional form for the Japanese audience. After *The Docks of New York* was released in Japan in 1929, *shinpa* theater first adapted the story in June 1931, then *First Steps Ashore* was produced in 1932, casting the same *shinpa* actress (Mizutani Yoshie) who had already established herself as a leading stage actress. In the process of adapting the film from silent to sound (*The Docks of New York* is silent, and *First Steps Ashore* has sound), the filmmaker not only added words, but also used the *shinpa* theatrical influence—most evident in Mizutani's acting and elocution—to "Japanize" the script. The scenario writer, Kitamura Komatsu, worked on both the *shinpa* and the film versions; his adaptation from the visual images to the words of the play and from the Hollywood to the Japanese film proceeded during a surge in the Japanese film industry that coincided with the cinema's shift to the talkies.[53] Adaptations from already well-known literature or well-received foreign films met the film industry's need to gain profits without taking big risks. Japanization was required for such profits, and the period created the stateless (*mukokuseki*) identity in the underworld genre.

Film scholar Yamamoto Kikuo points out the relation between filmmakers' Japanization of Hollywood gangster films and the *mukokuseki* identity in the films: "The Japanese action film genre has consistently observed Western norms, though many of the former [films] have a *mukokuseki* aesthetic. . . . Ozu produced the most successful examples of Japan's underground film genre in the 1930s."[54] The "*mukokuseki* aesthetic" is neither an incomplete imitation nor a misunderstanding of the West. The space of *mukokuseki* in these films should also not be identified as the term's literal expression designates (*mu* = none, *kokuseki* = nationality); rather than erasing nationality or national identity, the "aesthetic" indicates a specific "space" as one's recogni-

tion of locale, in relation to "place" as an actual geographical location in Michel de Certeau's definition.[55] In *First Steps Ashore,* for instance, the "place" of the diegetic location is understood as Yokohama by the film's contemporary audience; the replacement of the cityscape in *The Docks of New York* with the rather modest lighthouse in Yokohama Bay at the very beginning of the film emphasizes its "place" substitution to Japan, and the substitution works as a device for creating familiarity. However, in spite of the replacement, the film emphasizes the foreign experience or encounters with foreigners (the sailor who has visited various countries and the fallen woman who has met many foreigners) and the Westernization of everyday spaces such as the bar and hotel. In short, the "space" of the film is presented as de-Japanized and beyond the experience of ordinary Japanese.

The regional characteristics of Yokohama as a locale for trading, an entry for foreigners, and the province of criminals are inscribed in the underworld genre films with the images of a modern space that is simultaneously inclusive in terms of racial diversity and exclusive as a criminal center cordoned off from the rest of the nation. These images and cultural connotations were mediated through the wider popular culture in the 1920s and 1930s—music, novels, radio programs, and films.[56] In this cultural context, the harbor scenery, as the other aforementioned foreign signifiers, functions rather as an alternative sign to the regimented middle-class identities and values with which the audiences could easily identify. Many of the films deploy the contrast between foreign and middle-class domestic identities in order to develop their narratives, enhancing the ideology that Japan had already Westernized and modernized enough and yet had retained its unique character and traditional virtues.

As one example of this dichotomy, *Japanese Girls of the Harbor* deploys the contrasts of fallen and married women, Japanese and Eurasian bodies, and Yokohama streets and domestic spaces. Two high school friends, Sunako and Dora, grow up and take opposite paths; Sunako becomes a barmaid, and Dora marries Henry. Both Dora and Henry are supposed to be Eurasians born in Yokohama (actual Eurasian actors, Egawa Ureo and Inoue Yukiko, play the roles). The use of a "foreign" body and its contrast with the Japanese one in the discourse on Japanese modernity are more thoroughly examined in the chapters on the national body and the woman's film, but of interest here is how the film reverses the usual terms of the intruding foreign presence so that the domestic sanctity of the mixed-race home is challenged by a sexually autonomous Japanese figure. The fallen Japanese woman, Sunako, threatens the domestic space by her seduction of Henry. This reversal works well diegetically only through the film's use of the imaginary "foreign" locale of Yokohama. However, typical of the genre is the way the film disposes of the threat

posed by Sunako: she disappears in the end, thus reenforcing middle-class legitimacy.

First Steps Ashore uses double spatial structures that enhance the film's narrative adjustment to the vernacular audience: one is between real and imaginary spaces, and the other is the aforementioned city and country spaces. The film carefully eliminates two public spaces from the original Hollywood film that are firmly linked to experiential social institutions: marriage and court. In *The Docks of New York,* the stoker (George Bancroft) and the suicidal woman (Betty Compson) are married in a bar by a minister from the street, and at the film's end, their confirmation of mutual love is presented clearly in a court scene: Bancroft rescues Compson by giving himself up in the court where she was mistakenly accused. *First Steps Ashore* completely omits these sequences. The film's omission of such public spaces is an intriguing point in comparison with the tendencies of contemporary national cinema. In contrast, many recent world cinemas deploy particular public spaces to highlight their ethnic and cultural differences from the West. *The Wedding Banquet* (Taiwan and United States, dir. Ang Lee, 1993) and *My Big Fat Greek Wedding* (United States and Canada, dir. Joel Zwick, 2002) depict the strength of ethnic family ties over American individualism through the wedding narrative; *Yellow Earth* (China, dir. Chen Kaige, 1989), *Ju Dou* (Japan and China, dir. Zhang Yimou, 1990), *Raise the Red Lantern* (China, Hong Kong, and Taiwan, dir. Zhang Yimou, 1991), and many Iranian films use the institutions of marriage and married life to show the unequal status of women in their societies. Following the same logic but for reverse purposes, many old world cinemas, especially in films that highlight a sense of modernity, displace such public spaces in order to naturalize the films for their domestic audience. While these contemporary films, whether planned from their inception or not, are self-consciously imbedded with images and themes to engage their international spectatorship, *First Steps Ashore* creates the feeling of internationality by omitting the locality of space in the process of adaptation, since such social events as weddings in the Western public space are too culturally specific to fit with Japanese spectatorship. In order to create an imaginary international space, the film eliminates the reality of the Western public spaces.

First Steps Ashore also adds domestic specificity in the process of adaptation through the spatial contrast between city and countryside. Given that many of the urban audiences were from rural areas, the discourse of hometown/countryside was widespread in the popular culture of the period. The changes in the leading characters to highlight their family ties and local origins evince the further tailoring of the original film's spatial regime to suit the domestic audience. In *The Docks of New York* both George Bancroft and Betty Compson

are depicted as without ties to a geographical origin or family relationship; however, the Japanese film subtly includes sequences of the stoker writing a letter to his mother in his hometown and of Sato telling the story of her life— she is from the remote village of Abashiri in Hokkaido, and her stepfather tried to sell her to a brothel after her mother's death.

In the same manner, in *Everynight Dreams* Naruse Mikio presents contested spaces; the film creates a synthesis of the reality in everyday life and the imaginary of internationality, especially between the domestic space and the outlaw space, through the desires of the leading character, Omitsu. Briefly summarized, Omitsu works as a barmaid and occasionally a prostitute. She has a young son by her estranged husband, and one day her husband comes back to her. As they start to live together again, their son is hit by a car. The unemployed husband steals money for the son's medical care, and at the end of the film he commits suicide before the police close in. While Omitsu's situation (both working as a barmaid and being a single mother) puts her at a low social status, the film depicts her as having greater autonomy and economic independence than typical domestic housewives. Many of the female figures in this genre do not follow the gender and class roles of the middle-class film genre. For example, much like the female gangster in Ozu's *Walk Cheerfully,* who is portrayed as an active and equal participant in a mostly male gang, Omitsu is independent enough to choose prospective customers from an equivalent position. Within the harbor space, female figures are allowed to assert their own needs and desires. In Omitsu's case, as long as she lives in this space, she can be relatively "modern" in the sense of having freedom and independence, but her desire to live a domestic life brings another space with different social values into conflict with the criminal space in which she lives.[57]

This contestation of spaces is shown in the film's skillful contrast between the different images of Omitsu's one-room apartment. The film first shows her living room, barren except for a mirror and a chair, juxtaposed with an elder couple's room next door, cluttered with furniture and home articles, a symbolic image of domesticity. Omitsu's room is introduced when she comes back from jail (she was jailed for a night for prostitution), and the space, dimly lit and empty, creates an image of poverty and isolation. In a later scene, after her estranged husband's return, a fellow barmaid visits Omitsu with a bouquet of flowers. The film shows a sunny sky through a wide-open window, and Omitsu's room, decorated with the flowers and a man's shirt that she is mending for her husband, is transformed into an image of cozy domesticity. While Omitsu stays in her room, her husband and son appear in a vacant lot, a ubiquitous image of the expanding urban space, *kinko jutakuchi* (a residential suburb outlying the city), where the father plays baseball and the son enjoys watching the game.

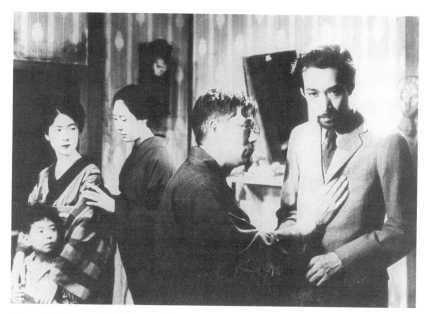

Everynight Dreams (dir. Naruse Mikio, 1933). The barmaid Omitsu's (Kurishima Sumiko) modest apartment and the mirror that blurs the distinction between the private (her room) and the public (the bar). Courtesy of Kawakita Memorial Film Institute.

At this moment, the film even seems to turn into a middle-class genre film, with the father's hope that he might find a job (in the previous sequence, the neighbor's wife has reported that her husband will recommend him to his company) and the intimate relationship between father and son in the vacant lot. On the one hand, the film inserts these domestic scenes as contested spaces in the crime film genre in order to develop the narrative seemingly toward a happy ending; on the other hand, it subtly foreshadows the family's future hardships. The empty lot is actually not the same as the typical Shochiku suburban playground; the harbor and ships are visible in the background, along with warehouses and numerous industrial sewer pipes, and residential houses are absent. These differences from the middle-class film genre, analyzed extensively in the following chapter, cast a sense of insecurity over the scene. Finally, the father receives the news that he cannot get a job in the neighbor's company, and the son asks the father to take him home after seeing a "real" middle-class family playing a ball game in the same empty lot.

The contested spaces in the crime film genre present a grand narrative that always affirms the middle class and their lives. In *Everynight Dreams,* Omitsu's desire for a normal, middle-class life foregrounds a middle-class value system. Similarly the film provides a cautionary narrative that equates Omitsu's independent position in the public sphere with a corresponding loss

in her role as nurturing mother in the private domestic sphere. The mirror in her apartment is used as a signifier of her workspace, the bar, and it creates a visual connection between Omitsu's room and the bar. The mirror here quite literally sutures public and private spaces: in one scene Omitsu gazes into it in her apartment, whereupon the film cuts to the following scene, where she is made up and in her working kimono costume, tidying her hair in front of the bar's dressing room mirror. The mirror blurs the distinction between public and private spaces, creating a threat to domestic stability. In a later scene, after her son is injured in a car accident, Omitsu is again in front of the mirror in her apartment, preparing for work. However, the film reveals that the boy lies injured in the same room; thus, the film undercuts Omitsu's autonomy in the public space because this autonomy is contingent upon the loss of her role as a good mother and a nurturing parent in the domestic space. In the end the film reinforces middle-class domestic values.

In conclusion, many of the interwar films, especially the *gendaigeki,* were shot on location in Tokyo and revealed the city in the process of rebuilding in the 1920s and 1930s. The urban space, reconfigured by its absorption of a new middle class, and the actual filmic spaces affected each other in a reciprocal manner. The interaction is not simply that the image of Tokyo was imbedded in such films; the films themselves shaped the image of Tokyo in the popular imaginary. As the Tokyo expansion organized space for the growing middle class, the films also provided space for imagining urban life and community for that same class. Through films with nostalgic hometown spaces and underworld films, many of the interwar directors created a legitimizing space for the cultural subject of the time, the middle class. While Ozu may serve as arguably the greatest exponent of this cinematic use of space, autonomous and otherwise, his work should be viewed as sharing the stylistic oeuvre of other interwar films and the period's Japanese cinematic traditions. As my analysis indicates, the omnipresent spaces in these films worked as cultural codes that applied only to an audience that had the knowledge of geopolitics, history, and culture of the time.

CHAPTER 2

Vernacular Meanings
of Genre

The Middle-Class Film

W hy has so little film scholarship considered the place of genre in national cinema? Addressing this question, Alan Williams comments on Thomas Schatz's *Hollywood Genres*: "The validity of his enterprise is largely determined by the validity of American genre studies (none of his references are texts in foreign languages; very few are translations). And there's the rub."[1] Williams further argues, "'Genre' is not exclusively or even primarily a Hollywood phenomenon."[2] His 1984 article foreshadows the tendency of a Hollywood-centered genre approach to national cinema studies during the following two decades, and since then we have encountered a relatively small number of works thoroughly applying genre criticism to national cinemas. As an exceptional work on genre in early Japanese cinema, Joanne Bernardi's *Writing in Light* develops the study of genre in national cinema by specifically focusing on the "contemporary drama form" before 1920.[3] Following the example of the complex theatrical genealogy of the *shinpa* film, for instance, Bernardi discloses the intricate relations among the genre terms in both theater and film: the period film genre (*jidaigeki*), the contemporary film genre (*gendaigeki*), *shinpa* film (or *shinpa daihigeki*, translated as *shinpa* melodrama), *shinpa* theater, the contemporary drama play of the Kabuki (*sewa-mono*), and new drama (*shingeki*). But apart from Bernardi's work, most writing on genre in Japanese national cinema runs into difficulty from the outset, largely due to the competing narratives of Hollywood and the national cinema.[4] In the case of Japanese cinema, some idiosyncratic genres have been focused on, such as the *yakuza* (gangster) film and *jidaigeki*; however, just introducing these in either the context of their Hollywood counterparts or as signs of cultural difference reveals neither their meanings in the specific genre system nor their

connections with the audience—that is, we learn little of the role of genre in the processes of production, distribution, and reception.

The difficulties encountered in genre criticism point to larger problems that are inherent in the study of national cinema itself. In many of the works on Japanese cinema, for instance, any discussion of the cultural specificity of the cinema is often subsumed within the overriding narrative of Hollywood's dominant system. In contrast, approaching Japanese cinema through the historical practice of genre allows us to see how the Japanese cinematic modes actually functioned. Within these modes Hollywood cinema's influence might be dominant but not to the exclusion of all others. Some basic acknowledgment of the particular structures configuring the Japanese cinema of the 1920s and 1930s is needed here.

First is the genre structure that divides Japanese films into the mega-genres of *jidaigeki* and *gendaigeki*. The important issue is that these mega-genres have divided the full range of Japanese film genres according to a temporal structure, a historical periodization of pre-Meiji (until 1868) and from Meiji onward. If this dichotomy signifies, as Mitsuhiro Yoshimoto has indicated, "the emergence of a new historical awareness" and that "by instituting the major distinction between *jidaigeki* and *gendaigeki*, Japanese cinema contributed to the ideological imperative of imaging the absolute point of historical disjunction, which was essential for Japanese national formation," the whole range of Japanese subgenres, contained in one of these mega-genres, cannot escape from historical consciousness—that is, each genre is connected with a historical sense of a national perspective.[5]

Second is the strong tie between particular genres and film studios. Because of such practices as "studio flavor," genres worked to distinguish among various studios' films, such as Shochiku's *josei eiga* (woman's film) and Nikkatsu's *jidaigeki* in the 1920s and 1930s, and this tendency was more widespread in the postwar period: Daiei's *haha-mono eiga* (maternal melodramas), Nikkatsu's action films and *roman poruno* (soft-core pornography), Shochiku's family melodramas, Toei's *yakuza eiga* (gangster films), and Toho's *kaiju eiga* (monster films) are singular examples.

Third is the frequent use of the film series as a particularity of Japanese filmic categorization. Different from genre in that the films centered on the continuing travails of a single character, the film series nonetheless circulated much as genre does in production, distribution, and reception. Although the best-known example is the postwar Tora-san series (1969–1997), the film series was already in common use in the 1920s, such as in Shochiku's Kare to (He and . . .) series (1928–1929), which cast the athletic actor Suzuki Denmei. Often star-oriented, a series is an economical filmmaking practice with less

difference from film to film and a higher predictability of profits. With heavy reliance on one director and supporting actors from the same studio, a series often showcases the flavor of its studio, as in the case of the Tora-san series' branding with Shochiku and the Zatoichi series' (1962–1989) tie with Daiei.

Fourth, from its inception Japanese cinema itself appeared as a mere category, *hoga* (Japanese films), in contrast with films from the Euro-American countries, *yoga* (Western films). This type of division can be seen in other arts, such as Nihonga (Japanese-style painting) and *yoga* (Western-style painting), and *hogaku* (Japanese music) and *yogaku* (Western music). As these other examples also indicate, the crucial point is that Japanese cinema acquired its identity through its coexistence with Euro-American films—that is, as a category, the Japanese film should not be seen simply as a given cultural quantity but as a conscious attempt to distinguish itself in the competition with Euro-American films.

In this chapter I want to offer an appraisal of genre criticism as a strategy for national cinema studies, as well as an elaboration of genre's specific historical construction in Japanese cinema, which, I argue, represents a subtle negotiation with Hollywood's dominant presence in Japan. My focus is especially on the middle-class film genre (*shoshimin eiga*), which gained prominence in the 1920s and 1930s, and reveals how the genre established connections with an audience of the urban middle class, conditioning particular regimes of spectatorship, and how idiosyncratically the Japanese film industry employed genres apart from Hollywood in the cinematic modes of that period. A central characteristic of the genre system was the Japanese film industry's embrace of the new, continual spinoff of subgenres from the *jidaigeki* and *gendaigeki* mega-genres. As I will elaborate, this practice of continual fragmentation signaled both an economic and a political strategy amid the prewar climate of nationalism.

Genre as a Marker of Difference

The examples of two representative approaches to national cinema illustrate the problematic effect of analyzing national cinemas through the application of a genre criticism that is inextricably linked to Hollywood. The first example is Jim Leach's article on genre and Canadian national cinema, in which he follows the encounters between increasingly less authoritative genre codes and rapidly changing national cultures.[6] Another approach is Dolores Tierney's essay on melodrama and Mexican cinema, in which she points out generic differences between Hollywood and Mexican melodrama that risk being

overlooked.[7] In the swing between similarity and difference in the relation of national genres to the dominant cinematic apparatus of Hollywood cinema, each of these studies faces the multiplying effects of dealing with the double narratives of Hollywood's and a national cinema's genre developments, as well as complex issues of genre hybridity. In the first case, as Leach is well aware, the blurring of boundaries between Canadian and Hollywood cinemas and their respective genres, as well as a corresponding fragmentation of Canadian national identity, makes the study of a Canadian genre system an unlikely proposition. The market domination of Hollywood films, the diminished output of the Canadian film industry, and the frequent exchange of capital and labor between the two have all led to the dissolution of identifiable Canadian genres. In the second case the emphasis on cultural specificity, with its focus on differences in the multiple subgenres of Mexican melodrama, guarantees incompleteness and nearly erases the benefit of the genre study itself.

The difficulties that these scholars encounter partially explain the dearth of studies taking this approach toward national cinema. Such problems in genre criticism reflect the dissymmetry underlying the structural relationship between national cinemas and Hollywood. In the case of Japanese cinema studies, as Donald Kirihara points out, "There remain some overlapping assumptions film historians use to explain what makes a Japanese film Japanese."[8] The logic is that Japanese film is different because of its isolation, the creators having a different aesthetic sense, and Japanese culture being non-Western. Its "difference" has always been conceptualized in comparison with the central institution of the classical Hollywood cinema, and in some cases, Japanese cinema scholars have followed the practices of Orientalism in national cinema studies.

We must have other norms for works in particular periods in addition to the Institutional Mode of Representation (IMR) that Noël Burch presented as "the codes," the dominant Hollywood style of linear narrative realism.[9] Any discussion by Burch of the cultural specificities of Japanese cinema is subsumed within the superseding narrative of Hollywood's dominant system. By conceptualizing an artwork such as a film as "a complex tangle of norms in a dynamic equilibrium,"[10] we may frame Japanese cinema not by how it deconstructed the IMR, as Burch does, by still holding to the same cinematic hierarchy (central Hollywood cinema and peripheral Japanese cinema) but according to how the Japanese cinematic modes actually functioned within the specific temporal, social, and cultural structures in which the IMR might be a dominant, but not exclusionary, influence. Genre as a social institution, with sociohistorical contradictions and ideologies, offers us such a way.[11]

Problematizing the Use of Genre as a Linear Form

From the relatively small number of Japanese genre studies, two respected works illustrate the historical peculiarities of Japanese genres. Such peculiarities seem to resist the prevailing model of genre continuity based on the economics of a prototype subsuming variations, a model that is closely associated with classical Hollywood genres. Both David Desser and Keiko McDonald have made serious attempts to explore genre categorizations; each offers a necessary beginning to an area of the cinema that is still uncharted. However, both scholars tend to use genre as an overdetermined cultural system, curiously disconnected from specific historical contexts.

In *The Samurai Films of Akira Kurosawa*, David Desser presents the genre as marked by the iconographic image of the samurai sword itself and by a central dichotomy between *giri* (the code of honor and obligation) versus *ninjo* (personal inclination).[12] He further defines the significance of the genre in its "mythicizing" of this dichotomy, an attempt by the culture to rewrite its feudal past. Desser's poignant notion of the mythic resolution of essential contradictions is particularly effective in his discussion of Kurosawa's films as "samurai films." The main problem, however, with Desser's "samurai film" genre is that it is wholly of his own making, a critical device that is detached from historical practices of production, distribution, and reception—that is, it has no cultural currency in the lexicon of Japanese filmgoers. His discussion of the cinema's mythical treatment of legendary heroes such as Miyamoto Musashi or Kozure Okami (the lone wolf *ronin,* a masterless samurai), for instance, does little to unravel the significance of the films as social historical discourse. Such questions as why these figures are reinvoked in certain ways and at specific times in Japanese society are left unanswered, as are issues of cross-cultural viewership and the foreign gaze in post-*Rashomon* "samurai films" that found success abroad. As Yoshimoto elaborates, "The samurai as a sign [is] imbued with colonial ideologies,"[13] which, contrary to Desser's emphasis on mythic content, has indeed a history of institutionalized and idealized national identity in Japan and abroad.[14]

Desser's intention to distinguish the "samurai film" from the broader period film category runs into trouble since he focuses on the continuity of iconography—the sword and the central dichotomy between *giri* versus *ninjo*—as an organizing principle. This approach is more compatible with exploring the illusion of linear continuity characteristic of Hollywood genres rather than the fractured nature of Japanese genre structure. The Japanese genre system has an endless variety of subgenres, new variations of the period

film and modern film archetypes. For instance, from the former there were such innovations as *chanbara eiga* (sword films), *meiro jidaigeki* (period comedy films), *rekish eiga* (historical films), and even tendency films or social realism films in the 1920s and 1930s. Most of these genres were particular to the period, often lasting for a scant few years, indicating further the discontinuity of the subgenre majority underneath the two archetypes. The sword iconography and the conflict between *giri* and *ninjo* are deployed in other genres, such as *yakuza* films; however, there is no explanation for how Desser's "samurai films" use these differently from *yakuza* films or even how or whether the genre has changed its use of iconography within larger social or spectatorial transformations.

Keiko McDonald's article "The *Yakuza* Film" conceives of the gangster genre as a continual reiteration of essential themes spanning a period from 1927 to the late 1980s.[15] Like Desser, McDonald focuses mainly on the narrative and iconography of these films and highlights the genre's evocation of the *giri* versus *ninjo* dichotomy as an essential quality of Japanese culture itself. She asserts that the "genre offers fascinating insights into the dynamic interplay between film, filmmaker, and culture" and introduces subgenres, such as the *ninkyo eiga* (films of chivalrous gangsters-gamblers and con artist vendors) and the *matatabi eiga* (films of wandering gangsters), each of which had cultural currency in different periods of Japanese film history.[16] However, the distinction between the latter two figures is arbitrary since both "travel" to "practice their trade." Indeed, McDonald's sole criterion for the genre is that a film merely include a gangster character, which, like the samurai figure in the "samurai films," carries a transhistorical quality of Japaneseness that is used to create national identity in Japan and to simplistically understand Japan abroad. The seeming continuity of the *giri* versus *ninjo* conflict in the genre allows McDonald to avoid dealing with the complexity of culture over a sixty-year span. Both Desser and McDonald use these national "myths" as a cultural shorthand, accepting the genre's version as is but without interrogating how the use of such mythic themes may vary as responses to or components of social contexts.

Addressing such changes in the tableau of gangster films, Mark Schilling notes that the longing for tradition as expressed in the *giri* versus *ninjo* dichotomy is not necessarily the focal point in these films anymore: "Today's gang film directors face fewer barriers to international acceptance, using the genre to address, not the threat of Westernization to traditional values, but the globalization of Japanese society, particularly its criminal segment. Overseas attention, however, tends to focus on directors such as Miike [Takashi] and Kitano [Takeshi], whose work is removed by both its excellence and eccentricity from the mainstream."[17] These characteristics of new gangster films

are not only applicable to the overseas audience, but they are the attraction for the domestic audience as well. Starting from Suzuki Seijun's work (which McDonald strangely ignores in her article), many filmmakers, such as Kato Tai and Fukasaku Kinji, have deconstructed and even eliminated the iconography of the *giri* versus *ninjo* dichotomy, and they have instead enhanced a "mod" aesthetic of garish color, off-kilter shot composition, unnatural acting, and eclectic mise-en-scène. As Schilling indicates, works by Miike or Kitano especially have seized the audience's attention with their blatant violence and dry humor and have shown little regard for the *giri* versus *ninjo* dichotomy as an essential aspect of national identity in such films as *Ichi the Killer* (*Koroshiya 1*, dir. Miike Takashi, 2001) and *Brother* (dir. Kitano Takeshi, 2000).

As my criticism should make clear, one needs an approach that is sensitive to the particular genre systems of Japanese cinema without the tendency of either a linear diachronic model or one that essentializes Japanese culture as a whole. We should not assume that the genre models that have already been applied to Hollywood cinema are equally applicable to Japanese cinema. In the following section, I posit a version of Japanese genre formation that allows for discontinuity and fragmentation, demonstrating that there is a historical basis for such an approach within the Japanese cinema itself.

The Middle-Class Film Genre

My focus here is on the historical construction of the middle-class film genre (*shoshimin eiga*). Despite their reputation as apolitical and light melodramas, the films exhibit a range of political discourses and ideologies beneath their sentimental, comical exteriors. I view their superficiality alongside the practice of dissembled ideological meaning, which I contend is an inherent characteristic of Japanese genre signification.

The term *shoshimin eiga* was in pervasive use in the popular culture of the 1930s, including industry marketing and the print media. It was widely acknowledged that these films were about a specific class, yet they also appealed to a broad cross-section of social classes, effectively helping to create a new national modern subject. Moreover, the films can now be seen for their political content, hidden in the family melodramas of reconciliation and survival that shielded the audiences from the harsh beginnings of militarism and its supporting ideologies.

Upon their initial release, the films were widely praised for their realistic depictions of the hard life of Japan's middle classes. They aroused sympathy from both critics and audiences, as one viewer of *I Was Born, But . . .* indicates:

"I see ourselves and our children in the film."[18] Later, however, the images of shared suffering, for which no one was to blame, were often cited in left-leaning Japanese criticism as the principal failing of the genre: its lack of genuine political content.[19] This type of criticism continued even after World War II, extending to all of Shochiku's hallmark family melodramas.

The middle-class genre in fact shows ambivalence toward the pursuit of modernity in Japan, a theme that it shares with the politically "progressive" tendency film genre from 1929 to 1931.[20] The implications of the genre in terms of a problematized Japanese modernity are twofold. First, the films create a new modern subject, the middle class, and promote the idea that Japan has already reached a level of modernization on par with the West. Second, the films enter a nationalist discourse, with which they paradoxically resist modernization by showing the social inequalities of modern society, due to the increasing saturation of capitalism, while evoking a lost "traditional" past. In this light, there is a profound and inseparable connection between this genre and postwar Japanese melodrama, such as the motherhood film genre in the 1950s, since both articulate a disparity between Japanese modernity and the act of modernization, especially their uneven development in Japan.[21]

Referring to this zeitgeist of pessimism, contemporary Japanese film historian Komatsu Hiroshi writes, "Shochiku, which was founded on the conformist ideology of American cinema, remained wary of the 'dangerous' ideology of the tendency film. . . . Unlike the tendency films of the previous decades, Ozu portrayed this gloom not as the result of the social structure, but rather as the loneliness of the human condition. This outlook, characteristic of Ozu's films, emerged from Shochiku's Kamata studio and its petty bourgeois tradition of films lacking an overt political ideology."[22] I would argue that the pessimism that Komatsu describes is solely a characteristic of neither Ozu's nor Shochiku's films. Rather, it should be read as both an aspect of the genre's ideology and a consequence of Japanese modernity that resonates from these films even beyond their happy endings when all is reconciled.

The middle-class genre film suggests the antinomy between Japanese modernity and rising nationalism in the 1930s, in the sense of a Japanese national subject's split between the call to modernize and the contradictory longings for the mythic cohesion of the past. The idea of "the middle class" at the center of the genre worked to mitigate long-standing differences in social strata and in the particularities of Japan's interwar social transformation; the collective image of the middle class served as a national identity for the modern subject. The middle class that emerged in interwar Japan referred less to a reconfigured labor force than to a new citizenry of a modern social formation. For

example, the reification of the suburban middle-class home as a democratic ideal of modern life simultaneously made the private domestic sphere an extension of the public realm of the nation-state. The genre's frequent protagonist, the salaried man, inevitably faced a disillusionment with modern life, the struggle to get ahead and his increasingly dehumanized role in the company workforce. The new concept of home and family life became compensatory for these modern subjects, but at the same time, the films often highlighted the protagonist's loss of patriarchal authority in the domestic sphere and revealed a longing for an elegiac old Japan and its social mores. I explore this antinomy by focusing mainly on two sites, the politics of genre amid the fundamental dissymmetry between Japanese cinema and Hollywood and the creation of a modern national subject in two films, *Tokyo Chorus* and *I Was Born, But* Genre works as a critical term and a historical cultural currency, a nexus of "systems of orientations, expectations and conventions that circulate between industry, text, and subject."[23] For all its inherent risks, this approach allows us to historicize the middle-class genre within the imperatives of modern capitalism and an emerging middle class.

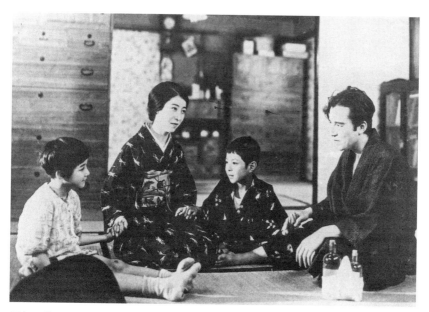

Tokyo Chorus (dir. Ozu Yasujiro, 1931). Having just lost his job, the salaried man (Okada Tokihiko) and his family remain intact. Such depictions of a nuclear family became the central image of the middle-class film genre. Courtesy of Kawakita Memorial Film Institute.

Politics of Genre in Japanese Cinema

As David Bordwell has noted, the middle-class genre films of Ozu appropriated many of the didactic concerns of the purportedly progressive tendency film.[24] The genre intertextualizes the class-based themes of the tendency films, focusing predominantly on the petty bourgeois rather than the working class. It suppressed the controversies of the political left and the agitprop characteristics of tendency films beneath a veneer of light comic melodrama in order to appeal to urban middle-class audiences.

Unlike the female-centered dramas of quintessential tendency films such as *What Made Her Do It?* (*Nani ga kanojo o so sasetaka,* dir. Suzuki Shigeyoshi, 1930), the genre typically put male characters at the center of its dramas, as with the urban businessmen and their families in *Tokyo Chorus* and *I Was Born, But....* As feminist criticism on melodrama has made clear, the female-centered narrative often allows for a more extensive social critique of patriarchy, albeit one that is contained within the marginalized domestic sphere.[25] This shift, along with the substitution of an educated middle-class male figure in place of a working-class female subject, served to mitigate the potential political repercussions of the family melodrama format. The genre depicted class consciousness while avoiding the appearance of a broader social critique. By distinguishing itself from the "progressive" text of the tendency films, the genre could promote a wider audience identification.

This pattern of a genre's appropriation of themes from outmoded genres can also be seen in Mizoguchi's "social realism" films of the mid-1930s, which feature suffering women as the central characters—five years after the tendency films were effectively banned. Some of the same social themes of the earlier genre continued to emerge in Mizoguchi's films as well as in the middle-class genre films, modified from their more overtly political form. The titles themselves—for example, *Osaka Elegy* (*Naniwa ereji,* dir. Mizoguchi Kenji, 1936) and *Sisters of the Gion* (*Gion no kyodai,* dir. Mizoguchi Kenji, 1936)—differ markedly from the provocative titles of the earlier tendency films, such as *What Made Her Do It?*, *A Living Doll* (*Ikeru ningyo,* dir. Uchida Tomu, 1929), *In Praise of Women* (*Josei-san,* dir. Abe Yutaka, 1930), and *And Yet They Go On* (*Shikamo karera wa yuku,* dir. Mizoguchi Kenji, 1931). This suggests an operative practice of dissembled meaning within the new genres.

The need to repackage earlier themes without their attendant political overtones can be partially explained in industrial terms. Apart from issues of censorship, such transformations of previous genre elements are evidence of the domestic production practices underlying the Japanese film industry's interpolation of genre coding itself. In a significant departure from Hollywood's

development of genre codes, which offer relative stability and continuity (to circumscribe meanings, precondition audiences toward modes of viewership, and of course distinguish product for marketing), the Japanese film industry emphasized genre as a continual reinvention of the "new." In the Japanese genre system, the genre is deployed not so much as a prototype as it is a direct form of promotion that emphasizes its discontinuity from earlier films. The Japanese film industry and the mass media's circulation of film-related discourse often used a genre category as a temporal package, a marketing device through which new genres would often coopt themes or subjects from outmoded ones.

This specific use of genres in Japan relates to the national cinema's emergence in the already dominant presence of imported films from Hollywood and Europe. Within this market, Japanese cinema of necessity occupied a single category, itself differentiated at its inception from other "brands" of cinema. The two broad genres, *jidaigeki* and *gendaigeki,* with various subgenres, have been maintained since the 1920s.[26] Both have historically depended to a greater or lesser degree upon close identification with stars, directors, and studio "flavors" rather than the characteristic semantic and syntactic patterns so central to Hollywood genres.[27] For example, Shochiku Kamata specialized in modern genre films with a recognizable stable of filmmakers and actors (Kurishima Sumiko, Tanaka Kinuyo, Suzuki Denmei, and Okada Tokihiko, among others). Moreover, in practical terms, the relatively small size of Japanese film studios (Shochiku Kamata, for instance, had only one production studio until it relocated to Ofuna in 1936) did not allow studios to produce a variety of genres.

The role of genre in Japanese cinema is marked from the beginning by Japan's role as a recipient of Hollywood's dominant cinema and its codes. When the Japanese cinema began to produce a variety of films and the earliest domestic genre system emerged, it was in the presence of an already formed sophisticated Hollywood genre system. The process of assimilation of Hollywood genres bears little resemblance to the acts of borrowing or copying that are typically used to characterize cross-cultural relations; rather the process is akin to the migration of foreign words into the Japanese language and the subsequent loss of the original, complete referential meaning. Wimal Dissanayake points out that "Although we may use the term melodrama to characterize some types of Asian cinema, it is well to remind ourselves that none of the Asian languages has a synonym for this word. Such terms as we find in modern usage are recent coinages based on the English word."[28] I would further argue that the recent coinage may often construct its own meaning, quite independent of its original English referent. This is apparent in the Japanese

term *merodorama* (melodrama), which is more narrowly circumscribed compared to its English counterpart. Granted that both terms are "open seamed" and subject to change over time; still, for the most part, in Japanese cinema through the 1950s, the term *merodorama* typically signified a widow-lover variation, as in the Shochiku films *The Katsura Tree of Love* (*Aizen katsura*, dir. Nomura Hiromasa, 1938) and *What Is Your Name?* (*Kimi no na wa*, dir. Oba Hideo, 1953–1954).[29] These films invented a peculiar narrative pattern, a passing-by-each-other story (*surechigai*) that led to further films about a couple's circuitous attempts to rendezvous. This suspended narrative owes much to the cliffhanger episodic devices of weekly radio serials, which often deployed an elliptical temporal structure rather than the linear one of Hollywood melodrama. In Japanese cinema this *merodorama* existed alongside and distinct from the family drama that, by any Western standard, would also be included under the melodrama category. Mitsuhiro Yoshimoto attributes the essential difference of *merodorama* directly to the colonial mentality of the Japanese, as a subliminal signal of "the lack of Western-style subjectivity in Japan."[30] As the example of melodrama makes evident, the construction of genre in Japan is the necessary result of the Japanese negotiation with the hegemony of Hollywood cinema. In this sense, genre reflects the "fundamental dissymmetry between the United States and other cultures," which Fredric Jameson describes as characteristic of the global influence of Hollywood.[31]

Although Japan was never colonized, the encounter with Western modernity brought with it the inescapable cultural domination by Western imperial powers. How, then, can one account for cultural contingencies in Japanese genre that allow for adaptation, interpretation, domestication, and redefinition by the Japanese as acts of cultural autonomy? Any postcolonial reading of Japan's genre system as a form of resistance or hybridity would have to account for the fact that genres and subgenres were also created out of quite random beginnings. The example of the Blue Bird film is a case in point. From 1916 to 1920, Universal's export of the Blue Bird production company's films found widespread popularity in Japan. Originally produced for the U.S. market, the 123 films achieved a nearly mythical status in Japanese cinema culture, out of all proportion to their undocumented marginality in the history of Hollywood cinema. In the Japanese market, the Blue Bird films spawned an indigenous subgenre of Blue Bird–type films, which in turn had a profound influence on subsequent Japanese films. As Japanese versions of a blatantly Western style of cinema, the Blue Bird–type films assimilated at least seven semantic elements from the Blue Bird imports: (1) a dancer/orphan story, (2) everyday domestic life, (3) pastoral/mountain romance, (4) married couple/mother story, (5) moral/religious redemption story, (6) hypnosis-based comedy, and (7) war

story.[32] From the evidence of films such as *Souls on the Road* (*Rojo no reikon*, dir. Murata Minoru, 1921), which mixes at least three of these themes (pastoral romance, married couple, and moral redemption), one can hypothesize that the Blue Bird films' semantics were assimilated en masse without the structural orientation of the Hollywood genre codes. Thus, while the production and reception of meaning is likely to be imbricated with global inequalities, genre as a signifying practice was often outside the control of *both* the Hollywood and Japanese film industries. Such an elaboration points to the inherent complexities of genre in Japanese cinema and, in a larger sense, national cinema as well. Further, it demonstrates the relative arbitrariness of cinema studies scholars trying to interpret Japanese cinema based on Hollywood codes.

Japanese Film Genre and the Studio System

Genre, of all types of cinema studies, especially requires the examination of specific industrial practices and historical cultural contexts. Even when the genre does not have a historical base in the popular discourse of the genre's period, as in the case of film noir, and is acknowledged as a later critical construction, it is still imperative to tie the discussion to the vicissitudes of culture and the genre's cultural subjects. Addressing the aforementioned need to account for a Japanese genre system that is discontinuous and multilayered, I approach the middle-class genre from two strategies: its place in a specific studio, Shochiku Kamata, and its role in the creation of a modern subject.

In Japanese cinema, genre has the tendency to be closely tied to specific studios to a much greater extent even than in Hollywood. This is especially true in the 1920s and 1930s, when studios created a distinct flavor in the narratives and visual images of their productions. This flavor is attributed to the studio system, in which directors, stars, artists, and technicians remained under contract, the same personnel often working together in repetitive ensemble productions. In this period of transition from silent to talkie, the less regulated aspects of individual crafts were still much in evidence, as in handwritten credits and inter-titles in the cinema, as well as the variation of techniques among studios for early sound recording. Budget constraints also contributed to the studio flavors with recycled sets, costumes, and so on. This further demonstrates why the middle-class genre and the Shochiku Kamata studios are closely tied together in popular discourse.

In such genre films as *Flunky, Work Hard!, Tokyo Chorus, I Was Born, But . . . , A Burden of Life,* and *My Neighbor, Miss Yae,* Shochiku used the same stable of actors and actresses in the lead and supporting roles. This sort of

continuity created an extra-diegetic discourse of the "extended family" that influenced the spectator's viewing expectations. Shochiku's use of ordinary-looking lead actors and the same bit players contributed as well to the audience's shared sense of neighborhood and place in the genre's salaried man dramas.

While most Japanese film histories point to Ozu's *Tokyo Chorus* and *I Was Born, But . . .* as the first emergence of the middle-class genre, these films have antecedents in Shimazu Yasujiro's earlier films, *Father* and *Sunday*, both of which are about a salaried man and his family and which were marketed as comedies.[33] This link suggests that the genre was formed in the development of the family comedy. The pattern of intertextualization of the comedy film can be seen in the comic vignettes of films such as *I Was Born, But . . .* , as well as in the narrative structure of *Tokyo Chorus,* built as a series of short distinct bits, with diminished comic effect as the narrative develops. Ozu's successful harnessing of comedy to a narrative of middle-class struggle, evidenced by *Kinema junpo*'s best of the year award, created a need to distinguish this new version of the genre from its more overtly comic predecessors.[34]

We can also view the genre's narrative concerns in relation to its historical role as a bridge between the silent and talkie films. The genre's focus on daily life merged with the elocution of everyday speech among urban dwellers in the new sound films; indeed both silent and sound versions of the genre existed simultaneously from 1931 to 1936. For directors like Ozu, who were reluctant to use the new sound technology, the genre that required fewer dramatic sound effects and allowed trial and error in the application of the technology matched not only their filmmaking style, but also their studios' whole film production. A constituent of the genre's comedy is the juxtaposition of silent sight gags and the verbal play of miscommunication, as in *My Neighbor, Miss Yae.* The silent films of this genre, such as *I Was Born, But . . .* , nostalgically preserved the refined visual comedy, as when the new kids on the block use their "supernatural" *ninja* powers to force the neighborhood kids to play dead, or in the signboard hanging from the neck of the tag-along kid with his mother's handwritten admonition, "Please don't feed this kid any food. He has a bad stomach." Shochiku Kamata's specific suburban locations were also transferable to the sound film; the empty lots and low-density neighborhoods were sufficiently tranquil to "stage" action without the technical demands of a crowded city scene. The studio took advantage of its Tokyo location, suturing the different spaces of the salaried man's commuter existence, the Marunouchi office district, and the Yamanote suburban neighborhood and home.

The closing of the Kamata studios on January 15, 1936, and Shochiku's shift of production to the Ofuna studios are further evidence of the strong

link between the middle-class genre and Kamata. The Ofuna studios dropped the genre in favor of a new style of filmmaking with younger, glamorous performers, projecting a mood of stylistic modernity in place of the social realism marked by class-based concerns of the middle-class genre.

The Modern National Subject: The Urban Middle Class

The depictions of urban middle-class people and the modern nuclear family in the middle-class genre are often paired with nostalgia for the traditional patriarchal family. A national census of 1920 showed that 54 percent of all Japanese households were already nuclear in structure.[35] In other words, by 1932 the family image depicted in such films as *I Was Born, But . . .* had few remnants of the "traditional" extended family headed by a strong father figure. The figure of the salaried man father in the film constitutes a modern national subject (a college-educated, middle-class, white-collar office worker, his identity interpolated by modern capitalism); the image of his subordination offers a critique of modernity while evoking the audience's nationalistic longing for a "traditional" patriarchal past.

I Was Born, But . . . links two parallel narratives: the salaried man's attempts to ingratiate himself with his boss and his two sons' attempts to dethrone the neighborhood bully and assume leadership of the local kids. The young boys' ascent to supremacy is comically juxtaposed with their father's humiliating submission as he tries to curry favor with the boss. In effect, the kids' social formations sarcastically comment on the adults' behavior and modern social hierarchies fueled by the middle-class illusion of upward mobility. Throughout the story we are reminded that the sons expect their father to be a strong patriarchal figure, which magnifies the later impact of their disappointment in the father's inability to be one. In a sequence in which the father's boss screens his amateur films, the boys witness the shameful behavior of their father playing the office clown. Darrell W. Davis analyzes this sequence: "Ozu's use of home movies as polarizer of spectatorial responses, splitting audiences according to their class, gender, and generation, is a beautiful illustration of the volatile, unpredictable effects of film."[36] Indeed, Davis points to the fundamental contradictions exemplified in the scene's mocking of "incompatible forms of spectatorship," which contain the contradictions at the root of the Japanese cinema itself.[37] I would add that the fracture extends to the discourse of national identity as well.

The film-within-a-film sequence bridges the parallel narratives of the father and two sons, as well as the private and public spheres (home and work-

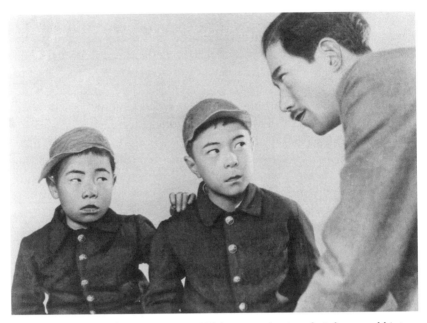

I Was Born, But . . . (dir. Ozu Yasujiro, 1932) is a story about a salaried man and his two sons, whose conflict emphasizes the Japanese longing for the mythic cohesion of the past: a good old Japan with a strong father. Courtesy of Kawakita Memorial Film Institute.

place). The scene reveals not simply the father's loss of patriarchal authority, but also the modern capitalist strategy of creating an imagined separation between the public and private spheres. It shows how a modern male subject's identity is necessarily split between these two realms. While in the public sphere, the father's subordination is explicitly linked to his family's survival and to the boss's own usurpation of the father role; on the other hand, the father must play the patriarchal feudal authority figure at home to maintain family order. Such separate identities can be managed only through the illusory boundary separating the two realms, a division that is nakedly revealed in the home movie scene.

This illusory division between public and private realms should be read in the broader context of nation as well. In her explanation of the link between the modern family and the Japanese nation-state, sociologist Ueno Chizuko writes: "The state, or the public sphere, needed to conceal its dependency on the private sphere, or to be more exact, its exploitation of the family. It was a patriarchal conspiracy to make the family a sanctuary that no one was to be allowed to transgress."[38] Ueno's comment is supported by the historical re-

cord of the state's ideological efforts to link the private individual family to the state as an extended family, in which the emperor ruled commoners as parents guided their children; such discourses were prevalent in the rising national-ism and militarism of the 1930s.[39]

The sequence following the film-within-a-film shows that the father's alienation cannot be easily resolved as he struggles for possible explanations that he can offer to his disillusioned sons. Thus the film evokes the loss of the past, the values of the traditional Japanese family, and the longing for a strong patriarchal figure. In 1931, there was already an intensification of such thoroughly modern preoccupations as retrieving an imagined traditional heritage in the service of national identity. As Ueno points out, the paternal-istic extended family, supposedly feudal and traditional, has been shown to be in fact a recent invention of the Meiji Civil Code;[40] thus the formation of the patriarchal family has a history of deployment for national imperatives. Mizoguchi's "social realism" films, *Osaka Elegy* and *Sisters of the Gion,* would go a step further than *I Was Born, But . . .* in their exposure of the central male figures of father, boyfriend, and patron to the films' geisha or mistress protagonists. Mizoguchi's so-called realism achieves a level of resistance in this regard, given the intense reiteration of patriarchal myth during this pe-riod of the mid-1930s. The portrayals of the male figures as thoroughly selfish, weak, and bereft of integrity demythologize the patriarchal authority figure as untenable and illusory. Therefore, as Mizoguchi's films tell us, the modern preoccupation with retrieving the past, whether in the form of nationalism or the traditional patriarchal family, is nothing but an illusory act.

The split subjectivity of the father in *I Was Born, But . . .* can never be made whole by evoking the lost patriarchal past. The film in effect expresses this by deploying the proletariat; without capital or land ownership, the sala-ried man must resign himself to his submissive role within the company, which has stolen the mantle of patriarchal authority. In the film's disavowal of this reality, the modern subject, the father, prophesies that his sons will become like him in the future, and his fatherly advice to them is only the message of careerism: "Study hard and become successful," the Meiji slogan of upward class mobility designed to erase feudal class differences. Such sentiments pro-vided an ideological rationale for managed capitalism, as well as a rationale for modernizing the nation through hierarchies in education and industry oriented toward achievement. The film substitutes for contemporary disillu-sionment with Japan's mythologized traditions an equally mythologized ideal of democratic equality under capitalism, which simultaneously links national-ism and Japan's pursuit of modernity.

Even the domestic setting of the middle-class genre film contains a nationalistic discourse, which prefigures that of the monumental style. Locating the monumental style loosely between 1936 and 1941, in the period leading up to World War II, Darrell Davis describes it as a promotion of nativist subject matter and a reaction against the more overtly foreign-influenced styles and genres of the 1920s and 1930s.[41] However, we clearly see the monumental style's nationalist discourse prefigured in the middle-class genre texts and a similar nationalistic ambivalence toward Westernization and modernity itself, despite the fact that the genre's display of Western references—flappers, jazz music, and baseball, as well as Hollywood filmic techniques—was in disfavor in the prewar military buildup. The original script for *I Was Born, But . . .* included a sequence in which the first son encounters a military troop after he has run away from home. His interaction with the soldiers demonstrates their humanity and the sanctity of home when he decides to return.[42] Even before the Manchurian Incident in 1931, films such as *The March* (*Shingun*, dir. Ushihara Kiyohiko, 1930) featured humanizing narratives of soldiers and pilots in combat with an unseen, unnamed enemy. The original script's naturalization of the military buildup reflects the shift toward Japan's increasing assertiveness in the international arena. The debate over Manchurian independence transformed the Japanese political system from the Democratic Party cabinet to a militarist cabinet in 1932. Japan also withdrew from the League of Nations after the league's refusal to recognize Manchuria's protectorate status under Japanese control. By 1931 Japan had already entered into a geopolitical space of modernity and international political power struggles, the beginning of the Fifteen Years' War.

In its ambivalent treatment of modernity, *I Was Born, But . . .* also prefigures the wartime affirmation of Japanese singularity and the confirmation of mastering modernity as later posited by Japanese intellectuals at the so-called "Overcoming Modernity" conference of 1941. The film-within-a-film segment provides a sequence midway through the home movie in which there are urban scenes, such as a rushing streetcar; buildings filmed from a moving vehicle; and an intersection where cars, bicycles, motorcycles, and passengers are coming and going at high speed. The ephemeral, careening activity of the city is made even more frantic by the boss's command to fast-forward the sequence, evidently to spare his wife the embarrassment of seeing him photographed with two geisha companions. On the one hand, following Walter Benjamin's comments on the cinema, we can read this fast-forward sequence as depicting the cinema's role of training the spectator's sensory perception to deal with the shocks of modern life; on the other hand, this sequence, inserted as it is amid everyday scenes, such as salaried men doing daily exercises on the

office building roof, also emphasizes the already routine experience of modern life.[43] The frenetic activity on screen is framed with the characters' control over the technology as well as the overt humor of the scene. This scene offers an image of mastery over the modern experience through the sophisticated bemusement of the characters toward the speeded-up images.

The device of the home movie creates a rupture in the film's narrative discourse that allows our closer identification with the characters as Japanese modern subjects. The film-within-a-film sequence presents the characters as viewing subjects; when the characters see the screen in the film, their positions change from viewed objects to viewing subjects, creating an overlap between their gaze and the spectator's. There is a central alignment between the father's gaze and the spectator's, and this alignment in turn sutures the gazes of the kids as well. This assimilation of gazes is heightened in the moment after the home movie shows the father's clownish, shameful behavior. The father views himself as an object on screen, while Ozu then shows the kids' distraught expressions and overlaps their perspective with that of the spectator. This convergence of gazes creates a viewing subject that is both modern and nativist in the father's resignation to the harsh reality of modern society and the kids' frustrated longings for a strong, patriarchal father figure.

As the example of the middle-class genre illustrates, Japanese genres' continuous transformation of the new is closely tied with the negotiation of a modern Japanese national identity. The middle-class films, the Blue Bird–type films, and Japanese *merodorama* are all inextricable from the dissymmetry of cultural relations between Hollywood and Japanese cinema. In this sense, genre studies offer a way to interrogate the historical terms of global capitalism and its effects on culture. Genre studies thus represent a viable alternative to the separation of theory and history and the fixation on authorship, which has characterized Japanese cinema studies for a long time.

Embodying
the Modern

The 1928 Olympics in Amsterdam played as radio drama in Japan, where listeners were enthralled with the first success of Japanese Olympians abroad. As a popular narrative, the Olympic spectacle offered a site for the transfer of Japanese anxieties over modernization, a spectacle in which the audience found compensation in the success of its athletes in an international arena. Against a background of crisis in the fragmented nature of Japanese modern identity, these Olympic games were but one chapter in a discourse of the body's involvement with the creation of a unified nation-subject, the national body. Japanese athletes acquitted themselves with medals in track and field events, as well as breaking records in swimming.[1] At the end of the games, *Tokyo asahi* praised the fourth- and sixth-place Japanese marathon runners as follows: "Although we lost the medals, Japan is the only country to have both runners place in the top six. People were yelling 'Banzai!' from the spectator stands when the two runners stood together for photographers. The other countries' reporters rushed toward us and asked to shake our hands. These Japanese runners embodied the Japanese spirit, demonstrating that Japanese resilience and power can win over the world, even though their bodies are small."[2] Viewed in relation to Japan's modernization efforts, the 1928 Olympics represented the enactment of Japanese desires for equal status with the West. As indicated in the newspaper quote, the spectacle of the small Japanese bodies was embedded with the nationalistic expression of a distinct Japanese identity, *yamato damashii* (the Japanese spirit). The event marks a shift from Japan's emulation of the West to nationalistic sentiments of Japanese singularity.

My analysis of the film *Why Do the Youth Cry?* views this national discourse as the imbrication of ideology and the material body that presents a

tangible confirmation of the modern nation—that is, the body quite literally represents a national identity. While the Olympic athletes established Japanese singularity with the spectacle of Japanese bodies competing against Western ones, subsequent filmic representations would depict the Japanese body as already containing Westernness and modernity, erasing, through this absorption, the visible inferiority implicit in the comparison to the Western Other. On the surface *Why Do the Youth Cry?* seems to mimic or emulate Western and modern elements; it also deploys these elements to lead the audience to a nationalistic affirmation of an ideal Japanese body. In my analysis I take up the issue of how the film constructs that national body and whether such an image, created from fractured Japanese notions of the West and modernity, could sustain itself against the suppressed shame of Japanese desires toward the Other.

The body as a national discourse existed in the popular genre called *wakamono supotsu eiga* (youth sports films). Heartthrob actors Asaoka Nobuo at Nikkatsu and Suzuki Denmei at Shochiku leaped from college athletics into fame as stars of the period. Through my analysis of *Why Do the Youth Cry?*, the body is revealed as a response to the anxieties and disturbances of modernity in interwar Japan. More specifically, my hypothesis is that the body in this film presents an image of an ideal integrated self, both Japanese and Western, traditional and modern, bourgeois and working class, even masculine and feminine—an image that served to buffer people's fears over the loss of self that accompanied the rapid changes of Japan's modernization. Apart from elaborating the body's function as compensation for Japanese anxieties toward modernization, I attempt to bridge the particular aesthetics of the filmic text and the social contexts in the process of writing a film history. I view the star's body in the film as a dual image carrying both the filmic text and its social context. In what follows, I analyze Suzuki Denmei's image in the film alongside its extra-diegetic existence.

The Colored Imperial Body

After Suzuki Denmei moved from the Nikkatsu to the Shochiku film studios in 1925, he and the director Ushihara Kiyohiko (1897–1985) made nineteen films, many in the youth sports film genre. Their collaboration, along with the popular screenplay writer Kitamura Komatsu, resulted in their most famous trilogy: *He and Tokyo* (*Kare to Tokyo*, 1928), *He and the Countryside* (*Kare to den'en*, 1928), and *He and Life* (*Kare to jinsei*, 1929). As was typical of the film series subgenre, a particular star was showcased, a further way to promote

studio flavor, differentiating the series from the youth sports films of other studios. Repetitions in film titles, such as "He and . . ." became the brand name of the series and circulated as a new subgenre.

Briefly summarized, the father of the leading character, Shigeru (Suzuki Denmei), is a cabinet minister who remarries a much younger woman, Utako. Utako is depicted as too modern and bourgeois to get along with the second daughter, Kozue (Tanaka Kinuyo), although the first daughter, Futaba, fully accepts the stepmother. The film sets up a contrast between the Western materialism of Utako and the traditional values of Kozue. The stepmother's modernity is presented negatively, as in a scene where she refuses to honor the custom of seeing her husband off to work. In another scene, she refuses to care for her husband, ill with the flu, demonstrating her consumerist proclivities by announcing, "We can just hire a nurse." While the stepmother is depicted as self-centered and hedonistic, Kozue demonstrates affection to others and traditional filial piety. In this regard, the film follows the tendency to mark a modern woman figure with the negative aspects of modernity. Shigeru and Kozue finally move out to a modest tenement apartment, where they meet a neighbor, Shigeru's future wife, Yumiko (Kawasaki Hiroko). Shigeru starts working at a newspaper company, in which he finds his best friend, Kojima (Okada Tokihiko), who is his boss; Kojima will later accuse Shigeru's father of graft. Shigeru's father clears himself of the charges by the end of the film, and his whole family is reconciled at its lakeside summer house.[3]

The film starts with a long sequence of a pushball game between two high schools. The sequence, which contains many subtly montaged shots of athletes in motion and ornamental shots of cheering spectators, establishes the sense of modernity through the spectacle of sport as an expression of the new, cultural expansionism and a collective modern identity. Ushihara shows an anonymous Shigeru being thoroughly integrated among the players without any close-up shots. The sequence functions on at least two levels to emphasize the experience of modernity. First, it presents an unfamiliar pushball training game as completely natural for the participants. The odd choice of the pushball game, obscure in both Europe and Japan, warrants explication as the scene's main spectacle. In a review of the film, a 1930s critic, Otsuka Kyohei, wrote, "As for the pushball game in the film, I suppose that the director deployed the game because of the large ball and the players' movements were easy to shoot. However, I think that selection caused more confusion among the audience since no one has ever actually seen the game."[4] Doubtless the spectacle furthered the sense of the new, as the youth engaged in an up-to-date training exercise. Second, the sequence continuously depicts, in the swarm of players around the huge ball and shots of the crowd, the anonymity of crowds and modern space.

Modern sports brought not only Westernization, but also an accelerated nationalism that connected with the growing militarism in Japan. With the slogan *"fukoku kyohei"* (a wealthy nation and a strong army), the first minister of education, Mori Arinori, promoted modern sports and formulated an ideal of a nationalized Japanese body starting in the late nineteenth century.[5] In Mori's tract *The Advocacy of Military-Style Exercise to Build Good Citizens* physical exercise was praised as fostering the ideological virtues of patriotism and obedience to the emperor. Modern sports, especially ball games such as rugby, started to be played in local high schools and colleges under the instruction of Western teachers and gradually became nationwide competitive games in the mid-1920s. In 1924, a government-sponsored national rugby game was held in the Meiji Shrine stadium. Japan's participation in the Olympics began in 1912, and, as noted, the first gold medalist appeared in the 1928 Olympics in Amsterdam.

The imbrication of nationalism with modern sports led to depictions of the strong ideal body, embedded with the discourses of nation and modernity. Modern sports became linked paradoxically with modernity and tradition through the literature of national sports associations, which invoked mythic masculine images of *bushi-do* (the warrior's code of Japanese chivalry) virtues reinvented as modern tradition. Indeed, there were two discursive responses to the problem of modern sports' compatibility with Japanese traditions. The first was to appeal to a mythic Japanese spirit to assert that modern sports were played with a different emphasis in Japan. The second was a reinvention of Japan's traditional sports, like judo and kendo, as modern collegiate institutions, with an emphasis on quantifiable achievement.[6] This process of reinvention corresponded with the interwar period's pervasive discourse of origins. As H. D. Harootunian describes in the case of Japanese scholars in search of national folklore, "The rapid pace of Japan's capitalist modernization in the twentieth century prompted an effort among [Japanese] to discover a fixed identity in relation to origin in the pre-capitalist past."[7]

The 1930s preoccupation with the essential difference of the Japanese spirit was expressed in the youth sports film genre. Yamamoto Kikuo points out that the Japanese genre was created under the influence of Hollywood's college comedies. College comedies such as *Brown of Harvard* (United States, dir. Harry Beaumont, 1918), *The Freshman* (United States, dir. Fred C. Newmeyer and Sam Taylor, 1925), *The Quarterback* (United States, dir. Fred C. Newmeyer, 1926), *The Campus Flirt* (United States, dir. Clarence G. Badger, 1926), and *College* (United States, dir. James W. Horne, 1927) were popular among other Hollywood films in Japan. The difference between the Hollywood and Japanese genres, according to Yamamoto, is that the heroes in the former fight for personal interests,

such as the love of a girl, but in the latter, the heroes fight for selfless reasons, such as the honor of their school or social justice. He also describes the Japanese genre as an escape from the depression caused by the economic turmoil after World War I and as a fantasy of individual freedom in the face of military values of discipline concurrent with the subsequent expansion of militarism.[8] The seeming contradiction of this genre—its articulation of nationalist collectivity on one hand and modern individualism on the other—reveals the state of national sentiments in the interwar period.

Film genres as a commercial practice are preloaded with already conditioned expectations from audiences and producers.[9] As we consider genres of any national cinema, we must contextualize them within their particular formative circumstances, such as cross-textual practices of moviegoing. It follows that the Japanese genre of the youth sports film should not be taken simply as a transplanted form or an imitation of a Hollywood genre, but rather as a newly created genre under the influence of Hollywood, tailored to suit local needs.

It is significant that both the Hollywood and Japanese genres provide compensations for the fragmentation of modern life, but in profoundly different ways. The former reiterates the subject's threatened identity in the form of frenetic slapstick comedy and appeals for audience empathy with the besieged protagonist; the latter provides a body perfectly suited to modern life as an imaginary solution for relieving the audience's real-life anxieties over modernity's hectic pace of change. This difference can be attributed to the complexities of Japanese modernity, in particular the condition of incompleteness, a provisional state of being that the body's spectacle offers to resolve. The genre's Japanese films are, from their inception, embedded with a twofold sense of inferiority: the inconsolable lack of sufficient modernity coupled with the resignation that the characters can never become the same as the Western Other that seemed so familiar to them through the movies.

Tom Gunning describes the qualitative difference between Buster Keaton and Charlie Chaplin as intrinsic to their respective roles as misfits in modern life. His comparison reveals their distinctive natures: "Keaton projects not the freedom of the open road but the plight of modern man trying to find, within a chaos of fast-moving traffic and demonic machinery, a spot where he won't get hurt. . . . If Chaplin's reaction to industrial production was one of Luddite destruction or anarchic hysteria, Keaton tried constantly to adjust his body to the new demands of systematic environments. These adjustments unmasked the absurdity of the system itself, its anxiety causing, infantilizing power."[10] The imperative concept of Keaton's comedy is his misfitness with modern sports and modern life, a condition that was of course shared with the audience at that time. The misfitness can be seen within the propensity of modern

life that Ben Singer discusses in his analysis on modernity and popular sensationalism: "The illustrated press's preoccupation with the perils of modern life reflected the anxieties of a society that had not yet fully adapted to urban modernity. We have had a century to get used to modern life. At the turn of the century, however, the metropolis was still perceived as overwhelming, strange, and traumatic."[11] Thus Keaton can be taken as not only a misfit, but also a representation of the inherent anxiety of modern life.

In the Japanese films, the fact that the leading male characters are depicted as completely integrated within modern sports and well adapted to modern life would seem to belie such anxieties. The substitution of the well-suited figure for the victims or misfits of Hollywood comedies stems from the Japanese need to create a "modern" national identity, which follows from Japan's double bind as a second- or third-tier nation vying for status with the great Western imperialist powers. In a broad historical sense, the process of modernization in Japan was not simply a matter of absorbing Western technology or transforming from an overwhelmingly agricultural economy into an industrial one, but it was suffused with Japanese desires to emulate the West during the period of Western imperialist expansion. The Meiji state's attempts to elevate Japan as an equal among the Western powers resulted in Japan's alienation from the non-West, Asia in particular. Japan's reenactment of the European imperialist epistemic model (which paradoxically placed Japan on the lower rungs of nations) restructured its Eurocentric hierarchy so that Japan would dominate in its own colonial interventions in Asia. This European model was dominant in the early stages of the Japanese creation of the modern nation-state, Japanese nationalism, and the exercise of its power in its hemisphere. Japanese modern identity was thus embedded with contradictory longings toward the West, on the one hand, and toward a "traditional" Japanese identity distinct from the rest of Asia on the other.

The precise nature of Japan's double-bind situation has been strongly debated in recent postcolonial discourse. The dominant argument applies Edward Said's idea of Orientalism, as in Kang Sang-jung's assertion that Japan internalized the same patterns of Orientalism as practiced by the European imperialist powers in its own expansion policy toward other Asian countries.[12] More recent scholarship argues for greater complexity in the colonial model. Oguma Eiji describes significant disjunctures with this pattern of Orientalism, finding great variation in the Japanese colonial practices in Okinawa, Taiwan, Korea, and northern Japan.[13] The main gap stems from the Japanese tendency toward forced assimilation of the colonized cultures, legislating Japanese language and customs in these countries. Unlike the British imperialist practice, which was predicated on maintaining a Western identity superior to

and separated from the non-West, in Japan's case imperialism, at least on the ideological level, was expressed as pan-Asianism. Under the already fixed racial hierarchy underpinning the imperial exercise, Japan could never adopt the same British tactics of administration and separation in its own colonial enterprise. In the late phase of Japanese colonialism especially, Japan had to distinguish itself from the rest of Asia while at the same time justifying its expansion against Western interference by invoking its links to Asia.

The Meiji government slogan *datsua nyuo* (withdraw from Asia and participate in Europe) could no longer provide a sufficient ideological basis for Japan's situation after 1931 in the international arena; internally, Westernization could continue to have currency, while globally Japan would perform as thoroughly modern and secure in its Asian identity. For the purposes of this study, Oguma's term "the colored colonial empire" carries the subtle contradictions of Japan's double bind as a modern nation: the simultaneous display of the nation's contending power and the deeply inscribed shame over its suspected inferiority.[14] In the context of 1920s imperialism, Japan's situation requires extending the discussion of military expansionism and economics to the political arena, where race and politics merge. The cinema as historical text is well suited to this context, since it represented the literal embodiment of these competing identities. This is the period when the male body as a perfect modern sports figure appeared in Japanese films, and the body can be seen as a representation made out of national needs. Carrying the sense of that national body as a resolution of modern contradictions, we might now call it *the colored imperial body.*

The Text with Open Seams

Why Do the Youth Cry? holds two narrative structures entangled with two men's lives. Following the structure of initiation, the leading character, Shigeru, becomes independent from his parents, an action that transforms his situation from one of innocence about the intricate social rules and corruption of politics and business to a new awareness of these matters. The second narrative structure, that of dissatisfied inversion, concerns his leftist friend Kojima, who charges Shigeru's father with corruption but fails to get an indictment because of a lack of evidence. The last sequence ties these two narrative structures with a forced happy ending in which Shigeru drives off in a motorboat with his fiancée and a second couple, Kojima and Kozue. The boat is bound for the lakeside house where the rest of the family members wait for them. With its double narrative structure the film can be categorized among

the films of "movement-image," as in classical Hollywood cinema, yet it also contains some "open seams" that make it and the leading character more ambiguous.[15] My discussion of the first narrative explicitly deals with the viewer's subject identification with the specularized body of Suzuki Denmei. The second narrative of Kojima's leftist political activities relates more directly with extra-diegetic political social currents pervading the Japanese film industry in the period.

Suzuki Denmei was publicized as the man of every woman's dreams, yet the film never assimilates any female character's gaze with the camera's point of view toward Denmei as the subject of desire to indicate a broader range of audience identification. Moreover, we recognize some scenes where the film reveals his ambiguous sexuality. In one sequence, Denmei lies in bed trying to fall asleep, but the noise of women—Utako and her friends—playing mah-jong upstairs disturbs him. The mise-en-scène of the sequence, including the low-key lighting of the bedroom, ostensibly juxtaposes the night's silence with the noisy play upstairs. Denmei starts posing audaciously on the bed; he sits up and slowly smoothes his hair upward with his left hand. Then his image becomes completely "feminized" in the conventional seeing-and-being-seen structure of classical Hollywood cinema; as he languidly reclines in the manner of a Hollywood starlet, he takes the position of an object of the camera.

These shots also persistently show his profile, which appears throughout the film emphasizing his "Westernness." The lighting and camera angles highlight the depth of his face, the high bridge of his nose, the shape of his skull, the lightly permed hair, and the distinctly un-Asian shape of his eyelids. The film even introduces him with this profile; on the way back to school from the ball game, athletes are chatting on the train, then the camera shoots Denmei in profile within a medium close-up shot. It is unusual in the cinema of the period to introduce the leading character with such an obliquely angled shot. The "femininity" he displays, coupled with his "Western" profile, has the effect of doubling his role as the sexualized, desired Other. This viewing structure causes a twofold incongruence with the classical Hollywood cinema. First, of course, the male figure usually does not take the position of being seen as a desired object; second, instead of the Asian being in the position of the feminized Other, the film presents the "Westernized" figure in the same position.

Miriam Hansen analyzes Rudolf Valentino as an erotic male object in his films in the sense that his image enables the female audience to invert the usual terms of scopophilia, which is typically structured by the male gaze in the classical Hollywood cinema.[16] In the case of Valentino and his films, either a vamp or a female romantic companion leads the look of the camera and provides easy access for the female audience to assimilate its viewpoint with the

woman's gaze in the film. Hansen also highlights the value of the Valentino films because of this device, which temporarily disrupts the male-centric viewing structure in which men look and women are looked at.

In *Why Do the Youth Cry?*, Denmei appears in the bed sequence without a subject guiding the desiring gaze. The sequence uses parallel montage between the bed shots and close-up shots of the upstairs women's faces laughing out loud, but it does not indicate who is supposed to be holding Denmei's sensual image in the cinematic viewing structure. This sequence, with the images of the sensual man and the ugly women, causes confusion on the level of gender for the spectator. Given the fact that Denmei's image is "feminized," the scene cannot be read as reversing the patriarchal structure of the cinematic gaze. Unlike the persona of Valentino, Denmei's image is ambiguous; the gaze is unassigned, which leaves the viewing subject undetermined in terms of gender. The montage of the harshly lighted, grotesque faces of the laughing women contrasted with the portrait-like shots of Denmei has the effect of allowing desire and denying it simultaneously. The women's faces are shot frontally in a strong light that erases any shadows; the effect emphasizes the flatness of their faces. Denmei, in contrast, retains the three-dimensional quality of his "Western" profile. Gender differences are here subsumed within the polarity of Japan and the West. Embedded in the contrast of images is the inconsolable oscillating shift between desire toward the imagined Western Other and shame in being Japanese.

The sequence without any viewer can be elaborated with Kaja Silverman's concept of the overlapping yet distinct subjectivities of the "gaze" and the "look."[17] Briefly defined, the former is the same as a camera eye, and it is not physically determined from one specific viewpoint. Silverman characterizes the gaze as an "unapprehensible" view. The latter is always someone's viewpoint, shaped and determined by social contexts, such as gender, class, and age. Silverman highlights the relation between the "look" and "lack": "Unlike the gaze, the look foregrounds the desiring subjectivity of the figure from whom it issues, a subjectivity which pivots upon lack, whether or not that lack is acknowledged."[18] With the adaptation of Silverman's idea, the bed sequence can be illuminated by the transvaluation of the gaze (with no subjective viewpoint in the diegesis), which can also be the look of the anonymous and collective audiences, the film's viewing subjects at the time. The bed sequence reveals the viewing subjects' desire toward Denmei on the screen; simultaneously, it reveals a lack within the subjects, typically unconscious of their condition. What is lacking in the viewing subjects' position is the ideal, cohesive, modern self, which Denmei's body represents in its unified Western and Japanese traits.

In a later scene in the film the connection between Shigeru's sexual ambiguity and national ideology is made more explicit. This occurs in the film's depiction of men's comradeship in homoerotic overtones, especially scenes of affection between Shigeru and Kojima. In a night scene when Kojima visits Shigeru to ask him to take care of his mother after his underground political activity has been exposed, the film shows them holding hands, Shigeru touching Kojima's shoulder, Kojima holding Shigeru's thigh. As Kojima gets up to leave, Shigeru again touches his shoulder and offers his umbrella. Kojima refuses the offer and goes into the pouring rain, whereupon Kozue switches roles with Shigeru and hurries outside to affectionately wrap Kojima in a coat. In his displacement, Shigeru's gaze from the doorway appears distraught, overtly normalized, however, by the assertion of the heterosexual couple, Kojima and Kozue. The substitution of Kozue's affection in place of Shigeru's leads the audience to consider the previous intimacy between the two men as simply an idealized friendship. Here and elsewhere the film disavows its deployment of the code of visual eroticism on the level of the narrative by emphasizing the "comradeship" of the men. The dissemination of comradeship as national ideology had historical precedence in Mori Arinori's advocacy of the three char-

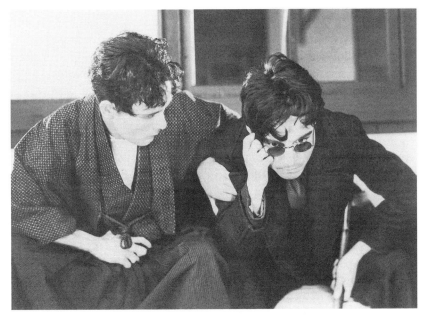

In *Why Do the Youth Cry?* (dir. Ushihara Kiyohiko, 1930), the visual eroticism of the intimacy between Shigeru (Suzuki Denmei), left, and Kojima (Okada Tokihiko) is masked with the virtue of comradeship. Courtesy of Kawakita Memorial Film Institute.

acteristics of Japanese citizens: obedience, comradeship, and dignity.[19] The state's promotion of the virtue of comradeship in its visual representations would always be associated with such physical attachments of the body; in other words, the media, and the youth sports film in particular, disseminated a performance of the physical body as the national body that corresponded to the state's attempts to instruct people in the ways of citizenship.

The second narrative, dealing with class differences, depicts the unequal positions of Shigeru and Kojima. They have been friends since high school and remain comrades until Kojima's betrayal. Kojima belongs to the working class; his membership in an underground leftist group is used to problematize class structure in the period. Shigeru is originally from an upper-class family until he leaves home and starts a modest life with his sister. The narrative shows his transformation from rich idler to businessman to blue-collar worker. Shigeru's intentional inversion of his class status fits closely with the didactic concerns of the period's left-leaning tendency films. However, *Why Do the Youth Cry?* is neither politically cohesive nor able to sustain its class narrative; by the end, the formulaic adaptation is exposed as a mere device. Although the film depicts dramatic class differences, its final sequence reasserts the stability of the patriarchal family order, obliterating in effect both the divisions of class and those of modernity and tradition. Shigeru and Kojima, neatly dressed in business suits and with their respective sweethearts, ride on the motorboat toward a happy reconciliation at Shigeru's family house. The happy ending closes the open seams of modernity and tradition shown in the earlier scenes. Read allegorically, the reconciliation of the traditional, self-sacrificing women on the boat, Yumiko and Kozue, with the obsessively modernized stepmother, Utako, and Shigeru's other sister, Futaba, consoles the Japanese audience with a reconfirmation of the social order.

It is necessary here to locate the second narrative in the context of 1930s politics surrounding the Japanese cinema. *Why Do the Youth Cry?* was released during the period of the politically left tendency films, and while it did not belong to that genre, Shochiku coopted some of that genre's progressive social themes—notably the modern predicament of the salaried man—albeit for different ideological ends. During this period, Japanese society faced severe economic and political problems precipitated by the worldwide financial panic in 1929. High rates of unemployment and drastic wage cuts strengthened the growing socialist movement. The government arrested many members of the Japanese Communist Party and its supporters in 1928 and 1929. In this pervasively leftist atmosphere, more overtly progressive tendency films were also being made and released.[20]

The 1930s film critic Iida Shinmi describes the film's conflicted politics: the supporting actor Okada Tokihiko gives a good performance in a role that is quite different from his previous middle-class salaried man roles; Kojima is a left-leaning journalist with ties to an underground political group. In contrast, Iida notes that Ushihara Kiyohiko displays his usual passive acceptance of the studios' commercial protocols.[21] Iida's criticism infers a parallel between Okada's leftist role and Ushihara's commercialism from the untenable exploitation of progressive themes in easily resolved melodrama. The majority of film criticism at that time viewed this as the primary failing characteristic of the tendency films as well.

The tendency films have rarely been analyzed by film critics and scholars mainly for two reasons. First is the comparatively short period of their production and the scarcity of surviving films. Second, the critics at that time harshly criticized the films for the central "contradiction" of their content: the films reveal the disparities of class and wealth in society, but under the capitalist structure of the film industry, they inevitably fall short of a substantial critique of capitalism as the essential cause of these disparities.[22] Such attacks were made mainly by the critics associated with the Prokino (Japan Proletarian Motion Picture League) of the early 1930s, and while the tone of their criticism was quite monolithic, it was unaccompanied by any clear definition of what a "true" progressive film was. Prokino itself produced only some documentary films, but lacking a progressive model, it was unable to produce a politically left dramatic feature film.

Why Do the Youth Cry? intertextualizes the politics of progressive socialism in narrative and the conservative control of labor and capital in the studio system. We witness the interplay between the off-screen cultural context of Shochiku's capitalist logic and the diegetic social commentary in the film itself. For instance, the second narrative's deployment of the conflict between capitalist hegemony and social justice intertextualizes the existing conflicts between studio heads and their workers. Kojima's attempts to expose corporate corruption through his newspaper articles are met with resistance from the newspaper management; after he resigns under fire, the other workers, including Shigeru, become agitated, and, in scenes that were eventually censored, they start a riot and are threatened with police action.[23] Shochiku was less successful in its attempts to diffuse its real-life skirmishes with its own filmmakers. The company's personnel conflicts started in the late 1920s, when many Japanese film studios tried to resystematize their production practices in preparation for sound technology, which required more capital investment. Subsequent to his direction of *Why Do the Youth Cry?,* Ushihara Kiyohiko di-

rected *The March,* which was produced to mark Shochiku's tenth anniversary. Despite his decade-long tenure as a Shochiku director, Ushihara was forced to resign from Shochiku after the commercial failure of the film. His sudden resignation made clear to other filmmakers and actors their own uncertain status in the studios. Ushihara's close colleague and friend, Suzuki Denmei, made attempts to launch his own productions and secure his independence from Shochiku. After studio head Kido Shiro arbitrarily reduced some actors' salaries, Denmei's plan went forward.[24] Kido and the upper-level management sought to prevent Denmei from taking other actors and actresses away from Shochiku; they decided to fire him as well. The mudslinging between Shochiku and Denmei and other stars, such as Okada Tokihiko and Takada Minoru, caused a great sensation in 1931, when these top actors left Shochiku and founded Fuji Film Productions, which lasted only two years.

What we see in this conflict stems less from the dichotomy between the feudalistic studio system and the modernist individual Denmei and more from the immanent contradictions of the modernization movement in the Japanese cinema industry itself. From 1928 to 1931, Shochiku had to concentrate its capital by combining small subsidiaries and purchasing theaters to strengthen its financial power in preparation for the technological change to talkie films and prospective competition from the newly launched Toho business group.[25] The disaffection of Denmei and other actors and directors toward the dictatorial studios found support in the print media's reporting of their struggle; the exiles deployed language that evoked democratic notions of freedom and individual equality stemming from the Taisho democratic movement. Indeed, Ushihara's official reason for resigning from the studios and his decision to go to Europe to study filmic sound can be read as a part of the Japanese modernization process itself, absorbing advanced technology from the West. *Why Do the Youth Cry?* was made out of these skirmishes with modernization.

This chapter has examined Suzuki Denmei as a site in which modernity, cinema, and the body are connected. The site appeared in tendency films, modern sports, and the two genres of college comedy and youth sports films. How should we see the relation between writing a history and the historical text, such as *Why Do the Youth Cry?* Louis A. Montrose refers to this relation when he writes of "the textuality of history and the historicity of texts": when a text is created, it is created within a specific social context, and although a text we examine presents some traces of the period, the traces do not always present the truth.[26] Borrowing Montrose's skepticism, I have revealed the cultural system in which the film was located as a synchronic accumulation of social and cultural events, discourses, and the like. We of course know that the intertextual discourses I have uncovered are not the only traces but some

of many that the film as a historical text provides. Given that the issue of how one writes a sufficient history remains problematic, writing history can also be seen as merely a provisional strategy leading some selected cultural and social codes in one direction according to one's intentions. However, if that is so, our task as film historians must be to continue to show that a film, as a historical text, is not autonomous, and that our analyses themselves are also part of the diachronic cultural system in which they originate, alongside other cultural events and discourses.

Imaging Modern Girls in the Japanese Woman's Film

> In Japan during the 1920s and early 1930s, the true other of
> modernity was not so much the worker but *woman*.
>
> —H. D. HAROOTUNIAN, *Overcome by Modernity*

This chapter focuses on the Japanese "woman's film" and considers how national and modern gender identities converged in Japan's interwar period.[1] Japanese cinema in this era coincided with a prevalence of cultural discourses on modernity: what it meant to be Japanese and modern was an open question. In these self-reflexive discourses about modernity, one detects a historical consciousness as newer forms of experience specific to capitalism were often pitted against older forms related to feudalism. In similar terms, the woman's film became the dominant subgenre of the modern film and a signifier of "the new" next to the antiquated genres of *shinpa* and period films, which remained tied to prefilmic theatrical representation and "masculine" feudal narrative respectively.[2] This is also the period when Japan witnessed an increased presence of women in the public sphere, especially in the cinema. With the increase of women in the urban workforce after World War I, they gained a newfound independence and autonomy, expressed in the popular trope of the *moga*, or the modern girl.[3] Women's visibility as actresses in place of *oyama* (female impersonators) and new storylines of women's struggles demonstrate the emerging ubiquity of the moviegoing experience as female consumer capitalism. Women's identities became linked to a new culture of consumption surrounding the appearance of modern capitalist forms and technologies such as department stores, movie theaters, and the print media. The woman's film

served both to configure a female identity as consuming subject and to provide material for her consumption.

My approach is to view the woman's film genre primarily as a reflexive discourse on the experience of modernity and the modern girl figure as the reification of this Japanese vernacular modernity.[4] One might counter that the concept of vernacular modernism presents an illusion of a centerless cultural formation standing outside the hegemony of the West. However, I intend to make the term "vernacular" serve as a constant reminder of the particularity of that modern experience, which is both culturally specific and globally influenced. I direct attention to a few core inquiries related to how the filmic genre expressed a material and delimited version of Japanese modernity, specifically focusing on the image of the modern girl. Japanese cinema—like other national cinemas—was marked, from its inception, by the cinema's Western origins in France and the United States—that is, the Japanese learned how to make films in the presence of these preeminent cinemas, especially that of Hollywood in the post–World War I period.[5] As a result, the Japanese films contain an "authenticity complex," and often display this history in their referentiality to their Hollywood predecessors.[6] Thus the primary question is how to analyze these films as something beyond insufficient copies of Western films, especially given the fact that Japanese films incorporated influences of Hollywood—but with subtle differences—as they competed against Hollywood-made pictures and other Japanese films in the domestic market. Within this context of the cinema's referentiality, I discuss the central trope of the woman's film, the modern girl, and the desires it embodies as a social discourse of the disruptions wrought by modernity in Japan.

How can we talk about the woman's film as both a critical term and a historical practice in the context of Japanese vernacular modernity? My discussion starts from the assumption that the concept of the woman's film—originating in studies on Hollywood cinema with its own spectatorial regime—cannot simply be applied to Japanese cinema without some modification. My historical research offers a definition of the woman's film genre based on audience composition and the genre's place within the Japanese film industry in the 1920s and 1930s. From this definition, the problem of the critical stance toward cultural discourse in the period can be developed by examining Miriam Silverberg's ideas on the identity play of the 1930s as it was often depicted through the modern girl images. I would like to offer in response some alternative structures for how to understand the apparent changes in Japanese identity in the historical swing between modernity and 1930s nationalism. My analysis of two representative woman's films, Ozu Yasujiro's *Woman of Tokyo* and Gosho Heinosuke's *A Burden of Life,* reveals how the images of the modern girl

in these films are constructed to produce in the audience a national sentiment toward their own modernity through multiple suture points: the insertion of Hollywood film clips into Japanese films; the on-screen modern girl image and the off-screen star image; and the expectations between film genre and its audience. The Japanese woman's film has been constructed in long-standing critical discourses as an apolitical film genre. However, this chapter illustrates the genre's profound ties with the political: the films' reinforcement of national sentiments work to safely contain the process of modernization.

The Japanese Woman's Film

Mary Ann Doane defines the Hollywood woman's film as "a specific genre allocated to the female spectator" that offers "a privileged site for the analysis of the given terms of female spectatorship and the inscription of subjectivity precisely because its address to a female viewer is particularly strongly marked." She goes on to say that the films remain compelling because their images are experienced as cultural memories, "mythemes of femininity" containing the "'obvious truths' of femininity with which we are all overly acquainted."[7] While her definition of the woman's film will be deployed here, fundamental differences in the Japanese genre and its construction of femininity require another set of objectives and politics for analyzing the Japanese woman's film. For instance, the parameters of the melodramatic form—so central to the Hollywood woman's film and its link with bourgeois sensibilities—are different in the Japanese woman's film, signifying instead a Japanese search for modern subjectivity and a colonial sense of anxiety toward Western modernity. The task of writing on the Japanese woman's film is thus perforce different at levels of both purpose and text, and it requires an elaboration of the cross-cultural aspects of film production since Japanese films have always been made with varying degrees of consideration and reflexivity toward Western cinematic models. When viewed as a constructed discursive system, the Japanese woman's film serves to remind us of the inseparable relation of gender and national identity.[8]

As Doane argues, the political implications of writing on the woman's film in the case of Hollywood cinema were "determined by a desire to shift the terms of an analysis of fantasy and history in favor of the woman and away from a paternal reference point."[9] The shift from gender to other subject-object relationships, such as race and ethnicity, occurred during the rise of cultural studies. Indeed, my own exploration of Japanese female subjectivity and spectatorship must deal with the relation between gender and ethnicity, which

Doane and many other feminist film scholars managed to sidestep until the late 1980s. The cross-cultural aspect of my work on the Japanese woman's film for the Western academic reader has less of the already inscribed familiarity of cultural memory that Doane describes. We can no longer assume such a commonality of cultural history as that which lies at the center of psychoanalytic feminist film critics' versions of woman, nor may we assume the convenience of a patriarchy neatly distinct from other forms of cultural hegemony such as Eurocentrism.

In ways similar to the Hollywood melodrama of the 1940s and 1950s, there have been several emergences of the woman's film in Japanese film history. In the postwar period, for instance, Daiei studios produced about thirty films categorized as motherhood film(s) while also producing such internationally recognized films as Kurosawa Akira's *Rashomon,* Mizoguchi Kenji's *Ugetsu* (*Ugetsu monogatari,* 1953), and Kinugasa Teinosuke's *Gate of Hell* (*Jigokumon,* 1953). At the same time, Naruse Mikio produced melodramas at Toho, and his films not only contributed to the studio's garnering of female audiences, but also refined the melodrama genre. Likewise, Kinoshita Keisuke launched into television in the 1960s and produced "home dramas" throughout the following three decades. This peak of Japanese melodrama had its roots in the earlier, prewar woman's film. The producer Kido Shiro at the Shochiku studios had encouraged the production of the woman's film as a particular business strategy since the 1920s, and indeed the woman's film became the seminal genre for Shochiku throughout its long history. Both Naruse and Kinoshita were former Shochiku directors, and in their separate ways they carried this Shochiku tradition into the postwar period.

Shochiku's woman's films were specifically targeted at a female audience.[10] The rise of that studio's woman's films is connected with the wider appearance of a female consumer subject in Japanese culture, brought about by the social stability and economic prosperity of a growing urban middle class in the 1920s. In this period, the print media became prevalent, and the number of women's magazines increased dramatically, many of them featuring a mix of fiction and practical advice, projecting a vision of bourgeois female domestic life.[11] Shochiku responded to this growing market by adapting an extensive range of fiction aimed primarily at women. The studio produced many woman's films, by directors such as Nomura Hotei, Ikeda Yoshinobu, Shimazu Yasujiro, Shimizu Hiroshi, Gosho Heinosuke, Naruse Mikio, and Ozu Yasujiro, and it employed a greater number of actresses than any other Japanese studio. Shochiku's woman's films solidified the studio's production system, which was characterized by the use of trademark star actresses such as Kurishima Sumiko and Tanaka Kinuyo, domestic sets, and Tokyo as the background for narratives of urban

middle-class life. Kido Shiro rationalized his emphatic promotion of woman's films at Shochiku as follows: "The fact that the old moralistic ideas have a repressive stranglehold on women presents opportunities for us to create various theatrical stories for our films. Also, women don't come to the movie theater alone; they are always accompanied by other people such as friends, sisters, and boyfriends, so we can have larger audiences while spending less money for advertising."[12] Kido's words also illustrate his interest in the woman's film as a strategic measure in the competition among period films, *shinpa*-style films, and foreign films in the 1920s and 1930s.[13]

Kido's statement implies the underlying constraints of the period's Japanese cinema: in order to compete with more capitalized, technically advanced foreign films, the cinema would have to modernize by promoting woman's films as a new genre, one that would actually become the dominant component of the modern film. His assertion of the commercial potential of Shochiku's woman's films was made in opposition to the *shinpa*-style films of Nikkatsu studios, which had been derived from an earlier modernization project in theatrical drama. The year 1920 marked the beginning of the competition between the two studios, with Shochiku's alignment with the *jun'eigageki* (pure film) setting the historical trajectory of the modern film genre as well. Shochiku's highlighting of the contrast between *shinpa* and pure film was meant as a separation from theatrical film style, which was typically marked by stage acting shot without camera movements or editorial devices. Shochiku tried instead to make films with strong influences from Hollywood cinema, which already dominated the Japanese film market.[14] Besides the usage of screenplays, camera movements, and advanced editing techniques, the overt difference between the Nikkatsu *shinpa* film and Shochiku's pure film was the latter's use of actresses instead of *oyama*. The woman's film thus embodied modernity in the Japanese cultural context as a historical contingency of the competition between the two studios. In this regard, Shochiku's further development of the woman's film along the lines of the pure film movement, with its implications of a more filmic, Westernized, and modernized film, placed a political consciousness of the modern cinema's combined embrace of the foreign and the feminine at the center of the genre. By erasing the visible traces of premodern Japanese storytelling conventions from the cinema and by substituting actresses for the *oyama*, filmic narration for the *benshi* commentary, and filmic realism for theatrical representation, the woman's film signaled opposition to a feudal past, as well as its own affiliation with a modern cinema. Shochiku merged Hollywood influences with narratives about Japanese urban life and hired many new university graduates as screenplay writers to develop scripts articulating what modern life should be in the context of Japanese culture.

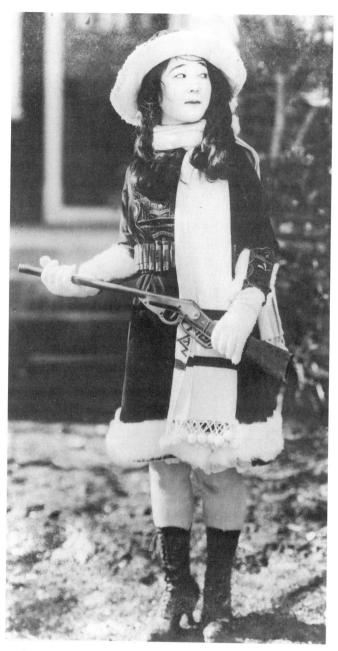

Souls on the Road (dir. Murata Minoru, 1921). Hanabusa Yuriko imitates Mary Pickford. Courtesy of Kawakita Memorial Film Institute.

In the 1920s and 1930s, the constellation of Japanese film genres became increasingly stable within the set of *jidaigeki* and *gendaigeki* mega-genres. While the tendency has been to view the Japanese genre system historically as constituted of the two mega-genres, it is also necessary to consider foreign films, as another type in the mega-genre system. The Japanese woman's film, especially its ties with national identity, should be considered within the context of the genre system of that period. As the structure of this system indicates, Japanese genres were constructed by competition between foreign and Japanese films, as well as between the period and modern genres. The woman's film was inextricable from Hollywood's narrative structures and formalistic norms, and it was simultaneously tied to how well it could distinguish itself from Hollywood. In contrast with the early pure film emphasis on direct imitation of Hollywood—as in *Souls on the Road,* in which Hanabusa Yuriko copied Mary Pickford's image down to the details of hair, clothes, and body language—the woman's film merged the Hollywood influence with a sense of authenticity drawn from the audience's everyday life. The Westernized salaried man and modern girl figures in the woman's film refer to Hollywood film images, yet

A Burden of Life (dir. Gosho Heinosuke, 1935). In this scene, the modern girl, Itsuko (Tanaka Kinuyo), imitates Claudette Colbert in the hitchhiking scene of *It Happened One Night* (dir. Frank Capra, 1934) while her husband (Kobayashi Tokuji) looks on. Courtesy of Kawakita Memorial Film Institute.

A Burden of Life: Itsuko (Tanaka Kinuyo) successfully hails a taxi. Courtesy of Kawakita Memorial Film Institute.

in a more self-reflexive enactment of the Japanese embrace of modernity. The woman's film thus opened up an imaginative space for a Japanese vernacular experience. In *A Burden of Life,* for instance, the character played by the best-known actress of the period, Tanaka Kinuyo (modeled on Claudette Colbert), exhibits a self-deprecating humor that distinguishes the woman's film from the histrionic imitation in *Souls on the Road.* In both tragic and comic terms, the film plays on the consciousness of its characters, and indeed of the audience, that "we can't be truly foreigners anyway." This awareness speaks of the process of referentiality, with the certainty of a reception pattern already embedded in the woman's film. In this way, the woman's film negotiated the audience's expectations, becoming at once modern and distinctly Japanese.

The Woman's Film in Interwar Japan

How did this complex process of referentiality develop in the creation of the woman's film? More specifically, what should we make of the apparent play of identity in the ambiguously Westernized images of the films' female figures? If we view these images as cultural discourses, what sort of approach should we

use to read them? Miriam Silverberg addresses the fundamentally global movement of modern popular culture in her analysis of 1930s Japanese film magazine iconography. In the magazines' photoplay juxtaposition of Japanese movie stars and their Western counterparts, she finds "a flexibility of identity," which she sees as a defining characteristic of Japanese modernity. The play of identity, she writes, "was fluid, compelling the reader to negotiate back and forth between Japanese and Western faces in a complex combination of gender juxtaposition, while putting into place Japanese, Koreans, and Chinese on the Asian continent through a form of code-switching." [15] While her discussion is less specifically concerned with the woman's film, her analysis of cross-cultural aspects of 1930s Japanese popular culture is relevant to interpreting the construction of *modan* (modern) identity through the iconography of film actresses.

Silverberg's intention is to write a bifurcated cultural history that resists the universal narrative in which Western modernity propagates a model for non-Western countries such as Japan. However, her attempt to account for the transformation of subject identity, which she sees beginning with the Pacific War in 1941, reiterates a linear narrative of nationalism and militarism after the collapse of the Japanese modern. Silverberg sees a historical shift from modernity, marked by "a fluidity of identity," to nationalism, a wartime period of rigid gender and national identities; she describes this shift with the Japanese term *tenko*.[16] Yet other areas of Japanese popular culture do not exhibit the same transformative tendencies. For example, many of the woman's films of the 1920s and 1930s depict the moralized exclusion or marginalization of modern girls as symbols of modernity, often in the service of supposedly traditional national values. While modern girl images often represented the seemingly ambiguous spectacle of Japanese women embracing Western style and values, as modern signifiers they were often contained within alternately patriarchal and national discourses. On this basis, I argue that there was no such distinct break between Japanese modernity and nationalism in the transition of historical periods but rather a nested box structure in which Japanese modernity occurred concurrently with nationalism, as in the case of the woman's film genre.

One might see the syncretism of Japanese film genres as a play of identity similar to the "code-switching" that Silverberg describes. She elaborates it as "the actively constructed aspect of the syncretism of prewar Japanese culture" and suggests "the Japanese reader *did not think* in terms of 'here and there.'" [17] Her interpretation of interwar Japanese cultural images in the movie fan magazine *Eiga no tomo* (Film Friends, 1923–1951) assumes that such images represent the highlight of modern syncretism of Japan and the West. However, in a wider historical perspective, one can see that the images represent a continuity of cultural colonialism as well, in which identity, for all

its apparent play, remains fixed and distinct. One needs to contextualize the juxtaposition of these magazine images within the historical development of cinema in Japan, established with an onslaught of Western, not Japanese, images. It was only later, in the mid-1920s, that magazines such as *Kinema junpo* began to feature Japanese sections of film criticism and star iconography that closely paralleled the sections on foreign film in terms of graphic format and pictorial quality.[18] Such juxtapositions as the ones Silverberg describes actually confirm national identity in relation to the Other, rather than transposing different identities. Indeed, I cannot help wondering if it is ever possible to construct one's own identity without having a sense of "here and there." Certainly throughout the 1920s and 1930s in the case of Japanese cinema, modernity was constructed within an already permeating nationalism. More specifically, in its assimilation of and distinction from Hollywood cinema, the woman's film of the period materializes both a desire oriented toward the West and a desire for national identity. Therefore the reader of film magazines and the audience of the film genre (in other words, the Japanese modern subject) had a distinct sense of "here and there"; the juxtaposition of the Japanese and its Western Other signifies an act of reterritorialization of the space of racial political hierarchy, compensating for the inequality of the respective positions.

In an argument over Bengal's colonial past, Partha Chatterjee writes: "The pattern is not one of radical liberalism in the beginning followed by a conservative backlash in the period of nationalism—in fact the fault lies with the very inception of modernity."[19] In similar fashion, the Japanese modern did not arise out of an ideological acceptance of Western liberalism, but rather stemmed from problems of local adjustment to Western modernity in a relationship within which the Japanese felt culturally inadequate. The aforementioned image of the nested box may explain the relationship between Japanese modernity and nationalism more precisely than does Silverberg's *tenko* transition from a period marked by the "fluidity of identity" to one of nationalism. The Japanese films of the period, for example, do not contain the sort of parity offered in film magazine photos that alternate Japanese and Western stars; instead, as I explained in chapter 1, they isolate the foreign identities within circumscribed foreign spaces such as the harbor or the cabaret. The territory of the Other more often reinforces the borders of national identity within the films. In consequence, the version of modernity that such iconography contains corresponds to distinctly national needs.

In sum, Japanese cinema, from its inception, has constructed a viewing subject as both modernized and nationalized, in stark contrast to Silverberg's separation of the two within a temporal frame. One needs to account as well

for the transnational aspect of the cinema. As a cross-cultural site, however, the non-Western woman's film is not always commensurable with its counterpart in classical Hollywood cinema, since it often constructs female spectatorship in different ways. The Japanese woman's film reenacts the modern exchange of cultures, constructing its gender subjects, such as the modern girl, as inseparable from the nationalistic struggle to contain the Western influences of modernity. The attempt to suppress the Western origins of cinema is most apparent in the monumental-style film of 1936–1941, in particular, through the style's mythic narratives and nativist aesthetic. The woman's film of the 1920s and 1930s, in contrast, was overtly modern in its images of a contemporary consumer subject, yet it also reflected national consciousness, albeit more subtly, in its circumscription of Western aesthetics and values.[20] The transition between the two periods of Japanese cinema, and indeed of Japanese culture, was thus far less abrupt than Silverberg's idea of *tenko* would imply.

Modern Girls

H. D. Harootunian historically contextualizes the appearance of discourses of modern identity in 1920s urban culture as follows: "The new modern life was figured first in discourse as fantasy, before it was ubiquitously lived as experience, and its major elements were independent women, commodities, and mass consumption."[21] If this is the period of a "feminization of culture" and "an age of declining authority"—as Harootunian quotes the Marxist critic Hirabayashi Hatsunosuke, writing in the 1920s—then by analyzing the discourses on independent women we can understand how the female figure was used to express the threat that modernity posed to traditional relationships.[22]

The word *moga*, an abbreviation of modern girl, is rooted in 1920s Japanese popular culture. As is evident in many woman's films of the time, a profusion of English words appeared throughout the mass media. Some magazines even carried a handbook of new cultural vocabulary that resembled a concise English-Japanese dictionary of borrowed words. Many of the foreign concepts introduced through these words were linked to particular commodities or marketing practices within Japan's new consumer society, thereby limiting the absorption of foreignness to the arena of commodification and creating the illusory sense of mastery over the West.

By the mid-1920s, the heretofore floating significance of modern girl representations became fixed and subsequently transformed into a convenient image of the modern subject that served the marketing needs of cultural produc-

ers and consumers, as well as the national political needs within patriarchal discourse. In such images and discourses, the figure was explicitly linked with the West and the flow of Western luxury goods as global commodities, styles, and expressions. Thus the modern girl was used to symbolize the assimilation of Westernness and the Japanese mastery over the encounter. Whether she was used as an affirmation or a mockery of the Japanese embrace of the West, the image always served to refigure and reestablish Japanese national identity; in either case, the external depiction of Westernness in the modern girl's materiality left the modern subject seemingly intact and safe from the profound interior transformations of the encounter. Mass media images of the modern girl were disseminated through print, photos, and illustrations, a continuous recycling of the now commodified figure.[23]

This patriarchal appropriation, trivialization, and subsequent control of such potentially subversive female subjectivities as those represented by the modern girl have historical precedent. In "A Study of Modern Girls," Kataoka Teppei contrasts the figure with the members of Seitosha (the Bluestockings, a group of women writers and intellectuals established in 1913). The Bluestockings' new women, according to Kataoka, tried to create an ungendered voice in literature and criticism so as to escape their confined role as women. They are often mockingly depicted in popular media of the period as bourgeois emulators of male intellectual life. Modern girls in the 1920s and afterward, by contrast, had little to do with such intellectual pursuits; they lived in a consumer society and were made out of it, often quite literally in the materiality of their appearance.[24]

The journalist Sakurai Heigoro further described the close relationship between the modern girl and consumer society: "Modern girls are emerging from modern working women, and both terms are somewhat interchangeable."[25] In contrast, another journalist, Kiyosawa Kiyoshi, described men's view of these figures as "girls who secretly socialize with young hoodlums, have sexual relationships with foreigners, and have day jobs such as *jokyu* [café waitresses]. . . . So far, modern girls mean Westernized young women. . . . At the same time, they are women who appear to embody resistance against male-dominant morality and society. So they are symbols of discontent within society."[26] As these examples illustrate, male journalists of the late 1920s were attempting to locate the social position corresponding to the prevalent modern girl media images. In conflating the modern girl with actual working women, such as waitresses, these attempts speak of the undetermined social context of the modern girl, and, moreover, of the journalists' inability to come to terms with their own anxious projections of modern transformations in the Japanese encounter with the West. Here the projections of female sexual and

economic autonomy in the modern girl figure directly identify her as a sexual Other that threatens the central male subject.[27] Such writing evinces the function of the modern girl in patriarchal discourses: to give corporeal form to an invisible, unacknowledged Japanese anxiety. The figure embodies the unseen but sensed transformation of Japanese identity within material and cultural flows of 1920s Japanese modernity. In the following sections, on *Woman of Tokyo* and *A Burden of Life,* I shall focus on the filmic terms by which the modern girl figure engendered Japanese vernacular modernity.

Mastering Modernity in Ozu's *Woman of Tokyo*

Given the displays of patriarchal control noted above, a basic question remains: How did the woman's film address female spectators? In other words, within its ideological imperatives, what sort of female spectatorial identifications did the woman's film allow? Shochiku produced many woman's films staging the dichotomy between the modern girl and so-called traditional Japanese women. The peculiar adherence to this narrative pattern stems from the fictional writings of the modern women's magazines in the 1920s. Shochiku adapted modern women's fiction by writers such as Kikuchi Kan, who wrote *Madam Pearl* (*Shinju fujin,* 1920), *The Second Kiss* (*Daini no seppun,* 1925), and *Suffering Flower* (*Junanbana,* 1925–1926), among others. Such fiction provided a foundation for the films' use of modern girl symbolism—a strong female character that represented material aspects of bourgeois urban culture—as well as the targeted address of women as consumer subjects as constructed in Shochiku's modern girl narratives.

 Shochiku's pervasive use of this dichotomy can be traced to the company's need to distinguish its brand of woman's film from the previous *shinpa*-style melodrama, as I have already noted. The excessive display of urban modernity, which the modern girl figure represented, marked Shochiku's woman's films as uniquely contemporary next to the more traditional women figures in *shinpa.* One example of the films' use of this dichotomy as a narrative pattern, *Undying Pearl* (*Fue no shiratama,* dir. Shimizu Hiroshi, 1929), is about a love-triangle rivalry between a traditional, prudent elder sister and a modern, haughty younger sister. Typical of this pattern, the film ends with the modern girl excluded on the visual and narrative levels. On the day of the husband's departure abroad, the modern wife does not appear to see him off, and the husband transfers his affection to the elder sister, who supplants the wife's role by bidding him farewell. Other film variations on this pattern include *The Stepchild* (*Nasanu naka,* dir. Naruse Mikio, 1932), which presents the

dichotomy between an estranged first wife, financially successful in the United States, and a second wife, who takes good care of her stepdaughter; *Sunny Cloud* (*Seidon*, dir. Nomura Hotei, 1933), which depicts the dichotomy between a modern daughter from a wealthy family and a traditional middle-class girl, the daughter of parents who own a lodging house; and *When One Goes Down the Tenryu River* (*Tenryu kudareba*, dir. Gosho Heinosuke, 1933), in which the dichotomy is represented by a sophisticated city girl and a geisha.

Ozu was one of the directors who fully applied this dichotomy of a modern hussy and an innocent, traditional girl in his silent films, such as *Walk Cheerfully*, *The Lady and the Beard* (*Shukujo to hige*, 1931), *Woman of Tokyo*, and *Dragnet Girl*.[28] In both *Walk Cheerfully* and *The Lady and the Beard*, the modern figure is depicted as a delinquent girl, while both *Woman of Tokyo* and *Dragnet Girl* present a double version of the dichotomy: a set of good and bad girls, as well as a woman leading a double life. In *Woman of Tokyo*, the pattern appears first in the contrast between the sister figure and her brother's girlfriend and then again in the sister's secret life—she works as a typist in the daytime and as a barmaid, possibly a prostitute, at night. The film shows the distinct change of the sister's hairstyle and makeup in her two roles. This internalized dichotomy determines a narrative trajectory that ends with her naïve brother's suicide and her chastisement.

Both Noël Burch and David Bordwell have written extensive analyses of *Woman of Tokyo* centering on a formalist interpretation of Ozu's stylistic characteristics. Burch describes how the film dissents from classical Hollywood norms—for instance, when it misaligns the camera's spatial arrangement of eye-line match and screen direction in the mise-en-scène. This constitutes for Burch a profound challenge to continuity that excludes the viewer from the film's diegesis.[29] However, it is doubtful that the Japanese audience, conditioned by a set of norms common to Ozu and other Japanese directors, would have found this discontinuity at all alienating. Such techniques in Ozu's films can be seen as not simply a form of dissent from Hollywood cinema, but also, as I will elaborate in my analysis of the film, as an act of overcoming the Hollywood norm. For the Japanese audience, the Hollywood norm would not have been dominant but would have been perceived as but one stylistic pattern among others, just as Hollywood film itself was positioned within the larger genre of foreign films in the Japanese market. Viewers, accustomed to seeing different films with different stylistic patterns, would not have felt excluded in any way from the film's diegesis; rather, they might have actively participated in, for instance, perceiving the aesthetic uniqueness as a supplemental value on top of Ozu's mastery of Hollywood style. Burch's logic of viewer alienation through discontinuity does not square with the Japanese audience's

acceptance of the film. In contrast, to account for the film's power, Bordwell describes "Ozu's use of narration to establish and vary expectations, to cite adjacent traditions, and create parallels."[30]

While Burch and Bordwell debate the terms of Ozu's singularity in deploying an auteurist orientation, neither accounts for the expectations and attractions that the contemporary audience, with its genre-conditioned sophistication, could have brought to the film. Taking this contemporary audience's experience and knowledge into account, I situate Ozu's mastery, his appropriation or inversion of classical Hollywood cinema, within the more specific cultural context of the woman's film genre. In *Woman of Tokyo,* he adds stylistic and narrative play to the pattern of modern and traditional women and offers us other meanings in the context of Japanese vernacular modernity. For instance, in an echo of Bordwell's attention to the film's sophisticated use of parallel editing as a stylistic pattern, one can find that the film's assimilation of female characters and spectators, in contrast to Burch's view, creates space for female identification by transposing the apparent mastery implicit in the multiple acts of appropriation to the spectators themselves.

Woman of Tokyo develops the dichotomy between the modern and the traditional woman in two sister and brother pairs, Chikako and Ryoichi (Okada Yoshiko and Egawa Ureo) and Harue and Kinoshita (Tanaka Kinuyo and Nara Masumi), alternately showing the material possessions of each character, such as socks and gloves, as respective signifiers. By the end of the film, the stylistic parallels have assimilated the paired characters, no longer leaving them in distinct separation. As noted in the introduction, Bordwell characterizes Ozu's quoting of Ernst Lubitsch's *If I Had a Million* in the film-within-a-film sequence as a point where "Ozu masters his master."[31] I would add that the sequence further shows that the film dramatizes this mastery as an assertion of the Japanese modern subject. The sequence creates a parallel between the office confines of Chikako, a typist, and those of the Charles Laughton office clerk character in Lubitsch's film. A further parallel occurs in the sequence between the suggested confrontation of Laughton with his boss and the still image of the policeman Kinoshita's uniform, white gloves, and saber as a visual symbolic parallel connoting an impending duel.[32] The additional, and rather more important, parallel that this sequence foreshadows is the actual confrontation that occurs later between Chikako and Ryoichi. The film shifts the space of conflict from the company office to the apartment, from public to private, as the tension between boss and worker is transferred to the family relationship between sister and brother. In this way, the film draws the atmosphere of confrontation into the domestic sphere of the woman's film.

Another parallel that Bordwell identifies lies in the rags-to-riches theme

Woman of Tokyo (dir. Ozu Yasujiro, 1933). Chikako (Okada Yoshiko) plays the modest sister of Ryoichi (Egawa Ureo). Courtesy of Kawakita Memorial Film Institute.

of the Lubitsch film, echoed in Chikako's sacrifice of working as a barmaid in order to send her brother to college. Even this parallel can be examined more extensively in the context of the woman's film and Japanese history. Ozu provides not a success story, but rather the tragic side of the nationalistic discourse of careerism, the modern period's exhortation to all young men to climb the social ladder. In *Woman of Tokyo,* that exhortation is tied to a woman's self-sacrifice, which could be read as supporting the national ideology by placing it within the concerns of a female subject, thus allowing for closer identification from female spectators.

In a further reading of Chikako's sacrifice, the film deploys another parallel in an act of whispering that occurs as the film reveals Chikako's moonlighting. The scandal is revealed to Harue by Kinoshita; first he states, "Chikako seems to be working as a barmaid after her daytime job. . . . The rumor involves not only that . . ."; then he whispers the rest to Harue, although the information is not shared with the audience. At this point we might imagine Chikako is involved in prostitution or something worse. More whispering occurs in a later sequence, when Harue reveals the rumor to Ryoichi. She

Woman of Tokyo (dir. Ozu Yasujiro, 1933). The self-sacrificing figure, Chikako (Okada Yoshiko), shares a modest apartment with her brother, Ryoichi (Egawa Ureo). Courtesy of Kawakita Memorial Film Institute.

says, "What would you do if your sister was not who you think she is?" Then she whispers to Ryoichi, and again the film conceals the information from the audience. Ryoichi replies, "What are you talking about? It's too ridiculous!" Harue continues, "That's not all. Your sister has disgracefully become a barmaid." This information, as delivered, effectively undercuts the possibility that Chikako's suspected disgrace involves prostitution, but leads the audience toward another possibility—that of Chikako's involvement with a Communist political group. The film encourages such a political inference by embedding details of a hidden social progressive narrative, as in an earlier scene of the police officer's inquiry at Chikako's office and later in a headline announcing the arrest of a criminal organization. The reason why the film contains this hidden story is related to the ongoing red purge at the time.

The year 1933 was one of intense anti-Communist government action, as

demonstrated by the arrest, torture, and murder in police custody of the prole-tarian writer Kobayashi Takiji, as well as the mass arrests of other Communist figures. With the government banning of the socially progressive tendency films in the early 1930s, Shochiku and other studios distanced their produc-tions from any political links to leftist film themes. Films such as *Woman of Tokyo* had to use characteristically oblique methods of narrative development in order to avoid censorship. The whispering scenes thus become signifiers of communication between the film and the contemporary audience. The film deploys a code of referentiality that asks the viewers to draw on their knowl-edge of the 1930s political culture and everyday life experiences. Of course, the act of whispering in a silent film supplies subversive humor as well. Given the fact that talkie films were already gaining popularity, Ozu's virtuosity is displayed in the creation of a sound-sensitive silent film. This self-referential technique invites the audience's identification with the whisperers as the audi-ence gets to fill in the verbal blanks left within the dialogue. The whisperers

Woman of Tokyo (dir. Ozu Yasujiro, 1933). Chikako (Okada Yoshiko) works in the daytime as a typist.

Woman of Tokyo (dir. Ozu Yasujiro, 1933). Chikako (Okada Yoshiko) moonlights as a barmaid.

are undercut at the end by Chikako's dignity remaining intact, since her sacrifice not only supports her brother, but is also linked with her leftist convictions, thus complicating the audience's sympathies. The film neither supports the audience in its identification with the whisperers nor praises Chikako's political act; rather, it reveals the politically charged atmosphere of the time.

A final series of parallels follows the scene in which Chikako, typing in English, produces text that becomes, through montage, the English screen credits of Lubitsch's film. Multiple parallels are at work here: first, Chikako's typing creates an illusion that she is producing the screen credit text of Lubitsch's film; second, Ozu likewise appropriates yet another element of Lubitsch's film; and third, Harue, shown in the audience of Lubitsch's film, states her role as a storyteller of the film. The spectator, meanwhile, is tested since Ozu's tightly edited version of Lubitsch eliminates both the title and outcome of the sequence, demanding that the spectator bring his or her own prior filmic experience to the act of viewing. Bordwell's interpretation of the sequence

ends here with praise for Ozu's act of mastering his master (Lubitsch) and his high expectations toward his audience's filmic expertise. However, we can also read the film's Lubitsch sequence as pivotal in creating a series of subject-object relationships. The spectator, for instance, becomes a parallel partner in the act of storytelling and in the film's sophisticated cinematic play. Through this multiple structure, the female spectator is allowed an imagined subject identification through the assimilation with Chikako and Harue. Moreover, in Ozu's appropriation of Lubitsch's film, the spectator participates in creating a semblance of mastery over modernity and the Western gaze of cinema in general.

The Actress as a Body of Discourse

What I have offered thus far is an account of the woman's film that places it within a modern vernacular set of practices. The filmic experience occurs within a cultural nexus, a correspondence of shared texts at all levels of production, distribution, and reception. By seeing the connections in the cultural nexus, such as the filmic text, the star discourse, and the audience, we can grasp how this cultural web created vernacular modernism in the 1920s and 1930s. In what follows I explore further the contemporary cultural context of the woman's film, situating it within the audience's possible preknowledge and preexperience of star discourses. My focus is on the leading actress Okada Yoshiko and the tension between her off-screen image of a sexually independent modern girl and her on-screen image as a doomed, disillusioned older woman. My interest here is in interpreting Okada's literal embodiment of the modern girl discourse and the repressive power of the cinema in using such imagery.

At the time of Okada Yoshiko's move to Shochiku in 1932, a year before *Woman of Tokyo* was produced, she was already an established star through her career as a stage actress in *shingeki,* or new drama, and as a movie star at Nikkatsu. After walking off the set of *Camille* (*Tsubaki hime,* dir. Murata Minoru, 1927) in a public dispute with the director, Okada was effectively blackballed by Nikkatsu, putting a lock on her film career for five years. When she quit *Camille,* she also took with her the leading man, Takeuchi Ryoichi, who later became her third husband. This aspect of the scandal in particular solidified her modern image as a sexual *provocatrice.* When she returned to the public's consciousness as the personification of the modern girl in 1932, her star image was inseparable from the 1927 scandal.

In addition to the 1927 incident, Okada's biography indicates two main

characteristics that explain the construction of her modern image. First is the discourse on the supposed foreignness of her body. Her lighter skin color and the deep features of her face have been associated with foreignness in some biographies, which claim, truthfully or not, that her mother was a Eurasian.[33] This foreigner discourse, aligning her physical body with the sexual Otherness of Western cinema, makes explicit the transgressive sexual terms that often mark mixed identity. These terms formed part of the symbolism of excess, intrinsic to the star persona, which also contributed to Okada's image as a more sexually autonomous figure. One should note that the connection between foreignness and the modern girl had already been established in literary fiction. Tanizaki Jun'ichiro's sensationalistic novel *Naomi,* published in 1925, features a couple obsessed with a masochistic attraction to foreignness. The man, Joji, (called Georgie) cannot stop himself from reeducating Naomi, Henry Higgins–style, to be a Western lady.[34] At the same time, Joji's attraction to Naomi is suffused with a servile pleasure in his own degradation. He follows her whims and swallows her insults as their relationship takes the form of Western "master" and Japanese "slave." This story enacts a desire for the foreign figure as being contingent on self-negation since it is based on the subject's own sensed lack in the presence of his fetishized object.

Whether Okada fully apprehended it or not, her star image was aligned with such figures as Naomi and was woven into this preexisting modern discourse in the 1920s. Her earlier career as a *shingeki* actress also gave her an association with the foreign and with foreign art since *shingeki* was a movement that translated Western plays and acting styles into a Japanese idiom. In 1938, Okada went into voluntary exile in Russia with the left-wing theatrical director Sugimoto Ryokichi and later became a naturalized Russian citizen. In the last act of her career in Japan, she literally merged herself with the foreign. The fact that her real life mirrors that of her earlier role as a left-wing sympathizer speaks of the ubiquity of Communist issues in the 1930s. While there is no evidence of any genuine leftist commitment on her part, the conflation of her on-screen and off-screen personas shaped the trajectory of her life.

The second element of Okada's modern legend is *ren'ai* (love). As I indicated above, Okada was known for twice running away with different men. Moreover, she had a number of affairs, starting with the college student with whom she had a baby at nineteen. Discourses on love in general dramatically increased in the 1920s, especially when Kuriyagawa Hakuson's series of essays on love and marriage appeared in 1922 in *Tokyo asahi*. Kan'no Satomi points out that the number of double suicides, a tragic romantic trope of Edo-period literature, increased with these popular stories during the time, and the attitude toward extramarital love affairs shifted from the disapproval of the Meiji

period to a high level of tolerance.³⁵ Okada was scandalous; however, according to Kan'no, her offense would not have been in having frequent affairs, but rather in her public performance of sexual autonomy.

During her five-year career at Shochiku (1932–1936), Okada appeared in a handful of films, including three by Ozu: *Until We Meet Again* (*Mata au hi made,* 1932), *Woman of Tokyo,* and *An Inn in Tokyo* (*Tokyo no yado,* 1935). Other filmmakers such as Shimizu Hiroshi and Shimazu Yasujiro cast her in such memorable films as *Crying Woman in Spring* (*Nakinureta haru no on'na yo,* 1933) and *My Neighbor, Miss Yae,* respectively. On-screen, she typically played dispirited, financially insecure, even doomed women; the noticeable gap, or counterpoint, between these roles and her off-screen image encouraged the audience to read other meanings into her performances. Her roles included a prostitute who goes back on the street after her boyfriend is drafted (*Until We Meet Again*); a woman whose brother commits suicide when he finds out that she is secretly working as a barmaid (*Woman of Tokyo*); a single mother, jobless and raising a young daughter who becomes ill, forcing the mother to work

Woman of Tokyo (dir. Ozu Yasujiro, 1933). Ryoichi (Egawa Ureo) slaps Chikako (Okada Yoshiko).

Woman of Tokyo (dir. Ozu Yasujiro, 1933). Chikako (Okada Yoshiko) reels from Ryoichi's (Egawa Ureo) slap.

as a sake house waitress (*An Inn in Tokyo*); a bar madam, neglecting her own daughter and seducing a young miner (*Crying Woman in Spring*); and a divorcée seducing a college student (*My Neighbor, Miss Yae*). The fact that these unglamorous figures were often surrounded by younger, debutante starlets made them seem older, even chastened, as if Okada's modernity had been safely bred out of her. The age issue in her 1930s films would have been heightened by the fact that she began her career as a rising young star at Nikkatsu in the 1920s, with no on-screen transition period leading to her now older presence at Shochiku. Audiences were faced with two radically distinct extremes of her persona, and they reacted to this gap in some fascinating ways. For instance, at a roundtable talk held after the screening of *An Inn in Tokyo*, critics and intellectuals, despite a favorable assessment of the film, focused their negative comments on Okada, as in the statement, "Okada is too beautiful and clean for taking the doomed role." Ozu's response to the criticism was, "She would not have liked it if I had made her dirty."[36] How do we interpret this gap? Is it reading too much into the film to see the casting of Okada in this series of Shochiku films as a castigation of her modern girl persona?

The images of Okada's body in these films form a discourse that supports such a reading. Okada's body in *Woman of Tokyo* carries the imprints of a sadomasochistic cycle of desire and its suppression. We see this in the film's invocation of the viewer's sadistic response toward the chastised modern girl figure and masochistic attraction to the foreign body, as explained above in the case of Tanizaki's novel. The film's punishment of Okada reflects Linda Williams's analysis of "gratuitous excess" in pornography, horror, and melodrama.[37] In *Woman of Tokyo,* there is a significant scene in which Chikako's brother slaps her (Okada) after discovering her secret night job. Her body bends wildly backward, and the huge sway makes the audience realize that the action is "real." This action surpasses the literal narrative meaning—the wrathful brother taking sanctions against his disgraced sister—calling attention to the real violence against the actress Okada Yoshiko's body.[38] However,

Woman of Tokyo (dir. Ozu Yasujiro, 1933). A close-up of Chikako (Okada Yoshiko) after she has been slapped.

the jolt of sensation caused by the sequence is a slightly different phenomenon from the patterns of pornography, horror, and melodrama that Williams presents as "film bodies."[39] In the case of Ozu's film, the presumed audience cannot be easily identified using Williams' patterns of sadistic men (for pornography) or masochistic women (for melodrama); rather, the film's sensation, its "gratuitous excess" of the "scandalous" actress Okada being assaulted by a man, provokes from the audience multiple identifications based on gender, nationality, and attitude to modernity. The modernity embodied by Okada in these films becomes a focal point for hailing the multiplicity of one's identity. The film's spectacle of Okada as both a modern star (with its conflicted attraction to the West) and a subjugated woman (with its reassertion of both traditional and national identities) entwines these aspects in the sadomasochistic cycle of the audience's attraction to the modern, Westernized star persona and in its simultaneous pleasure at witnessing her assault. Of course the interpretations of these texts are not limited to what has been described here; nonetheless, surely the sadomasochistic image will be seen differently depending on whether or not one is familiar with the star discourse of Okada Yoshiko.

The Modern Girl as the Consumer Subject

In terms of audience identification, the modern girl also engendered a modern subject explicitly linked with commodity fetishism in the transformation of capitalism. It is revealing to briefly contrast here Ozu's marginalization of the modern girl figure with Gosho Heinosuke's thorough embrace of it, with playfulness and measured autonomy, in the film *A Burden of Life*.[40] While both directors intertextualize the audience's modern cinephile sophistication, with Ozu citing Lubitsch and Gosho referencing Frank Capra's *It Happened One Night* (United States, 1934), Gosho more directly addresses the modern girl's role as a modern consumer subject in Tanaka Kinuyo's imitation of Claudette Colbert. Gosho's light touch allows the figure a degree of autonomy while simultaneously disarming her threatening aspects and linking her to the prevailing middle-class consumer culture of the 1920s. Briefly summarized, the film depicts a family with three daughters and a young son and the parents' financial sacrifices in getting the daughters married. The young son, who is still in primary school, represents a further burden to the already aging parents; hence, the film's title refers to their situation.

A film critic of the period, Otsuka Kyoichi, noted the ambivalent treatment of class in *A Burden of Life*. On the level of the characters' repeated utterances, the film is ostensibly about the middle class; on the level of filmic

image, however, it shows a family of much higher social class.[41] The gap reflects not simply the middle-class uncertainty of the period, but also the filmmaker's awareness of that audience's interest in commodity culture and urban life. The film exemplifies the manner in which people had come to materialize their identity within the new consumer culture, supplying images of what these middle-class characters eat (*udon* noodles, eel over rice), drink (whisky, beer), wear (a tight skirt with a deep slit, a jacket with a fur collar), and how they spend leisure time (in department stores and beauty salons). Meanwhile, the film directly relates the viewer's identification with the middle-class consumer subject to identification with a female subject by assigning these acts of consumption to the young daughters. In other words, the film transposes the audience's identification with middle-class subjects in general to, more specifically, female consumer subjects.

A Burden of Life evinces Shochiku's trademark representation of modern girl and other female figures while simultaneously locating the father and son relationship as the central narrative structure, depicting the male relationship's deterioration and its recovery. The film fuses two parallel stories of separation, a men's story and a women's story.[42] The story of male bonding leads the film's central narrative, whereas the story based on the relationship between the mother and her daughters presents the mundane actions and gestures of their daily lives. The typical order of narrative and visual formation, in which man is the viewing subject and woman a viewed object, is effectively subverted. In visual terms the disruption occurs in the women's story scenes, in which the women are always positioned from a female character's point of view. At the narrative level, the women's exchanges do not contribute to the central story arc of father and son; in Teresa de Lauretis' terms, the women's story functions "to render a presence in the feeling of a gesture, to convey the sense of an experience that is subjective yet socially coded (and therefore recognizable)."[43] In terms applicable to the "women's story" of *A Burden of Life,* de Lauretis indicates that the women's story in feminist film "*addresses its spectator as a woman,* regardless of the gender of the viewers."[44] While *A Burden of Life* is not strictly a feminist film, the narratives of male bonding depicted between father and son and the father and his colleagues are decentered by the narrative of daily exchange that characterizes the women's scenes. The final sequence resolves the contestation of narratives by depicting the women returning home, where the father and son are waiting.

A subversive woman figure or modern girl serves as a further, albeit temporary, displacement of the male-centric story between father and son. In a scene presented as a comic aside, the modern girl (played by Tanaka Kinuyo) enacts the Japanese desire toward Western culture in her stylish fur coat and

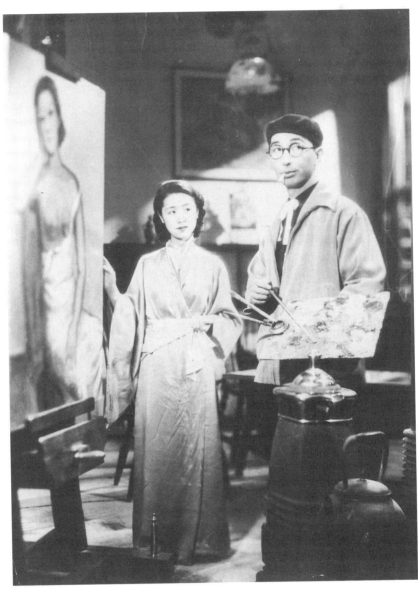

A Burden of Life (dir. Gosho Heinosuke, 1935). The husband (Kobayashi Tokuji) and his wife Itsuko (Tanaka Kinuyo) stand beside his painting of her. Courtesy of Kawakita Memorial Film Institute.

silk dress and in her provocative hailing of a taxi, recalling Claudette Colbert in *It Happened One Night*. This vulgar image of the overtly Westernized figure offers an excessive, negative portrayal of the embrace of Western culture that serves as a critique while also freeing the other female figures of the film to represent a more subtle—and subversive—potential for identification as consumer subjects with modern commodities. The ambiguous image of the modern girl becomes a site for elaborating the conflicting nature of Japanese modernity in the 1920s and 1930s. The following analysis of *A Burden of Life* demonstrates how the film constructs modern identity in the form of a Westernized Japanese woman.

In its first sequence, *A Burden of Life* highlights Tanaka Kinuyo's "to-be-looked-at-ness" through the camera's gaze at her partially nude body in real and painted forms. In this regard, the film's adaptation of classical Hollywood cinema closely replicates the patriarchal visual regimen as elaborated by Laura Mulvey.[45] Tanaka's image first appears on the screen as an object of aural and visual desire in the form of a nude portrait. The audience hears the private conversation between husband and wife in his studio and views her painted naked body on canvas. The audience's gaze then aligns with that of the brother-

A Burden of Life (dir. Gosho Heinosuke, 1935). The painting of Itsuko (Tanaka Kinuyo) in the empty shot.

A Burden of Life (dir. Gosho Heinosuke, 1935). Itsuko (Tanaka Kinuyo), who is modeling in the nude, reacts to her brother-in-law's intrusion.

in-law as the film presents her seminude body accompanied by her screaming at his unexpected entrance. The sequence represents a literal depiction of the placement of the modern girl within patriarchal discourse, her simultaneous appearance as image and object. In this sense, the film imitates the gendered Hollywood spectatorial system, the politics of seeing and being seen. Yet on another level, the use of the modern girl as portrait offers a version of visual materiality apart from the overtly patriarchal control of gaze and object; the interplay of visual fields of reference surrounding the modern girl as portrait represents a simulated mastery of the modern viewing register.

Jonathan Crary's analysis of Edouard Manet and the emergence of a modern viewing subject proves useful here in elaborating the film's interplay of gazes, both foreground and background, in which it "struggle[s] to channel the modern viewer's potential for both attention and distraction."[46] Crary detects new bodily responses in problems of attention and distraction in modern life, finding in the later work of Manet the beginning of an unstable attentive subject and the dissolution of anchored vision leading to our present-day "dynamic disorder inherent in attentiveness."[47] In similar terms, Gosho's film presents a series of visual shifts in attention, on both the levels of diegesis and

spectatorial identifications, offering a visible enactment of its mastery of the modern disordered viewing field.

In the first sequence, the painting of a modern girl is presented with Tanaka's voiceover, creating a momentary gap between the detached voice and the aphasic facial expression of her portrait. This gap fixes the spectator's amused attention onto the painted image, but with the subsequent appearance of an actual woman's body and Tanaka herself shouting, the film distracts the attention of the spectator so that the painting is no longer at the center but rather relegated to the background as one of the diverse objects in the scene. The film draws the viewer's attention to a painted image and then causes distraction by luring the gaze from one object to another in the strata of filmic space.

In a later sequence, while Tanaka visits her parents' home, her seminude painted image is left near the husband and brother-in-law as they drink and complain about their wives. Arranged as part of the backdrop, the painting seems to act as silent witness to their conversation, with the wife's "empty" face directing the spectator's attention toward a comic identification with the

A Burden of Life (dir. Gosho Heinosuke, 1935). The husband (Kobayashi Tokuji) is having a drink with his brother-in-law (offscreen), and his painting of Itsuko seems to be observing them.

A Burden of Life (dir. Gosho Heinosuke, 1935). The husband (Kobayashi Tokuji) and his brother-in-law (Oyama Kenji). The husband's discomfort at the portrait of Itsuko "overseeing" them leads him to move it to the foreground.

apparent sentience of the inanimate image. Finally, the painting distracts the husband, who feels as if his wife is listening to their insulting remarks, and he relocates the painting so that it is in the foreground of the shot, unseen by them but facing the camera and the audience's gaze. Here the image of the modern girl is displaced from a central attentive position to a peripheral one, a centrifugal visual movement within the patriarchal dictates of the narrative space. At the same time, the movement places the image forward within the spectator's field of attention, increasing the role of the image's commentary on the scene. With this sequence, the film shows its mastery of the dynamic shifts of modern viewing; the film displays the unstable subject at the center of such spectacles of disorder, in which the objects of vision may be located and displaced from one moment to the next. This shift of attention transforms the distinction between foreground and background, often merging one into the other. The film exhibits the naturalized play of the modern viewing subject in the distraction inherent in the attentive gaze.

On both levels of materiality, as nude model and as portrait, the modern girl figure gives visible form to Japanese anxiety over modernization. By

materializing the figure, the film circumscribes and manages the inherent fear of the displacement of Japanese identity in the embrace of Westernization. In terms of both narrative and image, the film contains the desire for control over the threat that the figure represents. In the narrative, we witness the containment of female subjectivity within patriarchal discourse; likewise in visual terms, the figure is depicted as materially contained within the filmic mastery of modern viewing. This threat becomes less central in the film's sophisticated management of modern viewing and the cinema's "Western" gaze.

The subtle deployment of the modern girl in popular culture exhibits the complex interplay of modernity and national identity operating at all levels of Japanese cinema. We should recall here how the unspecified nature of Japanese film genres, such as the woman's film, allows for a mix of elements, referential signs, and intertextual play of Western cinematic protocols, providing the viewer with a reassuring sense of modern sophistication and national identity. The semblance of mastery evident in such mocking assimilations is a characteristic of Japanese cinema itself.

The Modern Girl as Sign of the Autonomous Subject

As in *Woman of Tokyo*, *A Burden of Life*'s portrayal of the dichotomy between the modern girl and the traditional Japanese woman appropriates aspects of the modern girl's consumer identity in the construction of a more naturalized, modern, yet supposedly traditional Japanese woman. Many of the woman's films offer a subtle play within the strict terms of the dichotomy's separation, either decentering or deconstructing the relationship between modernity and the tradition for which these women stand. The films' excessive displays of the modern girl's vulgar autonomy often allow for more subtle female identifications to occur on the periphery, away from the attention drawn by the modern girl. In *A Burden of Life*, the woman figures seem at first to fit within the typical roles that serve to uphold tradition: while *ryosai kenbo* (a good wife and wise mother) symbolizes respectability and waitresses and geishas symbolize deviancy, all these categories typically reinforce the patriarchal system.[48] However, the film depicts a wife who alternately argues and runs away from her husband and a geisha who, rather than offering comfort to her elder patron, derides him as an old man. The modern girl figure is equally ambiguous, assimilating elements of respectability and deviance, increasing the possibility that the female audience will identify with the transfigurative new women in the film. The modern girl first appears as a bourgeois consumer through her lifestyle in a European house with a Western interior and her Westernized appearance in a silk robe and fur muffler, and yet she also gains respectability by being married

and having a baby. This character, who is first developed as a good wife and wise mother, also acts as a dark counterpart to the respectable figures by henpecking her husband and leaving her baby at home when going out to have fun.

Such play, by upending the distinction between modernity and tradition, works to construct a modern Japanese female subjectivity. For instance, in the first successful Japanese talkie film, *The Neighbor's Wife and Mine*, one finds a subtle reconstruction of tradition through the naturalized and also nationalized form of a Japanese woman's adaptation to modernity. This film ends with a long outdoor sequence of the playwright and his wife walking together with their children, and, as is typical, it erases the modern girl, their neighbor's wife, completely from the filmic space. We see, however, that the wife's image has changed in comparison to her first appearance in the film; she is now depicted in activities outside the home, and her traditional Japanese hairstyle has been remodeled to a modern one. While the change appears trivial, contained within the familial sphere and thus less threatening than the change the modern figure represents, it nonetheless allows for a significant identification with a Japanese woman figure who is becoming modernized. As this example illustrates, modernity is often merged with tradition in the cinema's construction of female identity.

On the level of the screenplay, *A Burden of Life* inscribes the manipulation of the modern girl image from a simple visual object to a modern consumer subject. The film in its present version has several differences from both the original screenplay and the completed prewar version.[49] One of the original scripted scenes goes as follows: Tanaka's husband and his brother-in-law are having a conversation over the husband's increasing disinterest at seeing his wife's naked body as a model and her insistence that he continue to hire her so that she can afford new clothes. This sequence offers her image as a modern consumer subject rather than simply a viewed object. She herself chooses the conversion from wife to model, constructing herself as both commodified object and active subject. Indeed, the sequence offers a metaphor for the address of the woman's film to its female spectator as consumer. The woman's film regulates female subjectivity within consumerism on at least two levels of its address to women: as spectators and by the presentation of women onscreen. As Mary Ann Doane writes, "the cinematic image for the woman is both shop window and mirror, the one simply a means of access to the other. The mirror/window takes on then the aspect of a trap whereby her subjectivity becomes synonymous with her objectification."[50]

Even when the films seem most subversive, when they offer women a fantasy of power over male social hierarchy through deception, the fantasy is relegated to the world of objects. The threatening image of the modern girl is

always marginalized through its excess materiality, its trivial preoccupation with luxury goods. We observe this pattern in the tradition within Shochiku woman's films of depicting *gyakute,* "the arts of feminine guile."[51] In *A Burden of Life,* the sequence in which the modern wife, Itsuko, and her sister discuss how to trick a man features an image of Itsuko that is directed in two ways. First, as a threatening sexual Other, she exemplifies guile in her mercenary attitude toward men. At the same time, her image on the screen—her facial expressions (sticking out her lips like a sulking child) and her obsession with objects (new clothes, cosmetics, dining out)—presents her as a rather powerless, childish figure.

This characterization of women can be explained by Rey Chow's analysis of third-world modernity in *Primitive Passions.*[52] Chow argues that cultural production becomes "modern" precisely by exploiting as primitive the marginalized social classes—typically women and children. In this case, the modern girl's childish material fixation and her assimilation with a Western Other trivializes her semblance of sexual autonomy, as well as, by association, Western modernity, thereby elevating the patriarchal force of the film. The woman's film offers a space for women to imagine themselves as active subjects through the lure of object commodification, but once they enter the realm of objects, they are trapped within it. The sequence in which Itsuko lectures her sister on how to use guile can be read as offering the possibility of a resisting agency in the patriarchal hierarchy for the sister and also for the female spectator. In the film, however, the goal of using deception is to buy new clothes—in other words, to become a better consumer. The film deploys a structure that offers hope of empowerment to the women it attracts, but the object of that agency as displayed in the film patronizes the women—they can gain only new clothes in the end. The film attracts the female audience's identification but ultimately does not offer them more than they already have.

In exploring the place of the woman's film in vernacular modernism, I have focused on the popular trope of the modern girl, how it was constructed and for whom it was constructed, in conjunction with the specific Japanese social context, a national space. While I do not intend to diminish the role of ideological forces in constructing these images as a mutually reinforcing discourse of Japanese modernity and nationalism, the fact that the woman's film addressed the spectator as female is very important nonetheless. The woman's film as a genre emerged within a hierarchy of genres, establishing, at least on the imaginary level, a space in film for the female subject. Thus the Japanese woman's film of this period can be described as the acquisition of a female subject in the public sphere of cinema as a social technology.

One needs to reiterate the basic circumstances of how the social politics

of genre and its attendant female subject occurred in Japanese cinema—the historical difference that marks the Japanese cinema from its Western counterparts. Mary Ann Doane views the central conflict within Hollywood cinema as existing between the masculine mode of its spectatorial regime and the feminized narrative mechanisms adapted from the nineteenth-century novel. Therefore she views the 1940s Hollywood woman's film as a containment strategy against "the historical threat of a potential feminization of the spectatorial position."[53] Locating the Japanese female subject, on the other hand, requires an elaboration of some of the key hegemonic aspects of the narrative tradition. In modern Japan, there is no similar tradition of the feminization of reading. The introduction of the modern novel into the country came via Europe and remained the exclusive province of Japanese male intellectuals until the 1920s, when the "modern reader," including female reading subjects, first appeared in popular culture, alongside the cinema's emerging female audiences.[54] The threat that the Japanese woman's film typically worked to restrain was not a resurgent feminized spectatorial position, but rather the inherently Westernized gaze of the cinematic apparatus itself. Confined to the seemingly trivial domestic landscape of the woman's film, the Japanese cinema's free assimilation of Hollywood-style narrative and aesthetics was safely contained. The depiction of women as modern consumer subjects in these films merges female subjectivity with the West, containing both women and the fear of unsettling Western influences within a circumscribed, regulated form. Ironically, the most seemingly apolitical of genres concealed and yet displayed the insurgent values embedded in the Hollywood modes in a Japanese response to globalized filmic aesthetics and Westernization.

The pronouncements of such canonical Japanese film historians as Tanaka Jun'ichiro and Komatsu Hiroshi about the apparent lack of an overt political ideology in Shochiku woman's films continue to fix the films within the same patriarchal discourse that rendered them apparently safe and trivial in the interwar period.[55] Yet the preceding filmic and historical analysis demonstrates the inherently political nature of the woman's film in its construction of female subjectivity within the continuous flux of Japanese modernity and nationalism. The role of the modern girl figure in *Woman of Tokyo* and *A Burden of Life* exemplifies how the Japanese woman's film constructed an imagined female subjectivity as a visible reenactment of Japanese anxiety over the interior transformative aspects of modernity.

The Japanese Modern
in Film Style

The very notion of "modern" in Japan signifies a particular series of transformations that distinguish its meaning from the Western sense. When I use the term "modern" in a Japanese context, I am referring to the concept of "modern" as Masao Miyoshi explicates: the term itself in the discourses of Japanese history and society signifies neither modernism, modernity, nor modernization as those are defined in the West so that "the signifier 'modern' [the word itself without the meaning] . . . should be regarded as a regional term peculiar to the West."[1] What then is particular to the Japanese modern?

In concert with Miyoshi's notion, the film scholar Iwamoto Kenji offers the fundamental characteristic of the Japanese modern in the 1920s and 1930s cinema: "What is modernism in Japanese cinema? . . . Though of course the significance of each word, *kindaishugi* [modernism] and *modanizumu* [modernism], is different from the other, the former contains both positive and negative connotations created by European rationalism . . . ; on the other hand, the latter is about images of lightness, frivolity, cheerfulness, and the new."[2] Iwamoto's statement indicates that the Western concept of modernism had by the 1920s already been split into multiple terms or new meanings in the Japanese lexicon. While the focus of this book is largely on *modanizumu*, the predominant expression of modernity in Japanese cinema, my overriding interest is in how popular cinema engaged with the bifurcated terms of Japanese modernity.

Tracing the conceptual history of the Japanese modern, one can recognize this bifurcation in the divide among participants at the notorious Conference on Overcoming Modernity (Kindai no Chokoku) in 1942. Facing the crisis of the beginning of the Pacific War, intellectuals met to discuss Japan's level

of modernity in contrast with the West. Echoing the Meiji state's ties to the European political, judicial, and educational systems, most of the conference participants were engaged with the European influence in largely conceptual terms, while only the film critic Tsumura Hideo argued for the need to address the widespread insurgency of Americanization in popular culture, especially cinema. In other words, consumer capitalism and Americanization were viewed with disdain or, at best, ambivalence by most of the Japanese intellectuals in their attempts to buttress national identity. The interwar Japanese film industry placed itself at the forefront of negotiations with the American presence through its imports and distribution of Hollywood films and also by producing its own films with images of the modern influenced by Hollywood films. The cinema was thus uniquely engaged with the formation of *modanizumu* in Japanese culture.

Iwamoto attempts to show how *modanizumu* as a popular aesthetic, rather than the conceptual term *kindaishugi*, was inserted into the 1920s and 1930s cinema, especially as the trademark modern idiosyncrasy of Shochiku Kamata films. He further emphasizes the connection between the Japanese cinema and *modanizumu*, the modern's performative image empty of content. It is this latter aspect of Japanese modern that concerns our discussion in this chapter on film's embodiment of the image of modern culture. How did the Japanese cinema of this period reconcile the pervasive Westernization in the structures of consumer capitalism and the construction of the Japanese modern that occurred in an era of intense nationalism?

There is general recognition in Japanese cinema studies of the need to specify the Japanese modern in historical terms. For instance, in "Reconsidering Modernism," Scott Nygren argues that Western traditions, specifically realism and humanism, were key influences in the development of what he terms "Japanese modernism."[3] He writes: "The most familiar example of *paradoxical* modernism in Japanese film is Yasujiro Ozu, whose films are simultaneously considered to be traditional in a Japanese context but treasured as modernist in the West."[4] Yet further consideration of the historical and cultural contexts of Ozu's modernism tells us there is nothing "paradoxical" here. First, Ozu was considered a modernist in Japan as one of the representative Shochiku directors in the late 1920s and 1930s. His early films, such as *Days of Youth* (*Wakaki hi*, 1929) and *I Flunked, But . . .* (*Rakudai wa shitakeredo*, 1930), dealt comically with university students as contemporary subjects, demonstrating Ozu's mastery of Hollywood gag rhythms. The notion of Ozu being traditional occurred only in the postwar discourses in comparison with new, politically overt directors such as Oshima Nagisa, Imamura Shohei, and

Yoshida Yoshishige.[5] Second, the gap to which Nygren points—that of Ozu being traditional in a Japanese context and modernist in a Western one—can be easily attributed to the different values of the comparative norms in each case, Ozu's Japanese contemporaries in the 1950s and classical Hollywood cinema respectively. To be fair, it should be noted that in his more recent work, *Time Frames,* Nygren brings more complexity to the inversion of traditional and modern appellations regarding Ozu in different cultural contexts.[6]

Kamata Style

David Bordwell's exhaustive work on Ozu ascribes the technical and narrational refinements of Ozu's filmmaking style to his singular creative talents without acknowledging the fact that many of the same stylistic elements are shown in equal measure in the works of other Kamata filmmakers, such as Shimazu Yasujiro. Whether Bordwell is praising the realism, intimacy, or (as cited below) temporal arrangements of Ozu's films, there is no indication of these as shared influences among the Kamata filmmakers. Within the discourse of Ozu's exceptionalism, Bordwell writes: "This [temporal] concentration is all the more remarkable in that normal filmmaking practice of his period had frequent recourse to long time periods for the unfolding action."[7] Such limited focus on internationally established auteurs is endemic to studies of national cinema generally. The overwhelming sense is that Japanese cinema itself has not been extensively researched and that many films have simply not been seen. In what follows, I elaborate on Shochiku's Kamata style and its role as a conduit for the discourses of the Japanese modern. My main focus is on the director Shimazu Yasujiro, whose oeuvre remains largely unresearched in spite of the fact that he was one of the founding contributors to the style. While film style has frequently been linked to the singularity of the auteur, as in Bordwell's treatment of Ozu, it is less often viewed in the historical context of industrial practices, the promotion of style by a studio to distinguish its production from that of other studios and Hollywood. This approach to style can account as well for the historical materiality of film, the broad range of cultural texts enveloped by the cinema and in which the audiences at that time were steeped.

Around 1915 the pure film movement emerged with Kaeriyama Norimasa's declaration that film should be an art form distinct from theater, and theatrical conventions such as female impersonators were gradually expunged from the cinema. With the technological transformation from silent to sound film in the early 1930s, the vernacular storytelling tradition of the commen-

tator was also eliminated from the industry. From the 1920s on, the film industry openly embraced Americanization in the appropriation of Hollywood technology and industrial structure—the studio production model with its star system and mode of distribution. Shochiku's Kamata studios in particular mastered the nuances of Hollywood's vision of modern life in the optimism of its hard-luck protagonists, the happy ending, and a thoroughly film-trained stable of actors. Shochiku emerged with the film industry's stability as a fully functional capitalist enterprise. The film journal *Nihon eiga* (Japanese Cinema) of the late 1930s described Shochiku's Kamata studios as marking the second period of Japanese film history after its infancy: "From the business viewpoint, it was a period when the film industry became systematized as a capitalist business entity, and from the viewpoint of film as art, studios consciously developed their own styles." [8]

In general, "Kamata style" refers to a style of filmmaking that flourished at the Shochiku film studios in the Kamata suburb of Tokyo between 1920 and 1936. [9] As studio head, Kido Shiro quickly commercialized Shochiku's hallmark style and masterminded its intense marketing through the popular media, such as the film picture magazine *Kamata*. The company employed graduates from the best universities as screenwriters and art directors in its efforts to create a "Kamata flavor" (*Kamata-cho*) in screenplays, set designs, posters, and movie theater programs. Shochiku made deft use of the mass media by adapting recent novels that had been serialized in newspapers into screenplays and even encouraged its own writers to publish stories first as ready-made vehicles for subsequent film adaptations. [10] Although Kido is often credited with the initial conception of Kamata-style films, his effort toward a continuous reiteration of the style is only one element in the defining characteristics of a historical Kamata style. The style represents less the achievements of a single director or producer than the industrial production of modern mass culture.

My Neighbor, Miss Yae

Shimazu Yasujiro's *My Neighbor, Miss Yae* uses both the visual image and concept of the Japanese modern in opposition to earlier cultural formations such as theatrical style, acting techniques, and feudalistic ethos. The film is about two Japanese middle-class families living next door to each other in a suburb of Tokyo. By setting two salaried men's houses in the forefront, the film depicts their everyday lives, using an episodic chain of mundane family events rather than the cause-effect climax that is characteristic of classic Hollywood narrative. The leading character, Yae-chan, is a high school student, and

she has a married sister, Kyoko, who has recently returned home because of her impending divorce. The cast of characters includes Keitaro, a college student, and his junior high school brother, Seiji, who is always playing baseball. At the end of the film, Yae-chan's parents must move to Korea, so she starts living in Keitaro's house until she graduates from high school. The film contrasts the younger sister, Yae-chan, as a modern character with the elder sister, Kyoko, as a symbolic figure from the antiquated *shinpa* theater. The narrative builds on this latter figure as problematic and archaic, only to resolve the family's difficulties with her subsequent erasure from the film.[11] In effect, the film "primitivizes" the elder sister in the contrasts with Yae-chan, Keitaro, and Seiji through her old-fashioned theatrical elocution, her pessimistic contribution to the narrative discourse, and finally her ejection from the narrative.[12] The film inscribes Kyoko as a cipher of *shinpa* theatrical style in order to establish, by way of contrast, the sense of cheerfulness—*modanizumu*—in the other characters, on whom it ultimately centers. The film develops the images

My Neighbor, Miss Yae (dir. Shimazu Yasujiro, 1934). Keitaro (Obinata Den), left, and Yae (Aizome Yumeko). Courtesy of Kawakita Memorial Film Institute.

My Neighbor, Miss Yae (dir. Shimazu Yasujiro, 1934). Keitaro (Obinata Den) and Yae's sister Kyoko (Okada Yoshiko). Courtesy of Kawakita Memorial Film Institute.

of new modern subjects, for instance, in the female high school students' complex identities and cultural code-switching in their clothes and behavior.[13]

In his work on Japanese film history, Tanaka Jun'ichiro, writing about the *shinpa* films of 1921, comments on the stiff performances of the leading actresses in parallel with the *shinpa* theatrical acting style and in comparison with the period's more advanced foreign films. Tanaka reiterates the long-standing critical discourse in which *shinpa* film is equated with archaic cultural aesthetics.[14] *Shinpa* film served as a common negative marker, the opposite aesthetic of all that the modern cinema was supposed to be. In critical works on the cinema in the 1920s and 1930s, Kamata film style is always presented as modern compared with the earlier *shinpa*-style films.[15] The latter was characterized as the "canned" image of the stage: a fixed camera, no filmic techniques, a melodramatic narrative, wooden performances, and female impersonators. The denigration of the *shinpa* film has persisted until quite recent attempts to recover and reevaluate it.[16] The stasis of *shinpa* film in Japanese

film history can be traced to both the scarcity of surviving examples after the Great Kanto Earthquake and World War II and the poor reputation of the films in the dominant critical discourses of the late 1910s and 1920s.

My Neighbor, Miss Yae consciously juxtaposes the elder sister's image as a *shinpa*-esque figure with the other characters to heighten the film's sense of the modern. The outcome of contrasting Kyoko with the modern figures— Yae-chan in her high school uniform, Keitaro in his college uniform, and Seiji in his baseball uniform—is that the audience starts seeing her as an "alien" and "exotic" character, even though her image as a woman in traditional Japanese clothes (kimono) was more familiar to the audience at the time the film was made in 1934.[17] The audience's alienation from Kyoko is accelerated by Keitaro's rejection of her advances, and finally the film completes the process of the relegation of her image by her unexplained disappearance from the narrative. The audience's lack of sympathy toward her stems not only from her aggressive attempt at seduction, but also from the fact that she is, among all the characters, the only formalized tragic Japanese figure, which is quite distinct from the Westernized associations of the other characters' frivolity. For the audiences at that time, Kyoko could be seen simultaneously as one of them and as estranged. The audience would perceive Kyoko's backwardness on the diegetic level (in comparison with the other characters), while her kimono-clad figure would be quite attractive for its familiar, consoling aesthetic. Spectators would have to internalize the difference beyond the level of aesthetics, and on the level of a conceptual acknowledgment of the modern, they could feel themselves elevated above Kyoko for their own grasp of the modern. The film naturalizes formal aspects of modernity while it disavows aspects that are linked to individuality and autonomy in Kyoko's expression of her desires and her preoccupation with her own happiness above the cohesion of the social order, family, and women's roles. This is demonstrated in one scene in particular when, as Kyoko complains of her frustrations to Keitaro, he gazes at the newly washed socks hanging to dry and hears again (as a flashback) his own joking admonition of Yae-chan that women should be subservient to their husbands. The scene in effect makes the Japanese modern seem compatible with older, authoritarian feudal values. The film's depiction of formal *modanizumu* in the characters such as Keitaro is used in the service of the nation-state's patriarchal values, while it expunges the threat to the social order of *kindaishugi* as represented by Kyoko's female autonomy and individualism. Both meanings of the Japanese modern, *kindaishugi* and *modanizumu*, conceptual and aesthetic respectively, are depicted here as distinct from a Western sense of modernism.

Modern Subjectivity

In contrast with Kyoko's link to an ostensibly theatrical aesthetic, the film's modern characters are shown as thoroughly cinematic subjects in the spatial and temporal flow of the camera's eye on frenetic urban life. Many of the Kamata-style films emphasize movement in outdoor locations, whether it is passing landscapes seen through the window of a bus or college students running on a track.[18] In *My Neighbor, Miss Yae* as well, there are scenes of passing scenery, which indicate both a moving subject and its viewpoint. Yae-chan, Keitaro, Seiji, and Kyoko go to a movie theater in the Ginza district on a Sunday evening. After seeing a film, they travel by car to a coffee shop and later to a restaurant. The scenery from the car window presents the audience with views of storefronts, displays of various merchandise, and pedestrians in the Ginza shopping area. Such scenes mirror the epistemological experience of modernity; the audience's experience simulates the act of window-shopping.[19] The characters gaze at the commodities, but they cannot fix on the same goods for any length of time; the present is always lost as the horizontally moving images disappear into the dark, off-screen. The film viewing experience itself becomes blurred, merging with that of the gaze through the window of the moving car. The characters' experience of the scenery indicates that a "new" urban subjectivity has been formed, and the film renders the subjectivity as the audience's own.

There is an ancestral link between the movements of human beings in the landscapes of the Kamata-style films and the earlier use of landscape description in Japanese modern literature of the late nineteenth century to indicate a particular point of view—subjectivity in Karatani Kojin's sense.[20] Embedded within the filmic practice are the visual dynamics of individual perspective and a focal point that constitutes an implicit viewing subject. From its foundation in Japanese literature, as Karatani has explained, the particular viewpoint, the new subjectivity, became part of mass culture over a thirty-year period. The Kamata-style films depict the dissemination of the point of view, an imagined "modern" subject, through the rise of the mass media. Karatani describes this discovery of landscape in Japanese literature as the seminal moment of a modern subjectivity: "We cannot describe the Japanese discovery of 'landscape' as a process that unfolded in a linear pattern from past to present. 'Time' has been refracted and turned upside down. A person who sees landscapes as natural will not perceive this reversal."[21] The transposition of this subjectivity from Japanese literature to Kamata style is also substantiated by the fact that Shochiku actively encouraged its film-

makers to adapt novels and short stories of authors such as Kawabata Yasunari, one of whose short essays was turned into the road film *Mr. Thank You.*

The Japanese Modern and High Culture

As seen within the context of the film industry itself, the acquisition of modern subjectivity was only one consequence of the film industry's adaptation of modern literary concerns. The cinema suffered from its low status in popular conceptions as an industry of "theft," producing a cheap imitation of Western culture, and from its deeper inferiority as a low form of modern culture, lacking in Japanese cultural traditions.[22] Shochiku's use of high culture in the form of *junbungaku* (high literature), mainly in the 1930s, was an attempt to traverse the modernist boundaries between high and low culture.

As the Japanese film historian Peter B. High points out, in 1934 the governmental Film Control Committee (Eiga Tosei Iinkai) was formed in order to oversee films and their distribution, and the film industry organized the Greater Japan Film Association (Dai Nippon Eiga Kyokai) to cooperate with the state committee. High writes: "The idea for the Association, it was reported, had actually come from the industry's leading intellectual, Kido Shiro. . . . Kido was filled with concern about the destructive internecine warfare within his industry and its nagging sense of inferiority to the other spheres of cultural productivity."[23] This reciprocity can certainly be interpreted as a government attempt to coopt film media for the purposes of propaganda, yet Kido himself tried to use the opportunity to elevate the industry's position within Japanese cultural production. The intriguing point is that Kido equated the film studios' partnership with the government with a modernization of the film industry, most likely with the belief that it would erase the "inferiority" of the cinema.

This "inferiority" is not simply due to the dichotomy of an advanced Hollywood and a backward Japanese cinema, as it has often been described. It is as well a condition of the domestic convergence of modernism and class conflict. In the study of Japanese cinema and its audience, there is a long-standing tendency to see them as a unified whole, reflecting the general tendency to see the Japanese as a cohesive, monolithic group. However, Kido's efforts in the interwar period indicate that the cinema as an emerging form of mass culture was the site of a struggle over class-based aesthetic hierarchies. For the Japanese cinema, the impetus to become modernized derives not only from Japanese desires to be like the West, but also from the desires of filmmakers to

establish their own social status inside Japan. The succession of literary adaptations in the Kamata-style films can be interpreted as the filmmakers' desire to assimilate themselves with the "high" art of literature. The film industry's attempts at linking a vision of modernity to the "high" art realm point to the significant difference of the Japanese modern, particularly regarding its sense of modernism in art and culture. In contrast to the Euro-American sense of modernism, with its challenge to bourgeois "high culture," the Japanese modern embraced the culture instead.

Bifurcation of the West and the Symbiotic Japanese Modern

The compulsive desire of Japanese filmmakers to elevate their own social status is also manifested in the bifurcated view of interwar film critics toward the "West." Within the dynamics of Self and Other, Japanese film critics sought recognition of themselves in their divergent views of American and European cultures. American film culture was copied, studied, and yet simultaneously disparaged and disavowed, while the critics tried to position themselves within European aesthetic traditions. Marking the beginning of film criticism as a formal discipline, many film critics of the period were university graduates with a knowledge of European languages, such as Iijima Tadashi with French, Iwasaki Akira with Russian, and Murayama Tomoyoshi with German. Their affiliation with European languages and cultures paralleled the earlier association of leading Japanese literary figures, artists, and intellectuals with German philosophy, French art, and British theater and literature beginning in the Meiji Restoration. The film critic Imamura Taihei praised the film journal *Nihon eiga* (Japanese Film) in 1939 for its "unique function of bringing writers and intellectuals into closer contact with the film world, while at the same time introducing general readers to critical perspectives on the medium they had never before suspected of existing." [24] Much later, Peter B. High also reported that the journal published articles not only about Japanese cinema, but also many academic essays on Western films—for instance, an analysis on the aesthetics of Nazi filmmakers Karl Ritter and Veit Harlan. However, classical Hollywood films were often criticized for their commercial aspect as mass culture, the product of "the country which emancipates Jews and worships dollars." [25] The bifurcated Japanese view toward the West did not simply begin with the upsurge of militarism and nationalism following Japan's alliance with Germany and Italy but can be found throughout the interwar period.

The bifurcation of the West can also be seen in *My Neighbor, Miss Yae*, especially in its way of connoting meaning through various filmic aspects—

character, dress, space, and language—and its depiction of "the constructed culture" of the Japanese modern.²⁶ The Japanese partiality toward European culture undercuts the assumption in film studies of the simple equation between the Japanese modern and Americanization. In the film, Keitaro is constantly gazed upon by the camera as the desired object of the protagonist Yae-chan. Keitaro has an elite status as a law student at Tokyo Imperial University; culturally fluent, he reads books written in German. The mise-en-scène in his study bears a European influence: a wooden floor, plastered walls, and Western-style furniture. The audience would more than likely view the space in Keitaro's room as European rather than American due to the film's use of a chic, refined décor. Japanese audiences by this time were equipped to tell the difference, from certain cinematic cues, and were versed in the aesthetic preconceptions of America as bold, frivolous, and nouveau riche and Europe as representative of traditional good taste. Needless to say, however, many of these preconceptions were often reinforced by imported filmic images but not first-hand "reality."

The bifurcation is depicted in the aspect of language as well; Yae-chan and Keitaro often make jokes using baseball's English lexicon. Other English words are frequently used between Keitaro and Seiji while they play catch. Even Yae-chan's mother makes a pun from her confusion of the phonetically similar English word "runner" and the Japanese *dan'na* (master). The casting of the ordinary-looking Iida Choko as the mother further emphasized how widely American popular culture had spread, along with various English expressions, in Japanese culture at that time.

The film constructs a hierarchy with the bifurcation of the West. On the one hand, it reveals the prevalence of English and even uses borrowed words as a source of gags; on the other hand, it uses German as a privileged language to signify Keitaro's refinement. Moreover, the film parallels the "European" Keitaro with the younger brother, Seiji, who is linked more closely with American baseball culture, through the side plot of Yae-chan being attracted to Keitaro and, in contrast, being annoyed by Seiji's childish friendliness. The film forefronts the girl's preference of Keitaro over Seiji—that is, Europe over America. However, overall the elevation and reification of the desired Europe/European modern are shown in contrast to the aforementioned more thorough assimilation of American popular culture at various levels: fashion, everyday language, and recreation. This assimilation in effect undercuts the Japanese imagined destiny of inclusion within the old school of the European Enlightenment and its high culture, exposing it as superficial and forced.

By deploying different spaces, the film also partializes a Japanese notion of modernity in spatial terms and represents a symbiosis of the different mo-

dernities. At the very beginning, the film introduces the two houses in which Keitaro's and Yae-chan's families live. Although the houses resemble small American townhouses in their facades, they have definite features of Japanese architecture in their side elevations. Keitaro's "European" room is contained within the Japanese space of his house. The film develops its narrative within this compound spatial arrangement and mitigates the sense of incompatibility. This is also reified through the body of Keitaro; the sequences in which Keitaro and Seiji play catch always focus on Keitaro, whose body synthesizes the three spaces into one: the authoritative elder brother (Europe) playing baseball (America) in his relaxed Sunday kimono in the vacant space (Japan).

National Identity and Shochiku Kamata Cinema

The sense of the modern expressed in the Kamata films has always been viewed as representing the surface play of *modanizumu,* its lack of political content with an emphasis on everyday domestic life. Yet there is never a total separation of cinema from the social and political realms. Perhaps the most profound omission in Japanese cinema studies discourses is the near complete absence of a political contextualization of the cinema. The cinema's formal and narrative uniqueness has often been attributed to the cultural particularity of the Japanese, and this type of approach has often treated Japanese films ahistorically. The Kamata-style films presented a national identity by adapting the forms of ordinary domestic life and conciliated the audience with nationalism and militarism, especially in the 1930s. Indeed, much as Etienne Balibar finds the politics of national identity masked in the "naturalized" customs and language of a community, Shochiku's films made their politics invisible in the narrative of everyday life.[27] While it should come as no surprise that the films served explicit national imperatives in wartime periods, the nostalgic postwar viewpoint toward the films continuously erases their political content and reveals the present's ideological investment in narrating the past.

My Neighbor, Miss Yae takes the form of a typical family melodrama, and the separation of family members in the film prefigures the actual disintegration of the family during the height of Japan's Fifteen Years' War. The film was created in the backdrop of the Manchurian Incident, when Japan's identity vis-à-vis the Western powers was rapidly changing. While the film is suited to the genre of middle-class films, it also works as preparation for the Japanese people's passive subordination to state nationalism. The narrative of Yae-chan's parents' transfer to Korea naturalizes Japan's ongoing policy of colonization and the dislocation of families during the Fifteen Years' War.

The relocation of the family occurs without any discussion among its members or neighbors about the fact that they are going to Japan's colony, where they would face unfamiliar and possibly hazardous conditions. Shimazu's last Shochiku film, *A Brother and His Younger Sister* (*Ani to sono imoto*, 1939), carried further the propagandistic function of constructing the family as the first unit of the nation's defense. After a conflict with his colleagues, the salaried man protagonist moves to Manchuria with his wife and sister. Dislocation again occurs without disagreement or even the simple question of why the family's destination has to be a colony of Japan.

Producer Kido Shiro was aware of the fact that while domestic dramas tended to be seen as apolitical, they could contribute to a national cohesiveness linked to the war effort. Kido touted the films' political attributes in statements on studio policy: "We will rechristen the popular films *[taishu eiga]* as films for our nation *[kokumin no eiga]*," and "we will not make romance films since this is not appropriate to the current state of affairs," and even further, "the Shochiku film company supports the invasion in China and will start making films there."²⁸ Indeed later Kido produced propaganda films such as *Suchow Night* (*Soshu no yoru*, dir. Nomura Hiromasa, 1942), which is still a romance, albeit one between a Chinese nurse and a Japanese doctor in Shanghai, and *Sayon's Bell* (*Sayon no kane*, dir. Shimizu Hiroshi, 1943), in which the title character is a native Taiwanese woman. Shochiku collaborated with the Manchurian Film Association (Manshu Eiga Kyokai) in order to produce these films and deployed the association's star, Li Xiang-lan (a.k.a. Shirley Yamaguchi or Yamaguchi Yoshiko), a bilingual singer/actress in Japanese and Chinese. While these propaganda films presented the Japanese occupiers as well-intentioned toward the occupied Chinese, they continued Shochiku's emphasis on female characters and romance themes. Moreover, Shochiku's propaganda films and its few war films, such as *A Little Aerial Navigator* (*Shonen koku-hei*, dir. Sasaki Yasushi, 1936) did not do well commercially, especially compared to Toho's and Nikkatsu's war films, such as *The War at Sea from Hawaii to Malay* (*Hawai Marei oki kaisen*, dir. Yamamoto Kajiro, 1942) and *Mud and Soldiers* (*Tsuchi to heitai*, dir. Tasaka Tomotaka, 1939) respectively. As a result of Kido's wartime efforts, the General Headquarters of the postwar U.S. occupation ousted him from his position as producer from 1947 to 1950. Yet Shochiku's support of national imperatives was more effectively pursued through domestic dramas in ways that were less explicitly tied to the state but supportive of a national collective nonetheless. Recall that in the Japanese view of a bifurcated West, Americanism was predominant in Japanese popular culture. Shochiku's films further partialized that influence by embodying it within the material experience of the Japanese cinema itself.

The most recognized aspect of the Kamata-style films is their intertextualization of images of domestic life as signifiers of nostalgia and nation. The Ginza sequence of *My Neighbor, Miss Yae* brings the characters through a panorama of Japanese urban modern life, the simultaneity of cultures and spaces that are already partialized within a Japanese matrix of experience. In the sequence the four main characters go out for a night on the town. It begins with a detailed approximation of a movie-going experience, from buying tickets to finding seats and sharing snacks. The film intertextualizes Dave Fleischer's Betty Boop cartoon *Ha! Ha! Ha!* (United States, 1934) and subordinates it to the main narrative as a setup for the ensuing gag of the four characters' different reactions to the cartoon. The Hollywood cartoon elicits explosive laughter from the audience within the film, and its mass appeal simultaneously serves the goal of light entertainment, which is characteristic of the Kamata-style films themselves. *My Neighbor, Miss Yae* uses the cartoon to create a scene with multiple levels of comedy as a gag ensues over Yae-chan being unable to enjoy the cartoon because of her frustration at being seated apart from Keitaro. Attempting to get Keitaro's attention, Yae-chan passes a piece of gum to him, which ends up with Seiji. The intertextuality between the real and imagined audience and the cartoon within the film mirrors the idiosyncratic *hogarakasa* (lightness) of the Kamata-style films as they tried to incorporate the cheerful qualities of Hollywood. In constructing comedy, the Kamata-style films showcased the optimism that had come to be associated with Hollywood, reconfigured within the trademark Shochiku form of the understated gag, which emphasizes the intimacy of ordinary domestic life.[29]

Shochiku, in the meanwhile, targeted its audience with its middle-class genre films in order to distinguish its films from classical Hollywood cinema. The Betty Boop cartoon in *My Neighbor, Miss Yae* is followed by the viewing-through-the-car-window-scene, after which the characters go into a coffee shop. There is another scene in a moving car, leading to the scene in a Japanese-style restaurant. The night on the town sequence ends with a coda of domestic tranquility as the scene segues from the dinner gathering to a close-up shot of a tempura pot, in which Keitaro's father is cooking fish at home. Coming at the end of a long series of modern excursions, which represent a dispersed identity, the shot of Japanese food has the effect of reasserting a national identity through the domestic image.

Many critics have generally characterized the Kamata-style films as imitations of classical Hollywood cinema; however, the process through which these films were constructed and the contexts in which they were seen are more complex than the often-stated themes of Japanese assimilation or adaptation would allow. In addition to the influence of Hollywood cinema, Japa-

nese cinema developed amid a confluence of social, economic, and political transformations. Social upheaval, such as the destruction of Tokyo and the city's major film studios by the 1923 Kanto Earthquake, gave rise to several movements that sought to renovate or reform Japanese cinema. Responding to these conditions, directors such as Shimazu Yasujiro turned to *katei-geki* (a genre closely equivalent to family melodrama, and later the genre was renamed *shoshimin eiga,* the middle-class film), which did not require elaborate sets, and this economical film style became the prototype of the Kamata-style films. Although we cannot ignore the influence of Hollywood, these examples illustrate that the classical Hollywood cinema could not completely determine the development of the Kamata-style films.

In a consideration of Japanese cinema as a national cinema, the question is also raised as to whether a Japanese national cinema could develop completely separate from Hollywood cinema. One might argue that there has not been a pure Japanese cinema since the first import of Western filmic technology and materials into Japan. Moreover, the presumption itself of a "pure" national cinema is against the social conditions of modernity—the exchange of capital, people, and cultures—in which cinema as a cultural medium was invented from the beginning. The term "Kamata style," and for that matter "classical Japanese cinema," needs to be understood as simultaneously containing the particular as well as the universal. As Eric Cazdyn notes, "Film may well be contingent on modernization, and modernization may well have happened in the West first, but modernization is part of a world structure that seems infinitely more productive to understand as having no firsts, only dependencies."[30] Furthermore, the imperative aspect of the analysis of Japanese cinema is how we interpret its dependencies. In "Writing a Pure Cinema: Articulations of Early Japanese Film," Aaron Gerow attributes a sense of "shame" in Japanese cinema to such dependencies while deploying Slavoj Žižek's idea of the "theft of enjoyment": "The issue of 'Japanese' film begins about the same time with the recognition of shame. . . . Such guilt was doubled with misgivings over the necessity to mimic and borrow, to duplicate and steal the style of foreign films in order to create one's national cinema. . . . In a reverse, Japanese film was made the source of shame that necessitated the transgression of stealing enjoyment and a mode of film style from the Other."[31]

The feeling of "guilt" or "shame" among Japanese filmmakers, however, does not exist in *My Neighbor, Miss Yae.* The insertion of the Betty Boop cartoon, for instance, in its up-front and honest presentation becomes an ironic commentary on the fact that Japanese cinema has borrowed from Hollywood rather than a moment of shame. By the mid-1930s the issue of "shame" over Japanese cinema's borrowings had been reframed within the context of recon-

struction after the devastation of the 1923 earthquake, which offered an alibi for the subsequent social transformations and disavowals of tradition. The film critic Sato Tadao writes: "On September 1, 1923, the earthquake in the Kanto area destroyed many areas of the Tokyo capital. Although the earthquake was a natural disaster, its effect was to spur the transformation of culture by destroying many of the social structures, manners, and customs in the capital. The earthquake was the monumental incident to punctuate the modern history of Japan, especially mass cultural history. Traditional Japanese culture retreated and new culture came forward." [32]

In contrast to the aforementioned pure films of the 1910s, the Kamata-style films of the late 1920s onward show that Western modern influences were by that time safely inscribed and contained within the familiarity of domestic life. The Kamata-style films mitigate the sense of "shame" since Western influences were shown to be partialized and domesticated within Japanese mass culture. Hence, the Kamata-style filmmakers such as Shimazu could afford to be generous in openly acknowledging their debt to Hollywood, as evinced in the Betty Boop cartoon's "tip of the hat" to Hollywood in *My Neighbor, Miss Yae.*

The popularity of the Kamata-style films and their tendency to rouse nostalgia in Japanese audience across many periods and generations also attests to the films' mitigation of "shame." Japanese audiences, many of whom have no authentic memories of the period, continuously invent the nostalgia of Kamata style. In this regard, the style's transformation of values within the reinvented form sustains the notion of nationalism in its depictions of the charms of ordinary Japanese domestic life; the intimate tone of the Kamata-style films continues in Shochiku's Tora-san film series, for instance. Ozu's films are the best known examples for their overt absence of shame; his postwar films in particular emphasize a consoling aesthetic with the elevation of Japanese life and culture. The aesthetic later caused conflicts with new filmmakers such as Yoshida Yoshishige, who criticized Ozu's films of the 1960s as lacking the weight of reality in their young characters. What seemed to be wrong in Ozu's films for Yoshida was not only the outdatedness of the characters, but also the films' lack of concern with the areas outside of Japan—namely, the West—and a denial of the Japanese desire to be recognized by the Other—in other words, the "sense of shame." Yoshida's series of art films, such as *Eros plus Massacre* (*Erosu purasu gyakusatsu,* 1970), may be seen in this regard as a counterpart to Ozu's films, bringing back a "sense of shame" to his audience.

Still, in the context of wartime militarism Shochiku's domestic dramas aroused ambivalence, even suspicion, among nationalists, precisely for their absence of "shame," their open embrace of hybrid aspects in modern popular

culture, such as Hollywood and Americanization. In 1940, the trademark of Kamata style, the middle-class genre film, was criticized for its overemphasis on individual values, and the intimate scale of the films' domestic narratives was interpreted as lacking a spirit of cooperation in the larger community. Tsumura Hideo writes: "Shimazu Yasujiro's film *A World for Two* [*Futari no sekai*, 1940] has been lambasted by many critics. . . . One of the reasons is that the film is in the middle-class genre. . . . In Japan now, the ethic is that people need to focus their attention on public interests in a discussion without any inhibitions. The protagonist in the film retreats from his career without complaining and just seeks his own satisfaction; that is the nature of the genre."[33] During the period of high militarism, starting in 1937, critics like Tsumura saw in the narratives of Kamata style, with their emphasis on the private lives of average people, the potential for resistance to the dominant ideology of sacrifice and civic responsibility.

The more ambiguous aspects of the Japanese modern presented in the Kamata-style films came under increased pressure during the militarist period to accommodate the needs of the nation-state. Shochiku's move from Kamata to the Ofuna studios in 1936—necessitated by the technical transformation from silent to sound films—parallels a political shift to the restoration of the ultranationalist emperor system and ideology, in which the emperor was seen as the living embodiment of the state and the citizens as his children. Much of the nostalgia that became imbedded in the Kamata-style films can be attributed to this political shift, which fixed the films in the Kamata period as having fewer constraints on individual expression and a less regimented social life. In the year following the production of *My Neighbor, Miss Yae,* the debate on *ten'no kikansetsu* (the theory of the emperor as an organ of the government), in which the emperor's role was fixed as a sovereign power only within a system of constitutional restraints, was silenced with the emergence of ultranationalism under the name of *kokutai no hongi* (the origin of national polity). The *ten'no-sei* (emperor system) lost its tolerance toward other ideologies, ideas, and intellectual disciplines. Although the emperor system had been less restrictive until then—for instance, it permitted the utilitarianism of Fukuzawa Yukichi, the overt display of Westernization in language and fashion (among other areas), and political debates on the merits of democracy and socialism— by 1935 these were no longer acceptable because of the political manifestations of the emperor ideology. Constraints can be seen in both the Ministry of the Army's and the Ministry of Education's official pronouncements asserting the emperor's absolute control. As the Ministry of Education's manual stated, "The unbroken line of Emperors, receiving the Oracle of the Founder of the Nation, reign eternally over the Japanese Emperor. This is our eternal and immutable

kokutai [the national polity]. Thus, founded on this great principle, all the people, united as one great family nation in heart and obeying the Imperial Will, enhance indeed the beautiful views of loyalty and filial piety."[34]

Following these political and social transformations, cinema was forced to change both internally—with the industry's self-censorship—and externally—through state controls—into *kokumin eiga* (films for the nation) and *kokusaku eiga* (national policy cinema), especially after the Manchurian Incident in 1932.[35] Tsumura Hideo defined the former in mythic terms: "The '*kokumin*' of *kokumin eiga* uses a different idea of nation than the Western sense, since the word also has the meaning of *shinmin* (people as vassals to the emperor)."[36] The Film Law, which was put into force in 1939, and other bureaucratic controls that were already in practice directly supported militarism and fascism in Japan. Whether the ideological shifts occurred with Kido's full advocacy or not, Shochiku's films were confined to the official genres of cinema. The national movement's emphasis of the relationship with the emperor appears in the cinema and Shochiku's Ofuna films in the late 1930s and 1940s as the deployment of mass culture, coopted from its capitalist foundations as the quintessential force for solidifying the masses.

Precisely how did Shochiku, as the embodiment of "Japanese modern," negotiate with the repressive forces of the fascist state? As my analysis on *My Neighbor, Miss Yae* suggests, Shochiku deployed a range of strategies to link the modern with national identity, often in a discourse on the cinema itself. The cinema survived as a place for imagining hybrid identities in modern culture by rescripting Hollywood iconography, as in *My Neighbor, Miss Yae's* Betty Boop cartoon or (as discussed in chapter 3) in the merged identities of the star's body: Western/Japanese, male/female, colonizer/colonized in the Valentinoesque postures of Shochiku star Suzuki Denmei. On the level of genre, while the vernacular category of the middle-class film borrowed the image of salaried men from Harold Lloyd's and Buster Keaton's comedies, Shochiku turned such films into family melodramas depicting the ironies of modern urban life and disillusionment with the modernization of society.

Shochiku deployed a nostalgic sense of space in order to present the encounter between the modern and a mythic, nativized past. In ways that were again intrinsic to the cinema, the movement of the camera and the subject's gaze through landscape offered the aforementioned comfort of a modern subjectivity as well as the attraction toward the recovery of a past, more "original" Japanese identity. As I elaborated in chapter 1, the films with "hometown space" placed the urban filmgoer's gaze in a simulated excursion through a backward yet "authentic" locale, recovering in nostalgic terms a mythic sense of identity in the image of the hometown. There is evidence as well that films

of the later period may have followed a similar strategy of retreat, as demonstrated in the novels of the 1940s, such as Kawabata Yasunari's *Snow Country* (*Yukiguni*) and Nagai Kafu's *A Strange Tale from East of the River* (*Bokutokidan*), both of which located their narratives outside of political realities and in isolated, ahistorical settings. One can see a similar disconnection in later Shochiku films such as Shimizu Hiroshi's *Masseurs and Woman* (*Anma to on'na,* 1938), which, as a road film to nowhere in an unspecified period, performs a narrative sleight-of-hand that reveals little of larger societal concerns. What the film offers, without allegory or symbols, is a leisure travel destination, quite literally set in the retreat of an unnamed mountain valley resort, seemingly "contemporary" and yet devoid of newspapers or any communications with the outside. It is as if the remoteness of the film space from the viewers' everyday reality would have allowed them a place to restore themselves and dream, safe inside the theater.

These examples raise questions about why both critics and audiences, in both the period of the Kamata films' production and in the postwar, have preferred to see the films as alternately woman's films or Hollywood-influenced melodramas, with largely middle-class, apolitical subjects that are somehow separated from the state's war effort. Obviously there is the larger context of postwar Japan's investment in erasing its complicity with the military state, but this is not the only answer. The postwar nostalgia surrounding the Kamata films is evidence of a cultural politics of self-nativizing. In times of social crisis nostalgia safely separates the past from the present and at the same time functions as a link to a longed-for imagined community. In the postwar gaze of Japanese audiences, Shochiku's home drama genre became the meta-home drama in the sense of André Bazin's analysis of the meta-Western of the 1950s, a reflective genre that speaks its own myth. As Slavoj Žižek explains the role of nostalgia, the nostalgic fascination for this type of cinema is in the certain gaze of "a mythic spectator who was still able to identify" with the film's universe. The nostalgia surrounding these films is for this naïve Other from the past, the "one still able to believe in this universe in place of us."[37] To at least this degree, the postwar spectators' nostalgic distance and sense of loss supplanted the propagandistic function of these films.

Conclusion

Through my analyses on five aspects of the Japanese cinema in the 1920s and 1930s—Tokyo urban space, the middle-class film genre, modern sports, the woman's film, and Kamata style—I have shown how Japanese cinema expressed a distinct vision of modernity. My hypothesis is that modern Japanese subjectivity was reified by the Japanese themselves through popular culture, especially the cinema. In *Overcome by Modernity,* H. D. Harootunian similarly sees the popular cinema as the site for an imagined vision of modernity and as a path for the Japanese "to grasp the new everyday life in its textured materiality." "Film was not just a sign of capitalism," he writes, but "it also put on display commodity culture produced by American capitalism, lived and experienced by its principal subjects, modern men and women."[1] Based on that hypothesis, I have sought to explicate how the interwar Japanese society, which had thoroughly absorbed Westernization in its cultural values, technology, and thought, could so readily conform to nationalist, invented traditions of identity and community. Language and ethnicity have often been used to analyze this process, such as the reading of intellectual discourses and literary works, but my interest is how the cinematic image worked to constitute what and who is Japanese. Instead of relying on only authoritative sources, academic or political public discourses, I read filmmakers' works and popular films as the cultural "translation" of ordinary people's desires, needs, and hopes.

In this reading, I selected two sites, the city of Tokyo and the Shochiku Kamata film studios, which formed a relationship of shared spatial cognition. Tokyo symbolically and materially figured as the capital of Japanese modernity, and the Shochiku Kamata Studio's prolific output of films consciously emulated Hollywood filmmaking modes to express a vision of modern Japanese life. For

me this selection was determined by the historical convergence of these sites; the Kamata studio stood alone in Tokyo after the unprecedented destruction of the city in 1923, a ready vehicle for the new imaginary of urban life.

Cinema literally "embodied" Japanese modernity to its spectators, beckoning them to identify themselves as "modern subjects," both Westernized enough and sharing a perfect national sentiment as Japanese through the moviegoing experience. Yet on the eve of World War II, that modern identity was in crisis, as Japanese intellectuals, disillusioned with the course of Western modernity that had led Europe to turmoil, sought a new course by which Japan could transcend Eurocentric historicism and finally "overcome" modernity. They viewed with disdain the sort of subject identification that cinema encouraged—such as the modern girl or salaried man, modern figures that were actualized through material consumption—as shallow masquerades of Americanism, a politically unviable source for forming a "genuine" modern identity. Amid the uncertainty over modern subjectivity and pressures of wartime anti-American ideology, what shape did Japanese modernity take? While I have elsewhere suggested that areas of cinema, such as woman's films, continued to allow a space for exploring identity apart from official wartime control, the discourse of film criticism is relevant here since it contains a history of engagement with the high and low aspects of culture, specifically the cinema's Americanization of Japan's culture. In my closing discussion of film criticism, I note how film critic Tsumura Hideo had to walk a cautious line in merely acknowledging the distinctly American influences in popular culture amid a climate of heightened nationalism. Tsumura's transformation from prewar liberal journalist writing on the power of American popular film to wartime ultranationalist to postwar self-reinvented aesthete of Hollywood cinema offers a parable for the trajectory of Japanese modernity itself.

My analyses on cinema constitute *a* history but not *the* history of Japanese modernity; I have largely dealt with a formation of Japanese modernity from the bottom up, the flux of expectations and longings in everyday life. As Iwamoto Kenji notes, the subject of Japanese modernity is historically bifurcated in terms of this stream of popular culture and the official authoritative discourse, often state-directed or top-down, and it is also shaped by particular contestations in history, such as, on the one hand, European historicism of the modern nation-state and, on the other, nascent Americanism in such manifestations as Fordism and a belief in fluid class identity.[2] This bifurcated modernity has continually transformed itself under these global influences.

Japanese modernity had various historical bases, such as global "Western" imperialism and modern capitalism, and it had no easy way out of the influence of historicism.[3] The Japanese began to experience uneven changes

from the late nineteenth century on, and they often equated modernization with "Westernization" (*seiyoka*), which stood as a blanket concept for ambiguous, but at the same time ubiquitous, changes. This aspect of modernity is not a single nation's phenomenon but the historical premise for all non-"Western" nations in the modern era. In other words, this equivalence is nothing but the outcome of the modernization process, in which the "West" has been both a subject, a region superior to other areas of the world, and an object that has been continuously constituted discursively.

This ambiguous and fluctuating "West" can be seen in the historical record of foreign film distribution in the 1910s in Japan. Film historian Komatsu Hiroshi asserts that there were frequent changes in the popularity of different foreign cinemas in Japan during the period of the film magazine *Kinema recodo*. The popularity of French film was already established by 1910, and *Kinema recodo* started dealing with an increasing number of Italian films in 1910–1914. German films became popular from 1913 on. American films were reviewed sporadically from the magazine's inception and only became dominant in 1916 because of the European film industry's decline following World War I.[4] Describing the situation of foreign films before 1915, Komatsu writes: "As for Pathe Co.'s films, they were disseminated throughout the world as French films, but the Japanese audience did not even see them as simply French [rather Western film (*yoga*) served as a criterion for everything]."[5]

Film criticism in the interwar period is particularly revealing in this regard. Historicism gradually shifted from centering on Europe to America after World War I, and Japanese film critics witnessed that transformation firsthand, saturating themselves with not only European but also nascent American culture. The early Japanese film critics were steeped in the cultural practices of the European Enlightenment, especially the English, French, German, and Russian languages. For instance, the editors of the film magazine *Kinema junpo,* itself founded by a coterie of college students, usually delegated the coverage of different cinemas based on a critic's language ability, and there was often a power struggle among different language specialists, such as German versus French.[6] At the same time, film critics were in a unique position to first apprehend the growing insurgent presence of American popular culture via Hollywood cinema.

Well aware of the power of the cinema, film critics were less dismissive of Americanism as a rising cultural force in the interwar period. However, their understanding of the power of Hollywood and American capitalism was gradually contained by the reinforcement of wartime national sentiment against the United States at the beginning of the 1940s. In the case of Tsumura Hideo, his discursive logic often reveals the contestation in Japanese modernity be-

tween the influence of popular culture and state-driven national ideology—in other words, between the competing narratives of history from the bottom or from the top. Many of the late 1930s film critics began to employ a discourse of cultural exceptionalism, asserting a version of Japanese cinema as unique and distinct from Western cinemas in its ties to traditional culture. Tsumura Hideo is considered representative of the more strident nationalistic tendencies of critics in that period.[7] Indeed, two of his books published during the war, *Film Policy Theory* (*Eiga seisaku-ron*, 1943) and *Film War* (*Eiga-sen*, 1944), were quite open about the ideological use of film as propaganda for the war effort. In *Film War,* Tsumura made a case for film as an opportunity for Japanese global expansion against Western strategies of containment: "Japan must take the lead in creating a cooperative sphere with Manchuria and China on the level of film."[8]

In 1942, the journal *Literary Society* (*Bungaku-kai*) invited thirteen intellectuals for a two-day symposium, entitled Kindai no Chokoku (Overcoming Modernity), on how Japanese might transcend Western modernity and what they viewed as the ill effects of over half a century of trying to emulate the West. Tsumura was the only film critic to participate in the symposium; all but one of the remaining participants, in contrast, were from established academic circles. The thirteen discussants were representatives of mainly three groups: the Kyoto philosophy group, the Japan Romantic School literary group, and the Literary Society (central members writing for the journal). Obviously Tsumura was not affiliated with any of these groups, nor was the classical music composer Moroi Saburo; their presence represented a token effort of the organizers at broadening the discussion to the realm of popular culture. According to Suzuki Shigetaka, a participating historian, there were three primary elements of Western modernity that the participants wanted to discuss and overcome: democracy, capitalism, and liberalism.

H. D. Harootunian points out that many of the later critical writings on the symposium have tended to emphasize the affiliations of the participants and have discarded the symposium discussions as trite. He argues against such reductions and instead insists on analyzing both the discussions and the manuscripts submitted by the participants beforehand. While there is much to recommend in his approach of textual analysis, I would argue in part with his emphasis on the centrality of Americanism—that is, the complete acknowledgement that he finds among the participants of the shift from European historicism to America after World War I. Parallel to this, Harootunian places Tsumura as a central spokesman for the dangers of American global dominance, spread through Hollywood films. Harootunian sees that Tsumura, because of his role as a film critic, had a firm grasp of Americanism's significant

influence on both the Japanese culture and economy. Tsumura seems to have understood that what was at stake was not a purely conceptual matter but that a new material reality had profoundly impacted Japanese life and society. In his chapter on the Overcoming Modernity event, Harootunian sees Tsumura as a pivotal figure at the symposium, "one of the most vocal participants," who "shared with most the conviction that the problem Japan and Europe faced was America and its principal export 'Americanism.' " [9]

However, after reading the *Literary Society*'s own record of the symposium, one realizes how marginalized Tsumura really was as the sole representative of "low" culture among intellectuals who were highly immersed in European Enlightenment traditions. The community of the symposium exhibits the historicist tendencies constructed largely from notions of these traditions. Indeed the high and low cultural structure of the symposium presents a picture of how thoroughly Japanese intellectuals had internalized Western historicism and its cultural hierarchy. For instance, in the record of the first day of discussions, one can find only minor comments from Tsumura responding to Moroi Saburo's observations on Western classical music in Japan. Tsumura's main contribution, in the section titled "Americanism and Modernism," occurred on the second day, yet it is only one out of twelve sections of the whole two-day symposium. While other critics offered rhetorical agreement with Tsumura's description of the problematic of Americanism with the example of Hollywood's prevalence, they were dismissive of the consequences of technological advancements such as film for Japanese "spiritual culture" (*seishin bunka*). The literary critic Hayashi Fusao strikes a patronizing tone toward film by saying that "as even in Japan the film audiences are described as uneducated and tasteless people (*michan hachan*), film is a leisure activity for the stupid masses in the world. American democracy has the power to grab the heart of only these idiots." [10] Tsumura's pragmatic conclusion that we cannot avoid the technological civilization that America represents and that, instead, Japan should master technology for Japan's own ends was also derided by the organizer and literary critic Kawakami Tetsutaro: "In my opinion, technological civilization is not even an object for us to overcome. The object that spirit must overcome is not technological civilization. For the spirit, technology is not even an issue." [11]

As such examples indicate, the Overcoming Modernity participants never fully grasped the challenge that Tsumura presented to them: the problem posed by the fluidity of Americanism and its infiltrating power of capital, materialism, and mass culture. The old affiliations and dichotomy of Europe versus America, high versus low cultures, were reasserted instead, and even Tsumura could not argue for the value of film in itself. One sees a forced

retreat in Tsumura's reply to Hayashi's criticism of film, as Tsumura shifts to a European model of cultured citizenry: "Film is not simply for a stupid audience. . . . Think about newsreels and documentaries; these films have a proven role in educating Japanese citizens. . . . The Germans have been doing this quite effectively, . . . and the Russians used it for mobilizing national movements."[12] Like the other participants, Tsumura himself seems trapped in the historicist pattern of European state-centered ideology.

Moreover, one question by Suzuki highlights the general uncertainty of the group toward America and its position within Western modernity: "Is Americanism also a representative form of modernism, or is it standing in a totally different arena from modernism?"[13] Japanese critics had a considerable investment in maintaining the boundaries between American and Japanese culture and in strengthening their connection to the "high" cultures of the European Enlightenment. The Meiji state's adaptation of European bureaucracy, institutions, and practices made the connection with Europe official and strengthened the Japanese identification with the traditional, refined culture of the European states. Japanese intellectuals' dismissals of America simultaneously reaffirmed their connection to the older cultures of Europe and disavowed any tendencies they shared with the ubiquitous, highly adaptable, and insurgent culture of America.

This formation of modernity can be seen as Japan participating in European imperialism, as Dipesh Chakrabarty indicates: "This equating of a certain version of Europe with 'modernity' is not the work of Europeans alone; third-world nationalisms, as modernizing ideologies par excellence, have been equal partners in the process."[14] In other words, the Japanese tended to view changes in their society as the result of Western influences in the period, rather than as the outcome of developments within their own culture. For all the talk of overcoming that Western modernity with notions of the intrinsic Japanese spirit, the participants at the meeting merely reinforced the view of a lack of Japanese subjecthood at the center of their modern culture.

In contrast, the Japanese films that I analyzed in the chapters above evince the creation of a modern Japanese sensibility that does not simply follow either European or American cultural models. As such, the films offer a record of the Japanese subject fully engaged in negotiations with different cultures. How do we read the gap between Japanese modernity as presented in the intellectual discourse and in the films as popular culture? The contested nature of Japanese modernity reveals the oscillation between the Japanese as accomplices of the "West" and as cultural subjects of their own. A postcolonial reading would see Japan as constructed by "Western" hegemony, while a cultural studies reading would view the local subject as a creator of its own cultural meanings regard-

less of the influences' origins. Taking one of these approaches seems to me too much of an imposition of the scholar's own preoccupations. The complexity of how modern culture was negotiated out of disparate influences has rather been my interest throughout the book.

I find a revealing parallel between Tsumura's coming to terms with Americanism throughout the war and the occupation and Japanese modernity's continual negotiation with the "West." Tsumura transformed himself from a nationalistic propagandist during the war period to a reformed specialist on film aesthetics, which he became in his postwar career.[15] Despite his conspicuous wartime role as a film critic for the top newspaper *Asahi*, Tsumura seems to have escaped the postwar cycle of accusation and ostracism that others in the film industry, such as studio executives Kido Shiro and Mori Iwao, suffered because of their complicity with the military state. Perhaps the notion of shared guilt as articulated by Itami Mansaku offers some explanation for why Tsumura was never delegitimized: "The one who deceives someone is guilty, but so is the one who is deceived."[16] However, the social mechanism of communal guilt expressed here does not account fully for Tsumura's reversal from his anti-Western polemics to the postwar embrace of Hollywood film and its values. His postwar writing shows a marked shift in rhetorical stance, a retreat from his earlier role as an agitating opinion maker to an educator, writing primarily for female enthusiasts and novices. Yet there remains an underlying politics in Tsumura's reconciliation of his new role in relation to an ascending American presence. He writes: "There is a tendency to see that Japan lost the war because of America's affluent material culture, but that is incorrect. The fundamental reason is America's superior spiritual culture. Technological civilization was after all created by spirit. Therefore, from this point of view, I will devote myself to sharing my appreciation of American films."[17] Tsumura finds his purpose in the newfound affinity between America's technological culture and transcendent spiritual values. I find it intriguing that such language recalls the Overcoming Modernity discourse, which also posed the dichotomy between "materialism" and "spirit"; Tsumura's rhetoric dissembles those terms so that both are now ascribed to Americanism or American culture, against which they earlier inveighed. There is a sense of overwhelming emotions beneath the surface in the critic shifting the discourse toward America, its cinema, and his own reinvented self. Through partializing America's presence in the cinema, Tsumura once again secures the role of cultural mediator, controlling the impact of that presence by embodying it in material terms subject to Japanese appreciation and consumption. The nation had become a vassal to the occupier, yet in a real sense America, through its movies, now belonged to Japan as well, reimagined in distinctly familiar terms. Tsumura's case offers an example of the

larger problematic relation between notions of Japanese identity, which constituted Japanese modernity, and an elusive yet ever present "Western" (especially in the postwar, an American) influence. His transformation in the postwar addresses the profound question of how Japanese society was able to accept such changes so readily whether in wartime or in the postwar period.

Such negotiations with the "West" have long been at the center of the construction of Japanese modernity. The contested nature of Japanese modernity, adapting high and low cultures, European historicism and Americanism, has been manipulated by cultural mediators, such as film critics, and the shifts in rhetoric correspond to social changes. In this sense, film critic Iijima Tadashi's description fully expresses the late 1930s Japanese national sentiment on Japanese modernity: "The contemporary Japanese are well equipped for appreciating foreign arts. The high spiritual condition of acceptance toward foreign civilization since the Meiji Restoration has been cultivating the national character, and it remains applicable when one sees a foreign film."[18] Iijima's statement discloses the notion that the Japanese had internalized historicism through their consumption of foreign art, literature, and film. Yet it is necessary for us to recall that historicism itself was not outside of historical transformation. While Japanese films, for instance, have always been seen and judged from this internalized perspective, that gaze has always been a constructed one based on the Japanese "assumption" that "Westerners" must see things this way. This does not mean that Japanese spectators and critics did not have their own point of view; rather it suggests that historicism was on certain levels an imaginary projection of their own desires. The pattern of creating critical ideas on Japanese cinema in consideration with the "West" and its films has been rather indispensable for discussing Japanese cinema, since the Western cinemas established norms for how to see the Japanese film from its inception. The late 1930s was the first period for Japanese film critics to assess their position as mediators, and they later suppressed Japanese cinema's connection with the "West" because of the wartime political situation. However, this was not the only moment for the critics to reconfigure the relationship to the "West." Even post-postwar Japanese film critics since the mid-1950s have conveyed on and off the dominant relationship between Western original and Japanese copy, such as Oshima Nagisa's obscenity dispute, Masumura Yasuzo's individualist assertion, and Sato Tadao's advocated return to Japanese cinema's ties to classical Japanese culture.[19] Although their works cannot always be considered equivalent with contemporary writing now categorized as "postcolonial discourse" since many of the critics lack even the certainty of their own positions as the "colonized" subject, their criticism surely has been created within an ongoing "colonial" formation.

Noël Burch's *To the Distant Observer* can be read as an attempt at emancipating Japanese cinema from this colonial formation. But even his attempt reasserts the "West" as the primary subject in tying his study to "the modern search for a Marxist approach to art," and the whole process of analysis on Japanese cinema is rather narcissistically posed as "a detour through the East."[20] By following Burch's metaphor, one could say that the Japanese film critics take the same detour in the reverse direction—a detour through the "West"—when they discuss Japanese cinema, but the significant difference between the two is that the path for the Japanese has never been simply a detour but the inevitable way to engage with their own cinema, which began after all in the presence of Western films. In this regard, Burch's depiction of the "originality" of Japanese culture can be read differently: "The champions of Japanese culture . . . are quick to counter, but they too invoke the value of originality: the Japanese do not copy, they adapt."[21] Japanese indeed adapted historicism or Americanism under the name of the "West," and yet with this imaginary gaze as their criterion, they created their discourse on the Japanese cinema and, further, on Japanese modernity. The process of making Japanese cinema through either critical writing or the production of films is nonetheless an original act without "originality" in a quantifiable sense. It signifies the accumulation of real and imaginary global cultural influences, and I would argue that the Japanese have embodied Nippon modern in the same way.

Notes

Introduction

1. Donald Kirihara, *Patterns of Time: Mizoguchi and the 1930s* (Madison: University of Wisconsin Press, 1992), David Bordwell, *Ozu and the Poetics of Cinema* (London: BFI Pub.; Princeton: Princeton University Press, 1988). As noted, there are numerous books on Kurosawa. Mitsuhiro Yoshimoto's *Kurosawa: Film Studies and Japanese Cinema* (Durham, N.C.: Duke University Press, 2000) is the most recent book-length work on the director.

2. Tanaka Jun'ichiro describes this period as follows: "From 1923 . . . Japanese cinema entered a period of transition from experimentation to growth, and many skilled filmmakers emerged in the film industry. Before the beginning of sound film, the industry reached the golden age of silent film *[musei eiga no ogonki]* around 1929 or 1930." Tanaka Jun'ichiro, *Nihon eiga hattatsushi* (Japanese Film Development History) (Tokyo: Chuo Koronsha, 1976), 2:12.

3. David Bordwell, Janet Staiger, and Kristin Thompson, *The Classical Hollywood Cinema: Film Style and Mode of Production to 1960* (New York: Columbia University Press, 1985), xiii, xiv.

4. Ibid., xiii.

5. *Mono* (literally, "matter" or "thing") was traditionally used to categorize Kabuki plays, the functional equivalent of "genre" denotation in Japanese—for example, *sewa-mono* (a drama dealing with common people's lives). The cinema later adapted this expression for film genres, such as *yota-mono* (film drama about hooligans), *haha-mono* (film drama about mothers), and *daigakusei-mono* (film drama about college students).

6. The Lubitch film is *If I Had a Million* (United States, 1932), and it was released right before the production of *Woman of Tokyo* in Japan. The expression "mastering the master" is from Bordwell, *Ozu and the Poetics of Cinema*, 241.

7. Masao Miyoshi, *Off Center: Power and Culture Relations between Japan and the*

United States (Cambridge, Mass.: Harvard University Press, 1991), 13–14; Miriam Hansen: "Fallen Women, Rising Stars, New Horizons: Shanghai Silent Film as Vernacular Modernism," *Film Quarterly* 54, no. 1:10–22, and "The Mass Production of the Senses: Classical Cinema as Vernacular Modernism," in *Reinventing Film Studies,* ed. Christine Gledhill and Linda Williams (London: Arnold Publishing, 2000), 332–350.

8. Masao Miyoshi and H. D. Harootunian, "Introduction," in *Postmodernism and Japan,* eds. Masao Miyoshi and H. D. Harootunian (Durham, N.C.: Duke University Press, 1989), vii–xix.

9. Yoshikuni Igarashi, *Bodies of Memory: Narratives of War in Postwar Japanese Culture, 1945–1970* (Princeton: Princeton University Press, 2000), 3.

10. Ibid.

11. The description of the conceptual gap over the Meiji constitution between the Americans and the Japanese is detailed in John W. Dower's *Embracing Defeat: Japan in the Wake of World War II* (New York: W. W. Norton/New Press, 1999), 346–352.

12. Elise K. Tipton and John Clark, "Introduction," in Tipton and Clark, *Being Modern in Japan,* 9.

13. Fukuda Tsuneari, "Kindai no shukumei" (Destiny of Modernity), in *Fukuda Tsuneari zenshu* (Fukuda Tsuneari Collection) (Tokyo: Bungeishunjusha, 1987), 2:431–468.

14. Tsutsui Kiyotada, *Showaki Nihon no kozo* (Social Structure of Showa Japan) (Tokyo: Kodansha, 1996), 102. Translated by the author.

15. Etienne Balibar, "The Nation Form: History and Ideology," in *Race, Nation, Class: Ambiguous Identities,* ed. Etienne Balibar and Immanuel Wallerstein (London: Verso, 1991), 96–97.

16. See Darrell William Davis, *Picturing Japaneseness: Monumental Style, National Identity, Japanese Film* (New York: Columbia University Press, 1996).

17. Balibar, "The Nation Form," 97.

18. Ibid., 100.

Chapter 1: The Creation of Modern Space

1. Scholars such as geographer Doreen Massey have noted the ambiguity of the concept of space. See her "Politics and Space/Time," in Keith and Pile, *Place and the Politics of Identity.*

2. Kristin Thompson and David Bordwell, "Space and Narrative in the Films of Ozu," *Screen* 17, no. 2 (1976): 41–73.

3. Ibid., 41.

4. Bordwell, *Ozu and the Poetics of Cinema,* 73–74.

5. Ibid., 74.

6. Thompson and Bordwell, 46.

7. Bordwell, *Ozu and the Poetics of Cinema,* 104.

8. Ibid., 143.

9. Ibid.

10. Stephen Heath, "Narrative Space," in *Narrative, Apparatus, Ideology,* ed. Philip Rosen (New York: Columbia University Press, 1986), 409.

11. Ibid., 385.

12. Ibid., 409.

13. Bordwell, *Ozu and the Poetics of Cinema,* 106.

14. Ibid., 143.

15. The total number of moviegoers in Japan in 1929 was 192,494,256, and the number of movie theaters was 1,270. The total number of moviegoers in Tokyo in the same year was 36,693,311, and the number of theaters was 208. Iwamoto Kenji and Makino Mamoru, eds., "Eiga nenkan 1930-nen" (Annual Records of Cinema in 1930), in *Eiga nenkan: Showa 5-nenban* (Annual Records of Cinema, 1930) (Tokyo: Nihon Tosho Senta, 1994).

16. Bordwell, *Ozu and the Poetics of Cinema,* 103.

17. Tokyo's mayor in the year of the Kanto Earthquake, Nagata Hidejiro, stated his appreciation for the government's support after the disaster. His political discourse on the revitalization of the capital puts forward the general consensus that the process of spatial modernization serves not only regional interests, but also national interests, and the ideological slogan that Japanese modernization should be accomplished for the nation was prevalent. Nagata Hidejiro, "Teito fukko to shin-Tokyo kensetsu-an" (Capital Reconstruction and the New Tokyo Plan), originally published in *Taiyo* [Sun], October 1, 1923; *Fukkokuban Taisho dai-zasshi* (Reprinted Edition, Taisho Magazine) (Tokyo: Ryudo Shuppan Kabushiki Gaisha, 1978), 306–308.

18. Koshizawa Akira, *Tokyo no toshi keikaku* (Tokyo Urban Plan) (Tokyo: Iwanami Shoten, 1997), 89–90.

19. Sabine Haenni, "Staging Methods, Cinematic Technique, and Spatial Politics," *Cinema Journal* 37, no. 3 (Spring 1998): 84. Haenni argues similarly that "public spheres of production are complemented by spatial representations."

20. Roland Barthes, *Empire of Signs,* trans. Richard Howard (New York: Hill and Wang, 1982), 30.

21. Tominaga Ken'ichi, *Nihon no kindaika to shakai hendo* (Japanese Modernization and Social Transformation) (Tokyo: Kodansha, 1990), 144.

22. Ibid., 164–165.

23. Ibid., 163.

24. Jordan Sand, *House and Home in Modern Japan: Architecture, Domestic Space and Bourgeois Culture 1880–1930* (Cambridge, Mass.: Harvard University Asian Center, 2003), 9.

25. Minami Hiroshi, *Taisho bunka 1905–1927* (Taisho Culture 1905–1927) (Tokyo: Keiso Shobo, 1965), 187.

26. The average income of employees in banking was about twice that of civil servants in 1919, and the numbers of Tokyo Imperial University graduates taking positions in private companies exceeded those joining the government bureaucracy in 1917. Minami, *Taisho bunka,* 194.

27. Yoshimi Shun'ya, *Toshi no doramatsurugi* (Urban Dramaturgy) (Tokyo: Kobundo, 1997), 193–261.

28. The first Japanese department store is Mitsukoshi (founded in 1911), which was transformed from the former Mitsui Apparel Store. With the faddish phrase "Kyo wa Teigeki, ashita wa Mitsukoshi" (Today, the Imperial Theater, tomorrow, Mitsukoshi), department stores established their position as sites of desirable consumption for the urban middle class, mainly women.

29. Anne Friedberg writes on the new social character: "Shopping like other itinerancies of the late nineteenth century—museum- and exhibition-going, package tourism and, of course, the cinema—relied on the visual register and helped to ensure the predominance of the gaze in capitalist society. The department store that, like the arcade before it, 'made use of *flanerie* itself in order to sell goods,' constructed fantasy worlds for itinerant lookers." Anne Friedberg, *Window Shopping: Cinema and the Postmodern* (Berkeley: University of California Press, 1993), 37.

30. Shimokawa Shuji, *Showa Heisei kateishi nenpyo 1926–1995* (Showa and Heisei: A Chronological Table of Living) (Tokyo: Kawade Shobosha, 1997).

31. Narita Ryuichi, *"Kokyo" to iu monogatari: Toshi kukan no rekishi-gaku* (A Story Named "Hometown": A Historiography of Urban Space) (Tokyo: Yoshikawa Kobunkan, 1998), 18–19.

32. Yanagita Kunio, "Tokai shumi no fubi" (The Dominance of Urban Style), in *Showa shonen~10-nen dai: "Shukan asahi" no Showashi* (1925–1944: A History of "Asahi Weekly"), vol. 1 (Tokyo: Asahi Shinbunsha, 1990). This article was published in *Shukan asahi* (Asahi Weekly), February 1, 1930.

33. Mita Munesuke, *Gendai Nihon no shinjo to ronri* (Sentiments and Logic of Contemporary Japan) (Tokyo: Chikuma Shobo, 1971), 199.

34. Kobayashi Hideo originally wrote "Literature of the Lost Home" (Ushinawareta kokyo no bungaku) in May 1933 for the literary magazine *Bungei shunju*. Kobayashi Hideo, *Literature of the Lost Home: Kobayashi Hideo—Literary Criticism, 1924–1939*, ed. and trans. Paul Anderer (Stanford: Stanford University Press, 1995).

35. Naruse directed *Wife! Be like a Rose!* at P.C.L. Film Studios right after he moved from Shochiku. The film was also released in the United States in 1937 under the title *Kimiko*. Despite the warm reception in Japan, it was criticized severely abroad and described as an incomplete imitation of Hollywood film. Frank S. Nugent, "Kimiko," *New York Times,* April 13, 1937, 31.

36. *Izu Dancer* was adapted for film by Gosho Heinosuke in 1933, Nomura Yoshitaro in 1954, Kawazu Yoshiro in 1960, Nishikawa Katsumi in 1963, Onchi Hideo in 1967, and Nishikawa again in 1974.

37. Sato Tadao, *Nihon eiga no kyoshotachi* (The Great Masters of Japanese Film), vol. 1 (Tokyo: Gakuyo Shobo, 1996), 187.

38. Arthur Nolletti Jr., *The Cinema of Gosho Heinosuke: Laughter through Tears* (Bloomington: Indiana University Press, 2005), 55.

39. Ibid., 61.

40. Shinba Akihiko, *Meisaku no eizo o saguru: "Izu no odoriko," Showa 8-nen,*

Gosho Heinosuke sakuhin (Analysis of the Great Film *Izu Dancer* [1933], Gosho Heinosuke's Films) (Shizuoka: Shinba Akihiko, n.d.), 80.

41. Gosho Heinosuke, "Shiawase datta eiga-ka no kikai" (The Fortunate Opportunity of Adaptation), in *Kinema junpo bessatsu: Nihon eiga shinario koten zenshu* (Movie Times Special Edition: Screenplay Collection of Classical Japanese Films) (Tokyo: Kinema Junposha, 1966), 2:168.

42. Gosho is not the only director who intentionally created the nostalgic space of the period. Other studios' directors also used the power of nostalgia—for example, Mizoguchi Kenji in his films *A Song of Hometown* (Furusato no uta, 1925) and *Hometown* (Furusato, 1930), in which he contrasted between city and country. The full title of *Hometown* is *Fujiwara Yoshie's Hometown* (Fujiwara Yoshie no Furusato), and it was produced at the Nikkatsu Kyoto Studios, as was *A Song of Hometown*.

43. Eric Cazdyn, *The Flash of Capital: Film and Geopolitics in Japan* (Durham, N.C.: Duke University Press, 2002), 90.

44. Tanemura Naoki, "Chotokkyu Tsubame-go hasshin suru: Supido appu sakusen no tenkai" (The Super Express Swallow Train Departing: A Plan for Increasing Rail Speed), in *Shogen no Showashi* (History of Showa Testimonies), vol. 1: *Tokyo koshinkyoku no jidai* (Tokyo: Gakushu Kenkyusha, 1983), 166–171.

45. Hashizume Shinya, *"Kindai Nihon no kukan pran'natachi* [Spatial Planners in Modern Japan], vol. 8: *Aburaya Kumahachi,"* *CEL* 47 (November 1998): 113–119.

46. Nikkatsu produced a series of *mukokuseki eiga* (stateless films), such as a migratory bird series starring Kobayashi Akira, beginning with *The Migratory Bird with a Guitar* (Gita o motta wataridori, 1959). Kobayashi appears as a guitar-carrying cowboy, wandering through various places in Japan, fighting for good. His appearance, along with the mismatch between the nonsensical narrative's development and contemporary Japanese society, leads to the genre name.

47. *The Asakusa Crimson Gang* also raises thematic questions concerning a sense of space and Japanese modernity; the story presents Asakusa as the place that symbolizes the essence of Japanese modernity, simultaneously denigrating as superficial the Ginza area that was highly touted as the center of Japanese modernity at that time. Un'no Hiroshi, "Kawabata Yasunari no toshi bukku" (Kawabata Yasunari's Book on the City), *Kokubungaku* 32, no. 15 (1987).

48. Kawamoto Saburo, ed., *Modan toshi bungaku: Hanzai toshi* (Modern Urban Literature: Crime City), vol. 7 (Tokyo: Heibonsha, 1990).

49. Newspapers reported various bizarre crimes in connection to harbors in this period, such as the large-scale smuggling of gold in Osaka via Kobe harbor in 1931 and the discovery of a woman's corpse in a suitcase in 1933. Minami Hiroshi, ed., *Kindai shomin seikatsushi* (A History of Modern Middle-Class Life) (Tokyo: San'ichi Shobo, 1991), 16:478–490.

50. Un'no Hiroshi, *Modan toshi Tokyo: Nihon no 1920 nendai* (Modern City Tokyo: The 1920s in Japan) (Tokyo: Chuokoronsha, 1983), 27–46.

51. Friedberg, 3.

52. Yoshimi Shun'ya, "Shosetsu: Teito Tokyo to modaniti no bunka seiji—1920,

30-nenndai e no shiza" (I-Novel: Cultural Politics of the Megalopolis Tokyo and Modernity—A View to the 1920s and '30s), *Iwamani koza 6: Kindai Nihon no bunkashi—Kakudaisuru modaniti 1920~30-nendai* (Iwanami Lectures 6: A Cultural History of Modern Japan—Extending Modernity in the 1920s and '30s) (Tokyo: Iwanami Shoten, 2002), 21–22.

53. Peter B. High, *The Imperial Screen: Japanese Film Culture in the Fifteen Years' War, 1931–1945* (Madison: University of Wisconsin Press, 2003), 149.

54. Yamamoto Kikuo, *Nihon eiga ni okeru gaikoku eiga no eikyo* (The Influence of Foreign Films on Japanese Cinema) (Tokyo: Waseda Daigaku Shuppanbu, 1983), 436.

55. De Certeau's explanation on the difference between space and place is as follows. While place is "an instantaneous configuration of position," such as the name of a place on a map, and "it implies an indication of stability," space "exists when one takes into consideration vectors of direction, velocities, and time variables." Michel de Certeau, *The Practice of Everyday Life,* trans. Steven Rendall (Berkeley: University of California Press, 1988), 117.

56. Many works of prose and poetry formed these cultural connotations of Yokohama. See, for instance, Kumada Seika's poem "February/July/October" (1918) and Yanagisawa Ken's poem "Kaikei" (1922) in Suzuki Sadami, ed., *Modan toshi bungaku: Toshi no shishu* (Modern Urban Literature: Poetry of the City), vol. 10 (Tokyo: Heibonsha, 1991), and Kitabayashi Toma's story "Nankin-machi no on'na" (A Woman of Chinatown) (1931) in Kawamoto.

57. For further studies on Japanese women working in the "erotic industry," see Miriam Silverberg, "The Cafe Waitress Serving Modern Japan," in Vlastos, *Mirror of Modernity,* 208–225.

Chapter 2: Vernacular Meanings of Genre

1. Alan Williams, "Is a Radical Genre Criticism Possible?" *Quarterly Review of Film Studies* 9, no. 2 (1984): 121–125.

2. Ibid., 124.

3. Joanne Bernardi, *Writing in Light: The Silent Scenario and the Japanese Pure Film Movement* (Detroit: Wayne State University Press, 2001), 38–44. Also see Bernardi's extended article "Genre Distinctions in the Japanese Contemporary Drama Film," in *La nascite dei generi cinematografici* (The Birth of Film Genres), ed. Leonardo Quaresima et al. (Udine: Forum, 1999), 407–421.

4. Meaghan Morris recently articulated another set of difficulties for genre discussion in national cinema due to "a marked imbalance or asymmetry in the disciplinary organization of cinema studies" and explains in the case of Hong Kong action films as follows: "On the one hand, most English-language accounts of 'action cinema' overwhelmingly focus on Hollywood, limiting Hong Kong's influence at best to the 1970s kung fu craze. . . . On the other hand, the many action films made in Hong Kong,

Japan, India, Thailand, Korea, Indonesia or the Philippines tend to be studied, if at all, by specialists in *national* or, sometimes, regional ('Asian') cinema." Meaghan Morris, "Introduction: Hong Kong Connections," in *Hong Kong Connections: Transnational Imagination in Action Cinema,* ed. Meagan Morris, Siu Leung Li, and Stephen Chan Ching-kiu (Durham, N.C., and Hong Kong: Duke University Press and Hong Kong University Press, 2005), 3.

5. Yoshimoto, *Kurosawa,* 209–210.

6. Jim Leach, "North of Pittsburgh: Genre and National Cinema from a Canadian Perspective," in Grant, *Film Genre Reader II,* 474–493.

7. Dolores Tierney, "Silver Silk-Backs and Mexican Melodrama: Salón México and Danzón," *Screen* 38, no. 4 (1997): 360–371.

8. Donald Kirihara, "Reconstructing Japanese Film," in Bordwell and Carroll, *Post-Theory,* 501.

9. Ibid., 506–507. See also Noël Burch's *Life to Those Shadows,* trans. and ed. Ben Brewster (Berkeley: University of California Press, 1990), for his explanation of IMR.

10. Kirihara, "Reconstructing Japanese Film," 509. Kirihara cites this idea from Jan Mukarovsky, "The Aesthetic Norm," in *Structure, Sign, and Function: Selected Essays* by Jan Mukarovsky, trans. and ed. John Burbank and Peter Steiner (New Haven: Yale University Press, 1977), 52.

11. Mitsuhiro Yoshimoto, "Melodrama, Postmodernism, and Japanese Cinema," in Dissanayake, *Melodrama and Asian Cinema,* 104.

12. David Desser, *The Samurai Films of Akira Kurosawa* (Ann Arbor: UMI Research Press, 1983), 21.

13. Yoshimoto, *Kurosawa,* 213.

14. Following Desser's logic of categorization, we might conclude that films such as *Ugetsu* (*Ugetsu Monogatari,* 1953) and *The 47 Ronin* (*Genroku chushingura,* 1941–1942), both by Mizoguchi, belong to the "samurai film" genre since both feature sword-carrying figures and mythologize the past; however, these films have little relation to the action-driven narratives of the "samurai film." Certainly one might question Desser's inclusion of the Zatoichi (the blind swordsman) series as a subgenre of "samurai film," given the fact that Zatoichi is not a samurai but a masseur. More recent revivals of *jidaigeki* collapse the "samurai film" category further, as in the latest version of *Zatoichi* (2003), ostensibly marketed as a Kitano Takeshi film.

15. Keiko I. McDonald, "The *Yakuza* Film: An Introduction," in Nolletti and Desser, *Reframing Japanese Cinema,* 165–192.

16. Ibid., 166.

17. Mark Schilling, *The Yakuza Movie Book: A Guide to Japanese Gangster Films* (Berkeley: Stone Bridge Press, 2003), 40.

18. Cited in Matsui Sakae, "Shoshimin eiga ron" (About the Middle-Class Film Genre), *Kinema junpo* 467 (April 11, 1933): 54.

19. Tsumura Hideo, *Eiga to kansho* (Film and Its Appreciation) (Tokyo: Sogensha, 1941), 51–56.

20. As some of the film criticism on the tendency film in the early 1930s reveals, there was a contentious debate about its progressiveness. By indicating that the tendency film was also a product of the commercial film industries, embraced by capitalism, criticism from the left emphasized the tendency film's regressiveness in comparison with the so-called Prokino films, films made by members of the Japanese Proletarian Union in the same period. Kishi Matsuo, "Sayoku eiga no hattatsu katei" (The Developmental Process of Left-Wing Films) and Nakajima Shin, "Sono jokyo ni tsuite" (About the State of Affairs), both in *Eiga orai*, July 1930: 16–23.

21. Yoshimoto, "Melodrama," 106–107.

22. Hiroshi Komatsu, "The Classical Cinema in Japan," in Nowell-Smith, *The Oxford History of World Cinema*, 416–417.

23. Steve Neale, *Genre* (London: British Film Institute, 1980), 19.

24. Bordwell writes: "Kido recalls that after *Body Beautiful,* Ozu's early films steered a course between Shochiku's humane optimism and the 'tendency film' of social protest; he thus appealed simultaneously to middle-class viewers and left-wing moderates." *Ozu and the Poetics of Cinema,* 174.

25. Mary Ann Doane, "The 'Woman's Film': Possession and Address," in Gledhill, *Home Is Where the Heart Is,* 285.

26. As Tanaka Masumi indicates in his article on *jidaigeki,* the transformation from *kyugeki* (old school film) to *jidaigeki* was not simply a change of labels. *Jidaigeki* appeared as another genre among other previous genres, *kyugeki* and *shingeki* (new school film). Tanaka describes their difference as follows: *kyugeki* had no spoken titles and were performed with a *kowairo benshi* (a speaker who imitates the characters' voices and dubs voices over a film). *Jidaigeki* had spoken titles and the speaker performed as the expositor of a film, not simply dubbing his/her voice on the characters. Despite this subtle division, the two umbrella genres, *jidaigeki* and *gendaigeki,* became stable in the period of the full-scale industrialization of the Japanese cinema in the 1920s. Tanaka Masumi, "Jidaigeki eigashi no tame no yobiteki shokosatsu, sengohen" (A Study of Postwar *Jidaigeki* History), in Tsutsui and Kato, *Jidaigeki eiga to wa nani ka* (What Is *Jidaigeki* Film?), 25.

27. One might, in this sense, choose to read Shochiku's concentrated effort at developing a signature Kamata style as constituting a meta-genre with consequences for Japanese cinema that surpass in scale the consequences that, for example, Warner Brothers' "style" of filmmaking might have had for Hollywood. See also Rick Altman, "A Semantic/Syntactic Approach to Film Genre," in Grant, *Film Genre Reader II,* 26–40.

28. Wimal Dissanayake, "Introduction," in Dissanayake, *Melodrama and Asian Cinema,* 3.

29. I am following Thomas Schatz's categorization of melodrama here; in his chapter on the family melodrama, he presents two variations of the genre: the widow-lover variation and the family aristocracy variation. Thomas Schatz, *Hollywood Genres: Formulas, Filmmaking and the Studio System* (New York: Random House, 1981), 232–238.

30. Yoshimoto, "Melodrama," 108.

31. Fredric Jameson, "Notes on Globalization as a Philosophical Issue," in Jameson and Miyoshi, *The Cultures of Globalization,* 63.

32. Yamamoto Kikuo, *Nihon ni okeru gaikoku eiga no eikyo,* 48–66.

33. Tanaka Saburo's review of *Father* stated that "the film presents the cheerful optimism that has been lacking in Japanese films. . . . It is an interesting *seikigeki* [pure comedy]." *Kinema junpo,* January 1, 1924, 20.

34. In the aforementioned "Shoshimin eiga ron," Matsui Sakae acknowledges the outstanding quality of Ozu's *I Was Born, But . . . ,* and he indicates that Ozu has created a new type of film, *shoshimin eiga:* "Although there are many films dealing with the subject of *shoshimin,* most of them do not depict our struggles in daily life; they are lies and imitations. They work as consolation for our lives. . . . However, I see the real figures of ourselves in [Ozu's] film."

35. Ueno Chizuko, "Modern Patriarchy and the Formation of the Japanese Nation State," in *Multicultural Japan: Palaeolithic to Postmodern,* ed. Donald Denoon, Mark Hudson, Gavan McCormack, and Tessa Morris-Suzuki (Cambridge: Cambridge University Press, 1996), 217.

36. Davis, *Picturing Japaneseness,* 35.

37. Ibid., 34.

38. Ueno, "Modern Patriarchy," 221.

39. Okoshi Aiko indicates that the family system described in the Meiji Civil Law was created with the state ideology linking the private individual family to the state. See her chapter "The National Strategy Called the Family Nation" in Okoshi Aiko, *Kindai Nihon no jenda: Gendai Nihon no shisoteki kadai o tou* (Gender in Modern Japan: Inquiry on Contemporary Japanese Thought) (Tokyo: San'ichi Shobo, 1997), 151–163.

40. Ueno, "Modern Patriarchy."

41. Darrell William Davis identifies the dominant strands of monumental cinema woven through Ozu's *Brothers and Sisters of the Toda Family* (*Toda ke no kyodai,* 1941): "The monumental style tells us something about the Japanese self-image in the late thirties because its primary purpose was the celebration of the national character and heritage. . . . The myth of the family complements this canonization of a glorious Japanese past. . . . Contemporary dramas also evoke the monumental style through their representation of the traditional family." Davis, "Back to Japan: Militarism and Monumentalism in Prewar Japanese Cinema," *Wide Angle* 11, no. 3 (July 1989), 17, 22. I see this nationalist discourse of monumental style in the middle-class genre films as well, particularly the evocation of a lost mythic past, the representation of longing for a traditional family, and the image of a patriarchal father figure in decline. While it is not my intention to argue over whether the genre is a direct precursor of the monumental-style film, I identify shared tendencies in the valorization of a traditional family hierarchy.

42. Fushimi Akira, "Umarete wa mitakeredo" (I Was Born, But . . .), in *Kinema junpo bessatsu,* 1:69–108.

43. Walter Benjamin, "On Some Motifs in Baudelaire," in Walter Benjamin, *Illuminations,* ed. Harry Zohn (New York: Schocken Books, 1968), 175.

Chapter 3: Embodying the Modern

1. After previous attempts, 1928 marked a Japanese sense of achievement as a modern nation. Although the Greater Japan Physical Education Association (JPEA; Dai Nippon Taiiku Kyokai) had continuously sent teams every four years, beginning with Stockholm in 1912, Japan had never been able to acquire any medals or remarkable records.

2. "Marason de Yamada, Tsuda ga nyusho," *Tokyo asahi shinbun,* August 7, 1928, evening edition; from *Showa nyusu jiten* (Dictionary of Newspaper Journalism from the Showa Period), vol. 1, ed. Showa Nyusu Jiten Henshu Iinkai and Mainichi Komyunikeshonzu (Tokyo: Mainichi Komyunikeishonzu, 1990).

3. I am indebted to Moriwaki Kiyotaka and Gibo Motoko at the Museum of Kyoto for letting me have a copy of the film's script, which was indispensable for writing about this rare film.

4. Otsuka Kyohei in *Eiga hyoron* (Film Criticism) 10, no. 1 (1931): 108–109. I thank Sakagami Yasuhiro for answering my questions as I researched this game.

5. Mori Arinori, "Heishiki taiso ni kansuru kengen'an," in *Mori Arinori zenshu* (Mori Arinori Collection), vol. 1, ed. Okubo Toshiaki (Tokyo: Senbundo Shoten, 1972).

6. Allen Guttmann and Lee Thompson, *Japanese Sports: A History* (Honolulu: University of Hawai'i Press, 2001).

7. H. D. Harootunian, "Figuring the Folk: History, Poetics, and Representation," in Vlastos, *Mirror of Modernity,* 145–159.

8. Yamamoto, 258–278.

9. Kato Mikiro, *Eiga janru-ron: Hariuddo-teki kairaku no sutairu* (Tokyo: Heibonsha, 1996), 10.

10. Tom Gunning, "Buster Keaton or the Work of Comedy in the Age of Mechanical Reproduction," *Cineaste* 21, no. 3 (1995): 14–16.

11. Ben Singer, "Modernity, Hyperstimulus, and the Rise of Popular Sensationalism," in Charney and Schwartz, *Cinema and the Invention of Modern Life,* 72–99.

12. Kang Sang-jung, *Orientarizumu no kanata e* (Beyond Orientalism) (Tokyo: Iwanami Shoten, 1996). Stefan Tanaka deals with these issues in greater depth in *Japan's Orient: Reading Pasts into History* (Berkeley: University of California Press, 1993).

13. Oguma Eiji, *Nihonjin no kyokai* (Boundaries of Japanese) (Tokyo: Shin'yosha, 1998).

14. Oguma Eiji, "Yushoku no shokumin teikoku: 1920-nen zengo no nikkei imin haiso to Chosen tojiron" (The Colored Colonial Empire: Termination of Japanese Immigration and Japanese Occupation in Korea around 1920), in *Nashonariti no datsukouchiku* (Deconstruction of Nationality) (Tokyo: Kashiwa Shobo, 1996), 81–102.

15. Gilles Deleuze, *Cinema 1: The Movement-Image,* trans. Hugh Tomlinson and Barbara Habberjam (Minneapolis: University of Minnesota Press, 1986).

16. Miriam Hansen, "Pleasure, Ambivalence, Identification: Valentino and Female Spectatorship," in *Star Texts: Image and Performance in Film and Television,* ed. Jeremy G. Butler (Detroit: Wayne State University Press, 1991), 267–297.

17. Kaja Silverman, *Male Subjectivity at the Margins* (New York: Routledge, 1992), 125–156.

18. Ibid., 142–143.

19. Kiba Sadanaga, "Ko shihaku Mori Arinori kun ni tsuite" (About Sir Mori Arinori), in *Mori Arinori zenshu* (Mori Arinori Collection), vol. 2 (Tokyo: Senbundo Shoten, 1972).

20. Joseph L. Anderson and Donald Richie defined "tendency films" as "those motion pictures which sought to encourage, or fight against, a given social tendency. This term, originating in Europe, soon came to have leftist connotations." *The Japanese Film: Art and Industry,* expanded ed. (Princeton: Princeton University Press, 1982), 64.

21. Iida Shinmi, "Eiga hihyo" (Film Criticism), *Kinema junpo* 386 (1930): 90.

22. Among later critical assessments of the tendency films, Fujita Motohiko writes that what the films actually accomplished was to oppose the remaining feudalistic system in modern society: "I would emphasize that we should not underestimate the tendency films' value. . . . Although the films had several flaws, they can be seen as the first conscious cinematic intervention against the feudalistic system; the films' critique came from the filmmakers' and the audience's political consciousness." Fujita's assertion that tendency films were against the feudalistic system is not applied to the level of narrative, but rather it claims that the films challenged both the feudalistic hierarchy of studio heads wielding complete authority while actors and workers lacked basic contracts or unions and the censorship system, which retained feudalistic views based on the emperor system, which emphasized individual compliance with the social order—that is, the state. It is necessary to note, however, that this discourse stems from the period following the 1950s modernism debate by Shimin Kindaiha (the Modern Citizens' Faction), which included Maruyama Masao, Otsuka Hisao, and Kawashima Takenori. Fujita's argument can be read in the context of the influence of the modernism debate since his criticism of Japanese modernity in the prewar period echoes the ideas of Maruyama's group by characterizing prewar modernity as containing antiquated, feudal aspects. Fujita Motohiko, *Gendai eiga no kiten* (Origins of Modern Film) (Tokyo: Kinokuniya Shoten, 1965), 96–98.

23. *Eiga ken'etsu jiho* (Comments on Film Censorship) (Tokyo: Fuji Shuppan, 1997).

24. "Kamata shinbun" (Kamata Newspaper), *Kamata* 10, no. 9 (1931): 89. The article relates Kido's announcement of his opposition to a previous newspaper article that reported pay cuts for some Shochiku actors. The article lists Oshimoto Eiji, Komura Shin'ichiro, Miyajima Ken'ichi, and others.

25. Uemura Taiji founded the Photo Chemical Laboratory (PCL), which was the forerunner of Toho, in 1930. PCL contracted with Nikkatsu to coproduce sound films in early 1932, but the collaboration ended later that year with Nikkatsu's financial crisis. Kobayashi Isamu, "Shinbun kisha no mita Kamata sodo" (Kamata Strife from a Newspaper Reporter's Point of View), *Kamata* 10, no. 11 (1931): 68–69.

26. Louis A. Montrose, "Professing the Renaissance: The Poetics and Politics of Culture," in *The New Historicism* (New York: Routledge, 1989), 64.

Chapter 4: Imaging Modern Girls in the Japanese Woman's Film

1. The epigraph above is from H. D. Harootunian, *Overcome by Modernity: History, Culture, and Community in Interwar Japan* (Princeton: Princeton University Press, 2000), 17.

2. *Shinpa* here is different from the *shinpa* theater. As I mentioned, the *shinpa* filmic genre is directly influenced by the theatrical tradition of *shinpa* (the literal translation is "new school," in contrast to the "old" Kabuki theatrical tradition). This influence can be seen in *shinpa* films' use of *oyama* (female impersonators) and the fact that the films are often shot as staged plays with a fixed camera from a distance that approximates the theater audience's point of view. In the linguistic distinction of the two *shinpa*, the film category is usually written as *shinpa-higeki* (*shinpa* tragedy); however, I use the more colloquial expression *shinpa* for the filmic genre. In the 1920s and early 1930s period genre films were very popular, and more of them were produced than films of the modern genre. Some of the former even borrowed the contemporary styles of the latter—language, acting, and themes—and presented possibilities beyond the limitations of masculine feudal narrative. These two genres are largely unexplored in Japanese film studies in both Japan and abroad.

3. The prevalence of female education and the economic expansion during and after World War I caused this increase of women workers. One female activist of the period, Yamakawa Kikue, reported that after the war, the demand for women workers surpassed the supply from new graduates of junior high and high schools. In particular, banks, the post office, and department stores (such as Mitsukoshi, Shirokiya, and Takashimaya) canvassed for new female graduates. Yamakawa Kikue, "On'na no tachiba kara" (From the Woman's Point of View), 1919, in Abe Tsunehisa and Sato Yoshimaru, *Tsushi to shiryo: Nihon kingendai joseishi* (History and Reference: Japanese Modern and Contemporary Women's History) (Tokyo: Fuyo Shobo Shuppan, 2000), 62.

4. The concept of "vernacular modernism" is a focal point of recent developments in cinema studies. It allows an elaboration of historical and local experience so that the national cinema, for instance, is cast within a broad range of influences that include the U.S. and other foreign models and transforming local traditions as well. Such work as Miriam Hansen's essay on Shanghai and Soviet cinemas in the interwar period effectively shifts the issues of text/intertext and historical spectatorship as they have frequently been practiced in the field of Hollywood cinema toward an exploration of national cinema. See Miriam Hansen: "Fallen Women, Rising Stars, New Horizons: Shanghai Silent Film as Vernacular Modernism," *Film Quarterly* 54, no. 1 (2000): 10–22, and "The Mass Production of the Senses." In recent historiography, meanwhile, ideas such as that of "bifurcated history," as presented by Prasenjit Duara, and "Japanese modern," presented by Masao Miyoshi, represent further efforts at naming modern local identities and reconfiguring the vernacular historical development and its relation to Western modernity. See Prasenjit Duara, *Rescuing History from the Nation:*

Questioning Narratives of Modern China (Chicago: University of Chicago Press, 1995), and Miyoshi, *Off Center*.

5. The history of Japanese cinema started with the importation of films from abroad. Many different kinds of moving pictures were imported from different countries in 1896 and 1897. The Kinetoscope was imported from the United States in 1896, the Cinematographe from France in 1897, and the Vitascope from the United States in 1897. See Tanaka Jun'ichiro, *Katsudo shashin no jidai* (The Early Period of Motion Pictures), vol. 1 of *Nihon eiga hattatsushi*, 28–66.

6. For a study of the "authenticity complex" in Japanese popular culture, see E. Taylor Atkins, *Blue Nippon: Authenticating Jazz in Japan* (Durham, N.C.: Duke University Press, 2001).

7. Mary Ann Doane, *The Desire to Desire: The Woman's Film of the 1940s* (Bloomington: Indiana University Press, 1987), 2–3.

8. Ubiquitous and elusive, genre itself encompasses a complex range of discourses. Steve Neale writes: "Genre is a multi-dimensional phenomenon, a phenomenon that encompasses systems of expectation, categories, labels and names, discourses, texts and groups of corpuses of texts, and the conventions that govern them all." *Genre and Hollywood* (London and New York: Routledge, 2000), 2.

9. Doane, *The Desire to Desire*, 4.

10. One might argue that Nikkatsu *shinpa* films had already targeted the female spectator in the 1910s. In fact, Tanaka Jun'ichiro described the *shinpa*'s contemporary audience as *komori musume* (nursemaids). See Tanaka, *Katsudo shashin no jidai*, 232–233. However, I frame the woman's film as starting in the 1920s with Shochiku for two reasons: first, Nikkatsu had no policy for targeting the female audience, and second, its films were firmly recognized as a continuation of Kabuki and *shinpa* theater, forms that do not directly address female audiences.

11. See Maeda Ai, *Kindai dokusha no seiritsu* (The Emergence of Modern Readers) (Tokyo: Chikuma Shobo, 1989), 151–198.

12. Kido Shiro, *Nihon eigaden: Eiga seisakusha no kiroku* (Japanese Cinema Tales: The Record of a Film Producer) (Tokyo: Bungei Shunjusha, 1956), 52–56.

13. Ibid., 42–46.

14. Donald Richie quotes the Shochiku manifest: "The main purpose of this company will be the production of artistic films resembling the latest and most flourishing styles of the Occidental cinema; it will distribute these both at home and abroad; it will introduce the true state of our national life to foreign countries." Donald Richie, *A Hundred Years of Japanese Film* (Tokyo: Kodansha International, 2002), 38. For the definition of pure film, see Bernardi, *Writing in Light*.

15. Miriam Silverberg, "Remembering Pearl Harbor, Forgetting Charlie Chaplin, and the Case of the Disappearing Western Woman: A Picture Story," *Positions* 1 (1993): 40–41.

16. Silverberg overdetermines *tenko* as a shift in popular culture, rather than its standard use as an individual political transformation. Tsurumi Shunsuke, in contrast,

defines *tenko* as "the act of understanding one's own thought processes and giving them a new direction in accordance with one's ideological beliefs." Tsurumi Shunsuke, *An Intellectual History of Wartime Japan 1931–1945* (New York: Routledge and Kegan Paul, 1986), 11.

17. Silverberg, "Remembering Pearl Harbor," 41; emphasis added.

18. Issue number 101 of the magazine was the first to include an article on Japanese cinema. "Honpo seisaku eigakai" (The World of Japanese Film Production), *Kinema junpo* 101 (1922): 8.

19. Partha Chatterjee, "The Nationalist Resolution of the Women's Question," in *Recasting Women: Essays in Colonial History,* ed. Kumkum Sangari and Sudesh Vaid (New Delhi: Kali for Women, 1989), 236.

20. Davis, *Picturing Japaneseness.*

21. Harootunian, *Overcome by Modernity,* 13. This explains Harootunian's comment in the epigraph above, which is from *Overcome by Modernity.*

22. Ibid., 11, 25. Both of Hirabayashi's statements are cited by Harootunian in translated form.

23. The circulation of the image on-screen in the 1920s coincides with depictions in other media, such as women's magazines (*fujin zasshi*). Barbara Sato focuses on these and shows how images of modern women (a modern girl, the self-motivated housewife, and the working woman) burst into Japanese life following the post–World War I economic boom. Barbara Sato, *The New Japanese Woman: Modernity, Media, and Women in Interwar Japan* (Durham, N.C., and London: Duke University Press, 2003).

24. See Kataoka Teppei, "Modan garu no kenkyu" (A Study of Modern Girls), in *Kindai shomin seikatsushi: Ningen, seken* (History of Modern Popular Life: Human and Public Society) (Tokyo: San'ichi Shobo, 1985), 1:159–189. His article was originally published in 1927 by Kinseido.

25. Sakurai Heigoro, "Modan garu to shokugyo fujin" (Modern Girls and Working Women), *Josei* (Women), February 1927, 169–173.

26. Kiyosawa Kiyoshi, "Modan garu no kenkyu" (A Study of Modern Girls), in *Kindai shomin seikatsushi: Ningen, seken,* 143–158. His article was probably written in the late 1920s, but no publishing date is cited in the 1985 edition.

27. For a fuller discussion, see Mizuta Noriko, "Seiteki tasha to wa dare ka" (Who Is the Sexual Other?), in *Iwanami koza: Gendai shakaigaku, sekushariti no shakaigaku* (Iwanami Contemporary Sociology: Sociology of Sexuality), (Tokyo: Iwanami Shoten, 1997), 10:25–62.

28. The moral polarization between good and evil displayed in these films fits the categorization of melodrama as elaborated by Ben Singer. However, the difference is that the Westernized figure is always depicted as more experienced and problematic in contrast to the protected and nationalized traditional Japanese woman. Here the melodrama becomes a national discourse. Ben Singer, *Melodrama and Modernity: Early Sensational Cinema and Its Contexts* (New York: Columbia University Press, 2001), 37–58.

29. Noël Burch, *To the Distant Observer: Form and Meaning in the Japanese Cinema* (London: Scolar Press, 1979), 159.

30. Bordwell, *Ozu and the Poetics of Cinema*, 240.

31. Ibid., 241.

32. Ibid.

33. Masumoto Kinen, *Joyu Okada Yoshiko* (The Actress Okada Yoshiko) (Tokyo: Bungei Shunjusha, 1993), 15.

34. The novel presents Joji as the first-person narrator, and it depicts Naomi as follows: "In fact, Naomi resembled the motion picture actress Mary Pickford: there was definitely something Western about her appearance. . . . And it was not only her face—even her body had a distinctly Western look when she was naked." Tanizaki Jun'ichiro, *Naomi*, trans. Anthony H. Chambers (San Francisco: North Point Press, 1990), 4.

35. Kan'no Satomi, *Shohi sareru ren'airon: Taisho chishikijin to sei* (The Consumed Love Discourses: Taisho Intellectuals and Sexuality) (Tokyo: Seikyusha, 2001).

36. Tanaka Masumi, ed., "Ozu Yasujiro kantoku no *Tokyo no yado* o kataru" (Discussion on Director Ozu Yasujiro's *An Inn in Tokyo*), in *Ozu Yasujiro zenhatsugen 1933–1945* (Ozu Yasujiro in His Own Words, 1933–1945), (Tokyo: Tairyusha, 1987), 67–70.

37. Linda Williams, "Film Bodies: Gender, Genre, and Excess," in *Film and Theory: An Anthology,* ed. Robert Stam and Toby Miller (Malden, Mass.: Blackwell Publishers, 2000), 208.

38. In terms of this bifurcation of a sadistic action, such extreme feminist arguments as Andrea Dworkin's and Catherine MacKinnon's on pornography might make a parallel, pointing out the victimization of the actress herself in pornography, not only as one of the characters within the film. See Andrea Dworkin, *Pornography: Men Possessing Women* (New York: Perigree Books), and Catherine MacKinnon, *Feminism Unmodified: Discourses on Life and Law* (Cambridge, Mass: Harvard University Press).

39. Linda Williams, "Film Bodies," 207. Williams explains that these genres "give our bodies an actual physical jolt"; for instance, in the case of melodrama, "it is deemed excessive for their gender- and sex-linked pathos, for their naked displays of emotion" (ibid.).

40. An earlier version of my analysis on the film was published in Japanese in 1998. Mitsuyo Wada-Marciano, "Shochiku kamata eiga ni okeru 'josei eiga' no sozo: *Jinsei no onimotsu* (1935) bunseki" (Creating "Woman's Film" in Shochiku Kamata Cinema: Reading *A Burden of Life* [1935]), *Eizogaku* 61 (1998): 68–84.

41. Otsuka Kyoichi, "Shochiku kamata eiga: *Jinsei no onimotsu; sugureta shinkyo eiga*" (Shochiku Kamata Film: *A Burden of Life;* It's an Excellent Psychodrama), *Eiga hyoron* 1 (1936): 197–199.

42. The film also indicates a double structure of the family, which reveals the transformation of social values and its complex relation with women's position in society. The family appears, on one hand, as a nuclear family of parents and children, while on the other, it resembles a multilateral feudalistic family because of the older teenage daughters

inserted between the elderly parents and the young son. The film indicates that the father's mentality is fixed within the modern familial system by his soliloquy, "It was a mistake. We had a son too late." (The son is too young to be the male successor.)

43. Teresa de Lauretis, *Technologies of Gender: Essays on Theory, Film, and Fiction* (Bloomington: Indiana University Press, 1987), 132.

44. Ibid., 133; emphasis in original.

45. Laura Mulvey, "Visual Pleasure and Narrative Cinema," in *Visual and Other Pleasures* (Bloomington: Indiana University Press, 1989), 25.

46. The words are taken from an introduction discussing Crary's essay. Leo Charney and Vanessa R. Schwartz, introduction to *Cinema and the Invention of Modern Life,* ed. Charney and Schwartz (Berkeley: University of California Press, 1995), 6.

47. Jonathan Crary, "Unbinding Vision: Manet and the Attentive Observer in the Late Nineteenth Century," in Charney and Schwartz, *Cinema and the Invention of Modern Life,* 68.

48. The sociologist Okoshi Aiko states that the male-centric structure of political power has created and controlled not only the bar waitress, geisha, and prostitute, but also their counterpart, the good wife and worthy mother, in the system of modern Japanese gender politics. Okoshi, *Kindai Nihon no jenda.*

49. The writer of the screenplay, Fushimi Akira, reedited the film right after World War II, following Shochiku's orders to erase inappropriate scenes or figures such as soldiers of the Imperial Japanese Army, which emphasized feudalistic values.

50. Doane, *The Desire to Desire,* 33.

51. Shochiku used the *gyakute* narrative repeatedly in its woman's films. Ozu, for instance, used this device often in such films as *What Did the Lady Forget?* (*Shukujo wa nani o wasureta ka,* 1937) and *Equinox Flower* (*Higanbana,* 1958). In the former, one of the most popular Shochiku actresses of the 1930s and early 1940s, Kuwano Michiko, instructs her uncle in *gyakute,* and in the latter, Yamamoto Fujiko uses *gyakute* over the male protagonist, Saburi Shin. The common ground of both films is the presence of an attractive actress who is a *gyakute* user and speaks in the Kansai dialect. The mismatched combination of a beautiful woman with a coquettish but unthreatening dialect creates the effect of confining female resistance toward patriarchy to trivial matters. Shochiku Kamata–style films, especially in the canonical genre of the woman's film, typically do not have a femme fatale not only for thematic reasons, but also because the films address a female subject position. The films create and fulfill both the audience's expectations of a woman's film and the desire to identify, from the start, with the women in these films.

52. Rey Chow, *Primitive Passions: Visuality, Sexuality, Ethnography, and Contemporary Chinese Cinema* (New York: Columbia University Press, 1995), 21.

53. Doane, "The 'Woman's Film,'" 284.

54. See Maeda, *Kindai dokusha no seiritsu,* 151–198.

55. Tanaka Jun'ichiro, *Musei kara toki e* (From Silent to Sound), vol. 2 of *Nihon eiga hattatsushi,* 167–174. Komatsu Hiroshi, "The Classical Cinema in Japan," 417.

Tanaka describes how the Shochiku Kamata studios insisted on producing films about mundane middle-class life, avoiding the expense of recording music or dialogue in the transition from silent to talkie. He also contrasts the period films produced by Shochiku's Kyoto studios, their assimilation of the tendency film's political aspects, with the Kamata studios' principle of avoiding political subtexts in their films.

Chapter 5: The Japanese Modern in Film Style

1. Miyoshi, *Off Center*, 13–14.

2. Iwamoto Kenji, "Modanizumu to Nihon eiga: Osanai Kaoru kara Ushihara Kiyohiko e" (Modernism and Japanese Cinema: From Osanai Kaoru to Ushihara Kiyohiko), in *Nihon eiga to modanizumu 1920–1930* (Japanese Cinema and Modernism 1920-1930), ed. Iwamoto Kenji (Tokyo: Libro, 1991), 6–11.

3. Scott Nygren, "Reconsidering Modernism: Japanese Film and the Postmodern Context," *Wide Angle* 11, no. 3 (July 1989): 6–15. Emphasis is mine.

4. Ibid., 12.

5. Sato Tadao attributes the postwar film critics' disapproval of Ozu's *Late Spring* (1949) to its lack of reality and concept of class, and the criticism became dominant for the rest of Ozu's career. In the chapter on Ozu's conflict with the New Wave filmmaker Yoshida Yoshishige, Sato also brings in Yoshida's criticism of Ozu's films, especially their circular narratives—that is, nothing happens and nothing changes. Sato Tadao, *Ozu Yasujiro no geijutsu* (Ozu Yasujiro's Art) (Tokyo: Asahi Shinbunsha, 1979), 2:146–149, 208–219.

6. Scott Nygren, *Time Frames: Japanese Cinema and the Unfolding of History* (Minneapolis: University of Minnesota Press, 2007).

7. Bordwell, *Ozu and the Poetics of Cinema*, 53.

8. "Nihon eigagai ronsoshi" (History of Disputes in Japanese Cinema), *Nihon eiga,* May 1938: 84.

9. Elements of the style endured after the company's move to the Ofuna studios in 1936 and even in the postwar period.

10. *Kamata* May 1, 1935, 3. The tradition of adapting contemporary novels into screenplays did not begin with the Shochiku Kamata studios. The early *shinpa* film *Hototogisu* (The Cuckoo), for instance, was an adaptation from a novel by Tokutomi Roka that was originally serialized in *Kokumin shinbun* from November 1908 to May 1909. The story was first adapted by *shinpa* theater and later appeared in five different versions between 1909 and 1911. Bernardi, *Writing in Light,* 39.

11. Sazaki Yoriaki also elaborates on this point in "*Tonari no Yae-chan* o meguru gekisekai no hensen" (Theatrical Transformation in *My Neighbor, Miss Yae*), in Iwamoto, *Nihon eiga no modanizumu 1920–1930,* 164–177.

12. I refer to both works of Rey Chow, "Against the Lures of Diaspora: Minority Discourse, Chinese Women, and Intellectual Hegemony," in *Writing Diaspora: Tactics*

of Intervention in Contemporary Cultural Studies (Bloomington: Indiana University Press, 1993), and *Primitive Passions.*

13. For further reference on this notion of cultural code-switching, see Miriam Silverberg. "Constructing the Ethnography of Modernity," *Journal of Asian Studies* 51 (1992): 30–54.

14. Tanaka Jun'ichiro, *Nihon eiga hattatsushi,* 1:359–362.

15. For example, Otsuka Kyoichi writes about Kamata style via the following description of Shimazu: "Shimazu Yasujiro is the representative filmmaker for the Shochiku Kamata–style films, especially when Shochiku refined the archaic form of Japanese cinema such as *shinpa* film into a contemporary filmic form." Otsuka Kyoichi, *"Ojosan"* (Young Miss), *Eiga hyoron* 10, no. 2 (1931): 50–52.

16. Komatsu Hiroshi and other recent Japanese film scholars have been reevaluating *shinpa* films. In a symposium on Mizoguchi Kenji, Mizoguchi Kenji seitan 100 nen kinen kokusai sinpojumu (Symposium for the One Hundredth Anniversary of Mizoguchi Kenji's Birthday) at Meiji-Gakuin University in November 1998, Komatsu presented a paper on Mizoguchi's *shinpa* films in the 1920s, "Mukojima shin eiga ni miru Mizoguchi eiga no genten" (The Starting Point of Mizoguchi Films in the Mukojima *Shinpa* Films), and noted the continuity of Mizoguchi's style in these films. Also refer to his article "Japan: Before the Great Kanto Earthquake," in Nowell-Smith, *The Oxford History of World Cinema,* 177–182.

17. One representative film critic in the 1930s, Otsuka Kyoichi, wrote the following in his film review: "The parts in which Okada Yoshiko [the actress who played Kyoko] appears obviously show [the film's failures]. . . . [I] even feel bad for Okada for acting in such a role under that way of directing." *"Tonari no Yae-chan"* (My Neighbor, Miss Yae), *Eiga hyoron,* August 1934: 136.

18. These scenes are in Shimizu Hiroshi's films *Mr. Thank You* and *A Star Athlete Hanagata senshu* (1937) respectively.

19. Ginza window-shopping was already a symbol of the modern in the 1920s and 1930s. The scene resonates with the same images of city life recorded by the Japanese ethnographer Kon Wajiro in his work on "modernology" (*kougengaku*). Miriam Silverberg summarizes Kon's work as follows: "Kon's celebration of a constructed street life is most evident in his analysis of the *konsutrakushon* (construction) of *Ginbura* (Ginza-cruising), contained in a study . . . 'Records of Mores on Tokyo Ginza Boulevard.'" Silverberg, "Constructing the Japanese Ethnography of Modernity," 37.

20. Karatani Kojin, *Origins of Modern Japanese Literature,* ed. and trans. Brett de Bary (Durham, N.C.: Duke University Press, 1993).

21. Ibid., 19.

22. Aaron Gerow, "Writing a Pure Cinema: Articulations of Early Japanese Film," PhD diss., University of Iowa, 1996.

23. High, *The Imperial Screen,* 61.

24. Imamura Taihei, "Eiga hyoron no genjo" (The Current Situation of Film Criticism), *Eigakai,* June 1939; cited in High, *The Imperial Screen,* 62.

25. High, *The Imperial Screen,* 62.

26. Miriam Silverberg writes: "In our endeavor to interpret the Japanese meaning of modernity, we should be looking at the formulations. . . . For what draws the Japanese ethnography of modernity together in texts providing resources for an ethnographic history of interwar Japan is a focus on the notion of *constructing*." Silverberg, "Constructing the Japanese Ethnography of Modernity," 30–54; emphasis is mine.

27. Balibar, "The Nation Form."

28. *Kamata,* March 1935: 1; *Oru Shochiku,* October 1938:70, and July 1938: 96.

29. This trademark of the Kamata style was criticized during the war years for its overemphasis on individual values and domestic relationships at the expense of narratives emphasizing cooperation in the larger community. Evidently during the war years, the intimate scale of the films' domestic narratives was interpreted by some as politically backward. There is a strong possibility that the so-called apolitical character of the Kamata-style films might indeed have formed a type of ideological resistance, given the context of wartime totalitarianism.

30. Cazdyn, 3.

31. Gerow, "Writing a Pine Cinema," 302–320. Gerow refers to Slavoj Zizek, "Eastern Europe's Republics of Gilead," *New Left Review* 183 (1990): 50–62.

32. Sato Tadao, *Nihon eigashi* (Tokyo: Iwanami Shoten, 1995), 206–208.

33. Tsumura, *Eiga to kansho,* 51–56.

34. Cited in Carol Gluck, *Japan's Modern Myths: Ideology in the Late Meiji Period* (Princeton: Princeton University Press, 1985), 283.

35. Hamada Yoshihisa, *Nihon eiga to senso to heiwa: Eiga hyakunen sengo gojunen* (Japanese Cinema, War, and Peace: One Hundred Years of Cinema and Fifty Years of the Postwar) (Tokyo: Issuisha, 1995), 70–73.

36. Tsumura Hideo, *Eiga seisakuron* (Film Policy) (Tokyo: Chuo Koronsha, 1943), 43.

37. Slavoj Žižek, *Looking Awry: An Introduction to Jacques Lacan through Popular Culture* (Cambridge, Mass.: MIT Press, 1991), 112.

Conclusion

1. Harootunian, *Overcome by Modernity,* 23–25.

2. Iwamoto, "Modanizumu to Nihon eiga."

3. Dipesh Chakrabarty describes historicism as follows: "Historicism—and even the modern, European idea of history—one might say, came to non-European peoples in the nineteenth century as somebody's way of saying 'not yet' to somebody else." Dipesh Chakrabarty, *Provincializing Europe: Postcolonial Thought and Historical Difference* (Princeton and Oxford: Princeton University Press, 2000), 8.

4. Komatsu Hiroshi, "Kioku no mokuroku" (Records of Memory), in *Kinema rekodo* (Film Record) (Tokyo: Kokushokanko, 1999), 1:15–28.

5. Ibid., 24.

6. Iijima Tadashi recollects this division between the French and German schools

in *Kinema junpo* and lists Uchida Kisao, Shimizu Chiyoto, and himself as the French school and Iwasaki Akira as the German school in *Kikigaki kinema no seishun,* ed. Iwamoto Kenji and Saeki Tomonori (Tokyo: Libro, 1988), 410–411.

7. Further evidence of Tsumura's right-wing nationalism is his prominent membership in the Japan Film Association (Dainippon Eiga Kyokai). Partially government sponsored, the association enacted state policies on film regulation and production standards. Kido, *Nihon eigaden,* 201–202.

8. Tsumura Hideo, *Eigasen* (Tokyo: Asahi Shinbunsha, 1944), 24.

9. Harootunian, *Overcome by Modernity,* 48, 57.

10. "Bunka sogo kaigi: Kindai no chokoku" (Cultural Conference: Overcoming Modernity), *Bungakukai,* October 1942: 104.

11. Ibid., 106.

12. Ibid., 104–105.

13. Ibid., 105.

14. Chakrabarty, *Provincializing Europe,* 43.

15. Tsumura started reissuing his books on film in 1947: *Eiga no kansho* (Tokyo: Rodo Bunkasha, 1947) and *Eiga no bi* (The Beauty of Film) (Tokyo: Koufukan, 1947). He especially focused on analyzing American films in the former and presented the latter for specifically female readers.

16. Itami Mansaku, "Senso sekininsha no mondai" (The Problem of Wartime Responsibility), in *Itami Mansaku zenshu* (Itami Mansaku Collection) (Tokyo: Chukuma Shobo, 1961), 3:205–214.

17. Tsumura Hideo, *America eiga dokuhon* (Reading American Film) (Tokyo: Kobarutosha, 1947), 10.

18. Iijima Tadashi, *Eiga bunka no kenkyu* (A Study of Film Culture) (Tokyo: Shinchosha, 1939), 44–45.

19. Nagisa Oshima, *Cinema, Censorship, and the State: The Writings of Nagisa Oshima, 1956–1978,* ed. Annette Michelson, trans. Dawn Lawson (Cambridge, Mass.: MIT Press, 1992). Masumura Yasuzo, "Itaria de hakken shita 'kojin,' " in *Eiga kantoku Masumura Yasuzo no sekai* (The World of Film Director Masumura Yasuzo), ed. Fujii Hiroaki (Tokyo: Waizu Shuppan, 1999), 59–61. Sato Tadao, "Sono shi to chisana sokatsu" (The Death and a Small Summary), in *Ozu Yasujiro no geijyutsu,* 2:221–237.

20. Burch, *To the Distant Observer,* 11.

21. Ibid., 31.

Bibliography

Journals

Chuo koron (1914–1936)
Dai nikkatsu (1930)
Dai shochiku (1929–1933)
Eiga asahi (1938–1939)
Eiga dai'issen (1933)
Eiga fan (1937)
Eiga geijutsu kenkyu (1933–1934)
Eiga hyoron (1928–1941)
Eiga jidai (1926–1931)
Eiga jyoho (1931)
Eiga kenkyu (1941)
Eiga kigyo (1940)
Eiga no tomo (1941–1943)
Eiga orai (1925–1931)
Eiga seishin (1937)
Eiga sekai (1930)
Eiga sozo (1937)
Eiga to butai (1938)
Eiga to engeki (1929)
Fuji (1929)
Gekkan eiga (1926)
Jidai eiga (1941)
Josei (1926–1927)
Kaizo (1926–1936)
Kamata (1920–1936)

Kamata shuho (1925–1930)
Katsudo gaho (1917–1921)
Katsudo hyoron (1919)
Katsudo kurabu (1920–1922)
Katsudo no sekai (1916–1919)
Katsudo shashin zasshi (1915–1919)
Kikan shinario kenkyu (1937)
Kinema (1925–1934)
Kinema junpo (1920–1936)
Kokusai eiga shinbun (1934–1937)
Nihon eiga (1938–1941)
Nikkatsu (1932–1934)
Nikkatsu eiga (1928)
Oru shochiku (1938)
Sande mainichi (1935)
Shinko kinema (1935)
Shin seinen (1927–1935)
Shochiku (1934)
Shochiku shuho (1931–1937)

Books and Articles

Abe Tsunehisa and Sato Yoshimaru. *Tsushi to shiryo: Nihon kingendai joseishi.* Tokyo: Fuyo Shobo Shuppan, 2000.

Allen, Robert C., and Douglas Gomery. *Film History, Theory, and Practice.* New York: Knopf, 1985.

Altman, Rick. *Film/Genre.* London: BFI Publishing, 1999.

———. "A Semantic/Syntactic Approach to Film Genre." In Grant, *Film Genre Reader II,* 26–40.

Anderson, Benedict. *Imagined Communities: Reflections on the Origin and Spread of Nationalism.* London: Verso, 1983.

Anderson, Joseph L. "Spoken Silents in the Japanese Cinema; or, Talking to Pictures: Essaying the *Katsuben,* Contextualizing the Texts." In Nolletti and Desser, *Reframing Japanese Cinema,* 259–311.

Anderson, Joseph L., and Donald Richie. *The Japanese Film: Art and Industry.* Expanded edition. Princeton: Princeton University Press, 1982.

Andrew, Dudley. *Mists of Regret: Culture and Sensibility in Classic French Film.* Princeton: Princeton University Press, 1995.

Aoki Tamotsu et al., eds. *Toshi bunka.* Kindai Nihon bunkaron Ser. 5. Tokyo: Iwanami Shoten, 1999.

Appadurai, Arjun. "Grassroots Globalization and the Research Imagination." *Public Culture* 12, no. 1:1–19.

Atkins, E. Taylor. *Blue Nippon: Authenticating Jazz in Japan*. Durham, N.C.: Duke University Press, 2001.

Balibar, Etienne, and Immanuel Wallerstein. *Race, Nation, Class: Ambiguous Identities*. Trans. Chris Turner. London: Verso, 1991.

Barshay, Andrew E. *State and Intellectual in Imperial Japan: The Public Man in Crisis*. Berkeley: University of California Press, 1988.

Barthes, Roland. *Empire of Signs*. Trans. Richard Howard. New York: Hill and Wang, 1982.

———. *Image–Music–Text*. New York: Hill and Wang, 1977.

———. "Kigogaku to toshi no rinri/Sémiologie et urbanisme." Trans. Shinoda Koichi. *Gendai shiso,* October 1975: 106–117.

Bazin, André. *What Is Cinema?* 2 vols. Trans. Hugh Gray. Berkeley: University of California Press, 1967–1971.

Benjamin, Walter. *Illuminations*. Ed. Harry Zohn. New York: Schocken Books, 1968.

Bernardi, Joanne R. "Genre Distinctions in the Japanese Contemporary Drama Film." In *La nascite dei generi cinematografici*. Ed. Leonardo Quaresima et al. Udine: Forum, 1999, 407–421.

———. *Writing in Light: The Silent Scenario and the Japanese Pure Film Movement*. Detroit: Wayne State University Press, 2001.

Bhabha, Homi K., ed. *The Location of Culture*. New York: Routledge, 1994.

———. *Nation and Narration*. New York: Routledge, 1990.

Bordwell, David. *On the History of Film Style*. Cambridge, Mass.: Harvard University Press, 1997.

———. "Our Dream Cinema: Western Historiography and the Japanese Film." *Film Reader* 4 (1979): 45–62.

———. *Ozu and the Poetics of Cinema*. London: BFI Pub.; Princeton: Princeton University Press, 1988.

———. "Visual Style in Japanese Cinema, 1925–1945." *Film History* 7 (1995): 5–31.

Bordwell, David, and Noël Carroll, eds. *Post-Theory: Reconstructing Film Studies*. Madison: University of Wisconsin Press, 1996.

Bordwell, David, Janet Staiger, and Kristin Thompson. *The Classical Hollywood Cinema: Film Style and Mode of Production to 1960*. New York: Columbia University Press, 1985.

Brooks, Peter. *The Melodramatic Imagination: Balzac, Henry James, Melodrama, and the Mode of Excess*. New Haven: Yale University Press, 1976.

Brown, Kendall H. "Flowers of Taisho: Images of Women in Japanese Society and Art, 1915–1935." In *Taisho Chic: Japanese Modernity, Nostalgia, and Deco*. Ed. Kendall H. Brown and Sharon A. Minichiello. Honolulu: Honolulu Academy of Arts, 2001, 17–26.

Bullock, Marcus, and Michael W. Jennings, eds. *Walter Benjamin: Selected Writings 1913–1926*, vol. 1. Cambridge, Mass.: Belknap Press, 1996.

Burch, Noël. *Life to Those Shadows*. Trans. and ed. Ben Brewster. Berkeley: University of California Press, 1990.

———. *Theory of Film Practices*. Trans. Helen R. Lane. Princeton: Princeton University Press, 1989.

———. *To the Distant Observer: Form and Meaning in the Japanese Cinema*. London: Scolar Press, 1979.

Cazdyn, Eric. *The Flash of Capital: Film and Geopolitics in Japan*. Durham, N.C.: Duke University Press, 2002.

Chakrabarty, Dipesh. *Provincializing Europe: Postcolonial Thought and Historical Difference*. Princeton and Oxford: Princeton University Press, 2000.

Charney, Leo, and Vanessa R. Schwartz, eds. *Cinema and the Invention of Modern Life*. Berkeley: University of California Press, 1995.

Chatterjee, Partha. "The Nationalist Resolution of the Women's Question." In *Recasting Women: Essays in Colonial History*. Ed. Kumkum Sangari and Sudesh Vaid. New Delhi: Kali for Women, 1989, 233–253.

Chiba Nobuo. *Eiga to Tanizaki*. Tokyo: Seiabo, 1989.

Chow, Rey. *Primitive Passions: Visuality, Sexuality, Ethnography, and Contemporary Chinese Cinema*. New York: Columbia University Press, 1995.

———. *Writing Diaspora: Tactics of Intervention in Contemporary Cultural Studies*. Bloomington: Indiana University Press, 1993.

Chuko Satoshi and Hasumi Shigehiko. *Naruse Mikio no sekkei*. Tokyo: Chikuma Shobo, 1990.

Clifford, James, and George E. Marcus, eds. *Writing Culture: The Poetics and Politics of Ethnography*. Berkeley: University of California Press, 1986.

Crary, Jonathan. *Techniques of the Observer: On Vision and Modernity in the Nineteenth Century*. Cambridge, Mass.: MIT Press, 1990.

———. "Unbinding Vision: Manet and the Attentive Observer in the Late Nineteenth Century." In Charney and Schwartz, *Cinema and the Invention of Modern Life*, 46–71.

Davis, Darrell William. "Back to Japan: Militarism and Monumentalism in Prewar Japanese Cinema." *Wide Angle* 11, no. 3 (1989): 16–25.

———. *Picturing Japaneseness: Monumental Style, National Identity, Japanese Film*. New York: Columbia University Press, 1996.

de Certeau, Michel. *The Practice of Everyday Life*. Trans. Steven Rendall. Berkeley: University of California Press, 1988.

de Lauretis, Teresa. *Technologies of Gender: Essays on Theory, Film, and Fiction*. Bloomington: Indiana University Press, 1987.

Deleuze, Gilles. *Cinema 1: The Movement-Image*. Trans. Hugh Tomlinson and Barbara Habberjam. Minneapolis: University of Minnesota Press, 1986.

———. *Cinema 2: The Time-Image*. Trans. Hugh Tomlinson and Robert Galeta. Minneapolis: University of Minnesota Press, 1989.

Desser, David. *The Samurai Films of Akira Kurosawa*. Ann Arbor: UMI Research Press, 1983.

———. "Toward a Structural Analysis of the Postwar Samurai Film." In Nolletti and Desser, *Reframing Japanese Cinema*, 145–164.

Dissanayake, Wimal, ed. *Colonialism and Nationalism in Asian Cinema.* Blooming-ton: Indiana University Press, 1994.

———, ed. *Melodrama and Asian Cinema.* Cambridge: Cambridge University Press, 1993.

Doane, Mary Ann. *The Desire to Desire: The Woman's Film of the 1940s.* Bloomington: Indiana University Press, 1987.

———. "The 'Woman's Film': Possession and Address." In Gledhill, *Home Is Where the Heart Is,* 283–298.

Dower, John. *Embracing Defeat: Japan in the Wake of World War II.* New York: W. W. Norton/New Press, 1999.

———. *War without Mercy: Race and Power in the Pacific War.* New York: Pantheon, 1986.

Duara, Prasenjit. *Rescuing History from the Nation: Questioning Narratives of Modern China.* Chicago: University of Chicago Press, 1995.

Ehrlich, Linda C., and David Desser, eds. *Cinematic Landscapes: Observations on the Visual Arts and Cinema of China and Japan.* Austin: University of Texas Press, 1994.

Eiga ken'etsu jiho. Tokyo: Fuji Shuppan, 1997.

Elsaesser, Thomas, ed. *Early Cinema: Space-Frame-Narrative.* Essex: BFI Publishing, 1990.

Ferro, Marc. *Cinema and History.* Trans. Naomi Greene. Detroit: Wayne State University Press, 1988.

Fiske, John. "Popular Culture." In *Critical Terms for Literary Studies, 2d ed.* Ed. Frank Lentricchia and Thomas McLaughlin. Chicago: University of Chicago Press, 321–335.

Fowler, Edward. *The Rhetoric of Confession: Shishosetsu in Early Twentieth-Century Japanese Fiction.* Berkeley: University of California Press, 1988.

Freiberg, Freda. "Japanese Cinema." In Hill and Gibson, *The Oxford Guide to Film Studies,* 562–568.

Friedberg, Anne. *Window Shopping: Cinema and the Postmodern.* Berkeley: University of California Press, 1993.

Fujimori Terunobu. *Nihon no kindai kenchiku.* 2 vols. Tokyo: Iwanami Shoten, 1993.

Fujita Motohiko. *Gendai eiga no kiten.* Tokyo: Kinokuniya Shoten, 1965.

———. *Nihon eiga gendaishi: Showa junendai.* Tokyo: Kashinsha, 1977.

Fukkoku Taisho daizasshi. Tokyo: Ryudo Shuppan, 1978.

Fukuda Tsuneari. "Kindai no shukumei." In *Fukuda Tsuneari zenshu,* vol. 2. Tokyo: Bungeishunjusha, 1987, 431–468.

Fushimi Akira. "Umarete wa mitakeredo." In *Kinema junpo bessatsu: Nihon eiga shinario koten zenshu,* vol. 1. Tokyo: Kinema Junposha, 1965, 69–108.

Geertz, Clifford. *The Interpretation of Culture.* New York: Basic Books, 1973.

Gerow, Aaron Andrew. "The Benshi's New Face: Defining Cinema in Taisho Japan." *Iconics* 3 (1994): 69–86.

———. "Celluloid Masks: The Cinematic Image and the Image of Japan." *Iris* 16 (Spring 1993): 23–36.

———. "Writing a Pure Cinema: Articulations of Early Japanese Film." PhD diss., University of Iowa, 1996.

Gledhill, Christine, ed. *Home Is Where the Heart Is: Studies in Melodrama and the Woman's Film.* London: BFI Publishing, 1987.

Gluck, Carol. *Japan's Modern Myths: Ideology in the Late Meiji Period.* Princeton: Princeton University Press, 1985.

Gosho Heinosuke. "Shiawase datta eiga-ka no kikai." In *Kinema junpo bessatsu: Nihon eiga shinario koten zenshu,* vol. 2. Tokyo: Kinema Junposha, 1966.

———. *Waga seishun.* Tokyo: Nagato Shobo, 1978.

Grant, Barry Keith, ed. *Film Genre Reader.* Austin: University of Texas Press, 1986.

———. ed. *Film Genre Reader II.* Austin: University of Texas Press, 1995.

Gunning, Tom. "An Aesthetic of Astonishment: Early Film and the (In)Credulous Spectator." In Williams, *Viewing Positions,* 114–133.

———. "Buster Keaton or the Work of Comedy in the Age of Mechanical Reproduction." *Cineaste* 21, no. 3 (1995): 14–16.

Guttmann, Allen, and Lee Thompson. *Japanese Sports: A History.* Honolulu: University of Hawai'i Press, 2001.

Haenni, Sabine. "Staging Methods, Cinematic Technique, and Spatial Politics." *Cinema Journal* 37, no. 3 (Spring 1998): 83–108.

Hamada Yoshihisa. *Nihon eiga to senso to heiwa: Eiga hyakunen sengo gojunen.* Tokyo: Issuisha, 1995.

Hansen, Miriam. "Early Cinema, Late Cinema: Transformations of the Public Sphere." In Williams, *Viewing Positions,* 134–152.

———. "Fallen Women, Rising Stars, New Horizons: Shanghai Silent Film as Vernacular Modernism." *Film Quarterly* 54, no. 1 (2000): 10–22.

———. "The Mass Production of the Senses: Classical Cinema as Vernacular Modernism." In *Reinventing Film Studies.* Ed. Christine Gledhill and Linda Williams. London: Arnold Publishing, 2000, 332–350.

———. "Pleasure, Ambivalence, Identification: Valentino and Female Spectatorship." In *Star Texts: Image and Performance in Film and Television.* Ed. Jeremy G. Butler. Detroit: Wayne State University Press, 1991, 267–297.

Harootunian, H. D. "America's Japan/Japan's Japan." In Miyoshi and Harootunian, *Japan in the World.*

———. "Figuring the Folk: History, Poetics, and Representation." In Vlastos, *Mirror of Modernity,* 145–159.

———. *Overcome by Modernity: History, Culture, and Community in Interwar Japan.* Princeton: Princeton University Press, 2000.

Hase Masato. "Ken'etsu no tanjo: Taisho no keisatsu to katsudo shashin." *Eizogaku* 53 (1994): 124–138.

Hasegawa Nyozekan. *Nihon eigaron.* Tokyo: Dainippon Eiga Kyokai, 1943.

Hashizume Shin'ya. "*Kindai Nihon no kukan puran'natachi, no. 8: Aburaya Kumahachi.*" *CEL* 47 (November 1998): 113–119.

Hasumi Shigehiko. *Kantoku Ozu Yasujiro*. Tokyo: Chikuma Shobo, 1983.

Hasumi Tsuneo. *Eiga gojunenshi*. Tokyo: Masu Shobo, 1947.

———. *Eiga zuihitsu*. Tokyo: Heibonsha, 1956.

Heath, Stephen. "Narrative Space." In *Narrative, Apparatus, Ideology.* Ed. Philip Rosen. New York: Columbia University Press, 1986, 379–420.

———. *Questions of Cinema.* Bloomington: Indiana University Press, 1981.

Hidaka Rokuro, ed. *Kindaishugi*. Tokyo: Chikuma Shobo, 1964.

High, Peter B. *The Imperial Screen: Japanese Film Culture in the Fifteen Years' War, 1931–1945.* Madison: University of Wisconsin Press, 2003.

———. *Teikoku no ginmaku: Jugonen senso to Nihon eiga.* Nagoya: Nagoya Daigaku Shuppankai, 1995.

Higson, Andrew. "The Concept of National Cinema." *Screen* 30 (1989): 36–46.

Hijiya-Kirschnereit, Irmela. *Shishosetsu: Jiko bakuro no gishiki.* Tokyo: Heibonsha, 1992.

Hobsbawm, Eric, and Terence Ranger, eds. *The Invention of Tradition.* Cambridge: Cambridge University Press, 1983.

Horiba Kiyoko, ed. *Seito josei kaiho ronshu.* Tokyo: Iwanami Shoten, 1991.

Hunt, Lynn, ed. *The New Cultural History.* Berkeley: University of California Press, 1989.

Igarashi, Yoshikuni. *Bodies of Memory: Narratives of War in Postwar Japanese Culture, 1945–1970.* Princeton: Princeton University Press, 2000.

Iida, Yumiko. *Rethinking Identity in Modern Japan: Nationalism as Aesthetics.* London and New York: Routledge, 2002.

Iijima Tadashi. *Eiga bunka no kenkyu.* Tokyo: Shinchosha, 1939.

Iijima Tadashi et al., eds. *Eiga nenkan 1936-nenban.* Tokyo: Daiichi Shobo, 1936.

Imamura Shohei et al., eds. *Koza Nihin eiga.* 8 vols. Tokyo: Iwanami Shoten, 1985–1998.

Imamura Taihei. *Imamura Taihei eizo hyoron.* 10 vols. Tokyo: Yumani Shobo, 1991.

Inagawa Masato et al., eds. *Ozu Yasujiro o yomu.* Tokyo: Firumu Atosha, 1982.

Irie Katsuki. *Nihon fashizumu-ka no taiiku shiso.* Tokyo: Fumaido Shuppan, 1986.

———. *Showa spotsu shiron: Meiji jingu kyogi taikai to kokumin seishin sodoin undo.* Tokyo: Fumaido Shuppan, 1991.

Irokawa Daikichi. *Irokawa Daikichi chosakushu: Jomin bunkaron*, vol. 3. Tokyo: Chikuma Shobo, 1996.

Ishikawa Hiroshi. *Goraku no senzenshi.* Tokyo: Tokyo Shoseki, 1981.

Itami Mansaku. *Itami Mansaku zenshu.* 3 vols. Tokyo: Chikuma Shobo, 1961.

Ito Akira et al., eds. *Nihon supotsu hyakunen no ayumi.* Tokyo: Besuboru Magajinsha, 1967.

Iwamoto Kenji. "Koen, modanizumu to nashonarizumu." *Symposium on Gerarde de Leon "The Dawn of Freedom" and "Noli Me Tangere."* Tokyo: Kokusai Koryu Kikin Asia Senta, 1995, 9–20.

———. "Modanizumu to Nihon eiga: Osanai Kaoru kara Ushihara Kiyohiko e." In Iwamoto, *Nihon eiga to modanizumu.*

———, ed. *Nihon eiga to modanizumu 1920–1930.* Tokyo: Libro, 1991.

Iwamoto Kenji and Makino Mamoru, eds. *Eiga nenkan: Showa 5 nen-ban.* Tokyo: Nihon Tosho Senta, 1994.

———, eds. *Eiga nenkan: Showa 11-nenban.* Tokyo: Nihon Tosho Senta, 1994.

Iwamoto Kenji and Saeki Tomonori, eds. *Kikigaki kinema no seishun.* Tokyo: Libro, 1988.

Iwasaki Akira. *Eigashi.* Tokyo: Tohoku Keizai Shinposha, 1961.

———, ed. *Negishi Kan'ichi.* Tokyo: Nigishi Kan'ichi-den Kankokai, 1969.

Iyotani Toshio. "Kindai sekai sisutem to shuhenbu kokka." In *Nashonariti no datsukochiku.* Ed. Naoaki Sakai, Brett de Bary, and Toshio Iyotani. Tokyo: Kashiwa Shobo, 1996, 267–286.

Jameson, Fredric. "Cognitive Mapping." In *Marxism and the Interpretation of Culture.* Ed. Cary Nelson and Lawrence Grossberg. Urbana: University of Illinois Press, 1988, 347–360.

———. *The Political Unconsciousness: Narrative as a Social Symbolic Act.* Ithaca, N.Y.: Cornell University Press, 1981.

———. *Postmodernism, or, the Cultural Logic of Late Capitalism.* Durham, N.C.: Duke University Press, 1992.

———. "Reflections in Conclusion." In *Aesthetics and Politics.* Ed. Ronald Taylor. London: Verso, 1977, 196–213.

Jameson, Fredric, and Masao Miyoshi, eds. *The Cultures of Globalization.* Durham, N.C.: Duke University Press, 1998.

Kanagawa Kenritsu Kindai Bijutsukan Gakugeika, ed. *Moga mobo 1910–1935 ten.* Kanagawa: Kanagawa Kenritsu Kindai Bijutsukan, 1998.

Kang, Sang-jung. *Orientarisumu no kanata e.* Tokyo: Iwanami Shoten, 1996.

Kan'no Satomi. *Shohi sareru ren'airon: Taisho chishikijin to sei.* Tokyo: Seikyusha, 2001.

Kano Masanao. *Senzen ie no shiso.* Tokyo: Sobunsha, 1983.

———. *Taisho demokurashi no teiryu.* Tokyo: Nihon Hoso Kyokai, 1975.

Kaplan, E. Ann. *Looking for the Other: Feminism, Film, and the Imperial Gaze.* New York: Routledge, 1997.

———. *Motherhood and Representation: The Mother in Popular Culture and Melodrama.* New York: Routledge, 1992.

———. *Women and Film: Both Sides of the Camera.* New York: Methuen, 1983.

Karatani, Kojin. "The Discursive Space of Modern Japan." *boundary 2* 18, no. 3 (Fall 1991): 191–219.

———. *Origins of Modern Japanese Literature.* Ed. and trans. Brett de Bary. Durham, N.C.: Duke University Press, 1993.

———. *Senzen no shiko.* Tokyo: Bungei Shunju, 1994.

Kataoka Teppei. "Modan garu no kenkyu." In *Kindai shomin seikatsushi: Ningen, seken,* vol. 1. Tokyo: San'ichi Shobo, 1985, 159–189.

Kato Mikiro. *Eiga janru-ron: Hariuddoteki kairaku no sutairu.* Tokyo: Heibonsha, 1996.

Kawakami Tetsutaro et al. *Kindai no chokoku.* Tokyo: Fuzanbo, 1979.

Kawamoto Saburo, ed. *Modan toshi bungaku: Hanzai toshi,* vol. 7. Tokyo: Heibonsha, 1990.

Kawashima Yasuyoshi. *Fujin kateiran kotohajime.* Tokyo: Seiabo, 1996.

Kawatake Shigetoshi. *Gaisetsu Nihon engekishi.* Tokyo: Iwanami Shoten, 1966.

Kawatake Toshio. *Engeki gairon.* Tokyo: Tokyo Daigaku Shuppankai, 1978.

Kiba Sadanaga. "Ko shihaku Mori Arinori kun ni tsuite." In *Mori Arinori zenshu,* vol. 2. Tokyo: Senbundo Shoten, 1972.

Kido Shiro. *Nihon eigaden: Eiga seisakusha no kiroku.* Tokyo: Bungei Shunjusha, 1956.

———. *Waga eigaron.* Ed. Yamada Yoji. Tokyo: Shochiku Kabushiki Gaisha, 1978.

Kim, So-Young. "Question of Woman's Film: The Maid, Madame Freedom, and Women." In *Post-Colonial Classics of Korean Cinema.* Ed. Chungmoo Choi. Irvine, Calif.: Korean Film Festival Committee at the University of California, 1998, 13–21.

Kinema junpo bessatsu: Nihon eiga shinario koten zensyu. Tokyo: Kinema Junposha, 1966.

Kirihara, Donald. *Patterns of Time: Mizoguchi and the 1930s.* Madison: University of Wisconsin Press, 1992.

———. "Reconstructing Japanese Film." In Bordwell and Carroll, *Post-Theory,* 501–519.

Kishi Matsuo. *Jinbutsu Nihon eigashi,* vol. 1. Tokyo: Davittosha, 1970.

Kitagawa Fuyuhiko. *Junsui eigaki.* Otsu: Daiichi Geibunsha, 1936.

Kitamura Komatsu. *Kitamura Komatsu shinarioshu.* Tokyo: Seikodo, 1930.

Kiyosawa Kiyoshi. "Modan garu no kenkyu." In *Kindai shomin seikatsushi: Ningen, seken,* vol. 1. Tokyo: San'ichi Shobo, 1985, 143–158.

Kobayashi, Hideo. *Literature of the Lost Home: Kobayashi Hideo—Literary Criticism, 1924–1939.* Ed. and trans. Paul Anderer. Stanford: Stanford University Press, 1995.

Kobayashi Kyuzo. *Nihon eiga o tsukutta otoko: Kido Shiro den.* Tokyo: Shin Jinbutsu Oraisha, 1999.

Komatsu Hiroshi. "The Classical Cinema in Japan." In Nowell-Smith, *The Oxford History of World Cinema,* 416–417.

———. "Japan: Before the Great Kanto Earthquake." In Nowell-Smith, *The Oxford History of World Cinema,* 177–182.

———. *Kigen no eiga.* Tokyo: Seidosha, 1991.

———. "Kioku no mokuroku." In *Kinema recodo.* Vol. 3. Tokyo: Kokushokanko, 1999.

———. "Mukojima shinpa eiga ni miru Mizoguchi eiga no genten." In *Eiga kantoku Mizoguchi Kenji.* Ed. Yomota Inuhiko. Tokyo: Shin'yosha, 1999, 24–65.

Komori Yoichi and Takahashi Tetsuya, eds. *Nashonaru hisutori o koete.* Tokyo: Tokyo Daigaku Shuppankai, 1998.

Kon Wajiro. *Kougengaku: Kon Wajiro shu,* vol. 1. Tokyo: Domesu Shuppan, 1989.

Koshizawa Akira. *Tokyo no toshi keikaku.* Tokyo: Iwanami Shoten, 1997.

Koyasu Nobukuni. "Nihon no kindai to kindaikaron: Senso to kindai Nihon no chisikijin." In *Datsu seiyo no shiso.* Ed. Nitta Yoshihiro et al. Iwanami Koza: Gendai shiso 15. Tokyo: Iwanami Shoten, 1994.

Kurahara Korehito. "Puroretaria riarizumu e no michi." *Showa hihyo taikei*. Tokyo: Bancho Shobo, 1968, 68–71.

Kyoto Bunka Hatsubutsukan, ed. *Interview eiga no seishun*. Tokyo: Kinema Junpo, 1998.

Landy, Marcia, ed. *Imitation of Life: A Reader on Film and Television Melodrama*. Detroit: Wayne State University Press, 1991.

Leach, Jim. "North of Pittsburgh: Genre and National Cinema from a Canadian Perspective." In Grant, *Film Genre Reader II*, 474–493.

Lefebvre, Henri. *Critique of Everyday Life*, vol. 1. London: Verso, 1991.

———. *The Production of Space*. Trans. Donald Nicholson-Smith. Oxford: Blackwell, 1991.

Leiter, Samuel L. *Kabuki Encyclopedia*. Westport, Conn.: Greenwood Press, 1979.

Maeda Ai. *Kindai dokusha no seiritsu*, vol. 2. Tokyo: Chikuma Shobo, 1989.

Makino Mamoru, ed. *Fukkokuban kinima junpo*. 4 vols. Tokyo: Yushodo Shuppan, 1993.

———, ed. *Sanzen eizo riron zasshi shusei*. 9 vols. Tokyo: Yumani Shobo, 1989.

Maruyama, Masao. *Thought and Behavior in Modern Japanese Politics*. London: Oxford University Press, 1963.

Massey, Doreen. "Politics and Space/Time." In Keith and Pile, *Place and the Politics of Identity*, 141–161.

Masumoto Kinen. *Joyu Okada Yoshiko*. Tokyo: Bungei Shunjusha, 1993.

———. *Shochiku eiga no eiko to hokai*. Tokyo: Heibonsha, 1988.

Masumura Yasuzo. "Mizoguchi Kenji no riarizumu." In *Koza Nihon eiga: Toki no jidai*, vol. 3. Ed. Imamura Shohei et al. Tokyo: Iwanami Shoten, 1986, 246–257.

McDonald, Keiko I. *Japanese Classical Theater in Films*. London: Associated University Press, 1994.

———. "The *Yakuza* Film: An Introduction." In Nolletti and Desser, *Reframing Japanese Cinema*, 165–192.

Minami Hiroshi. *Kindai shomin seikatsushi*, vol. 16. Tokyo: Sanichi Shobo, 1991.

———. *Nihonjinron: Meiji kara kon'nichi made*. Tokyo: Iwanami Shoten, 1994.

———, ed. *Nihon modanizumu no kenkyu, shiso, seikatsu, bunka*. Tokyo: Buren Shuppan, 1982.

———. *Showa bunka 1925–1945*. Tokyo: Keiso Shobo, 1992.

———. *Taisho bunka*. Tokyo: Keiso Shobo, 1965.

Minami Hiroshi, Hayashi Kiyoshiro, and Ono Tsunetoku, eds. *Kindai shomin seikatsushi, kyoraku, sei*, vol. 10. Tokyo: San'ichi Shobo, 1988.

Minami Hiroshi, Use Tsuyoshi, and Sakata Minoru, eds. *Kindai shomin seikatsushi, ningen, seken*, vol. 1. Tokyo: San'ichi Shobo, 1985.

Minami Hiroshi et al., eds. *Taisho bunka 1905–1927*. Tokyo: Keiso Shobo, 1988.

Mine Takashi. *Teikoku gekijo kaimaku: Kyo wa Teigeki ashita wa Mitsukoshi*. Tokyo: Chuo Koronsha, 1996.

Mita Munesuke. *Gendai Nihon no shinjo to ronri*. Tokyo: Chikuma Shobo, 1971.

Miura Masashi. *Shintai no reido: Nani ga kindai o seiritsu sasetaka*. Tokyo: Kodansha, 1994.

Miyoshi, Masao. *Off Center: Power and Culture Relations between Japan and the United States*. Cambridge, Mass.: Harvard University Press, 1991.

Miyoshi, Masao, and H. D. Harootunian, eds. *Japan in the World*. Durham, N.C.: Duke University Press, 1993.

———, eds. *Postmodernism and Japan*. Durham, N.C.: Duke University Press, 1989.

Mizuta Noriko. "Seiteki tasha to wa dare ka." In *Iwanami koza: Gendai shakaigaku, sekushariti no shakaigaku,* vol. 10. Tokyo: Iwanami Shoten, 1997, 25–62.

Montrose, Louis A. "Professing the Renaissance: The Poetics and Politics of Culture." In *The New Historicism*. New York: Routledge, 1989.

Mori Arinori. "Heishiki taiso ni kansuru kengenan." In *Mori Arinori zenshu,* vol. 1. Ed. Okubo Toshiaki. Tokyo: Senbundo Shoten, 1972.

Mori Iwao. *Watashi no geikai henreki*. Tokyo: Seigabo, 1975.

Morris, Meaghan. "Introduction: Hong Kong Connections." In *Hong Kong Connections: Transnational Imagination in Action Cinema*. Ed. Meagan Morris, Siu Leung Li, and Stephen Chan Ching-kiu. Durham, N.C., and Hong Kong: Duke University Press and Hong Kong University Press, 2005, 1–18.

Mulvey, Laura. *Fetishism and Curiosity*. Bloomington: Indiana University Press, 1996.

———. *Visual and Other Pleasures*. Bloomington: Indiana University Press, 1989.

Muta Kazue and Shin Ji-Won. "Kindai no sekushuariti no sozo to atarashii on'na, hikaku bunseki no kokoromi." *Shiso* 886 (1998): 89–115.

Nakai Shoichi. *Ikiteiru kukan: Shutaiteki eiga geijutsuron*. Ed. Seitaro Tsujibe. Tokyo: Tenbinsha, 1976.

Narita Ryuichi. *"Kokyo" to iu monogatari: Toshi kukan no rekishigaku*. Tokyo: Yoshikawa Kobunkan, 1998.

Neale, Steve. *Genre*. London: British Film Institute, 1980.

———. *Genre and Hollywood*. London and New York: Routledge, 2000.

Nihon shinario taikei, vol. 1. Tokyo: Maruyon Purodakushon Shinario Bunko, 1973.

Nikkatsu Kabushiki Gaisha, ed. *Nikkatsu gojunenshi*. Tokyo: Nikkatsu Kabushiki Gaisha, 1962.

Nitta Yoshihiro et al., eds. *Datsuseiyo no shiso,* vol. 15. Tokyo: Iwanami Shoten, 1994.

Nolletti, Arthur, Jr. *The Cinema of Gosho Heinosuke: Laughter through Tears*. Bloomington: Indiana University Press, 2005.

Nolletti, Arthur, Jr., and David Desser, eds. *Reframing Japanese Cinema*. Bloomington: Indiana University Press, 1992.

Nornes, Abé Mark. *Japanese Documentary Film: The Meiji Era through Hiroshima*. Minneapolis: University of Minnesota Press, 2003.

Nowell-Smith, Geoffery, ed. *The Oxford History of World Cinema*. New York: Oxford University Press, 1997.

Nugent, Frank S. "Kimiko." *New York Times*. April 13, 1937, 31.

Nygren, Scott. "Reconsidering Modernism: Japanese Film and the Postmodern Context." *Wide Angle* 11, no. 3 (July 1989): 6–15.

———. *Time Frames: Japanese Cinema and the Unfolding of History*. Minneapolis: University of Minnesota Press, 2007.

Oba Masatoshi et al., eds. *Film Center 85: Nihon eigashi kenkyu 3, kamata eiga no sekai 1921–1936.* Tokyo: Tokyo Kokuritsu Kindai Bijutsukan, 1986.

Oe Ryotaro. "Shinpa no ayumi 90-nen: Seibidan kessei made." In *Shinpa no keizu.* Tokyo: Gekidan Shinpa, 1977.

Oguma, Eiji. *Nihonjin no kyokai: Okinawa, Ainu, Taiwan, Chosen, shokumin shihai kara fukki undo made.* Tokyo: Shin'yosha, 1998.

———. *Tan'itsu minzoku no kigen: Nihonjin no jigazo no keifu.* Tokyo: Shin'yosha, 1995.

———. "Yushoku no shokumin teikoku: 1920-nen zengo no nikkei imin haiso to Chosen tojiron." In *Nashonariti no datsukouchiku.* Tokyo: Kashiwa Shobo, 1996, 81–102.

Okada Yoshiko. *Okada Yoshiko: Kuinaki inochi o.* Tokyo: Nihon Tosho Senta, 1999.

Okoshi Aiko. *Kindai Nihon no jenda: Gendai Nihon no shisoteki kadai o tou.* Tokyo: San'ichi Shobo, 1997.

Ooka Shin, Taki Koji, and Abe Yoshio. "Nihon modanizumu to ha nanika." *Gendaishi techo* 29, no. 10 (October 1986): 72–96.

Oshima Nagisa. *Taikenteki sengo eizoron.* Tokyo: Asahi Shinbunsha, 1975.

Otsuka Kyoichi. *Nihon eiga kantokuron.* Tokyo: Eiga Hyoronsha, 1937.

———. *"Tonari no Yae-chan."* *Eiga hyoron,* August 1934: 136.

Richie, Donald. *A Hundred Years of Japanese Film.* Tokyo: Kodansha International, 2002.

———. *Ozu.* Berkeley: University of California Press, 1974.

Russell, Catherine. "Insides and Outsides: Cross-Cultural Criticism and Japanese Film Melodrama." In *Melodrama and Asian Cinema.* Cambridge: Cambridge University Press, 1993, 144–146.

Sakagami Yasuhiro. *Kenryoku sochi to shiteno supotsu: Teikoku Nihon no kokka senryaku.* Tokyo: Kodansha, 1998.

Sakai, Naoki, et al., eds. *Shizan sareru Nihongo Niohonjin.* Tokyo: Shin'yosha, 1996.

———. *Translation and Subjectivity.* Minneapolis: University of Minnesota Press, 1997.

Sakamoto Kazue. *Kazoku imeji no tanjo: Nihon eiga ni miru homudorama no keisei.* Tokyo: Shin'yosha, 1997.

Sakurai Heigoro. "Modan garu to shokugyo fujin." *Josei,* February 1927: 169–173.

Sand, Jordan. *House and Home in Modern Japan: Architecture, Domestic Space and Bourgeois Culture 1880–1930.* Cambridge, Mass.: Harvard University Asian Center, 2003.

Sasaki Kan'ichiro. *Jitsuroku Nihon eigashi: Teikine den.* Tokyo: Kindai Bungeisha, 1996.

Sato, Barbara. *The New Japanese Woman: Modernity, Media, and Women in Interwar Japan.* Durham, N.C., and London: Duke University Press, 2003.

Sato Tadao. *Currents in Japanese Cinema.* Tokyo: Kodansha International, 1982.

———. *Nihon no eiga, hadaka no Nihonjin.* Tokyo: Hyoronsha, 1971.

———. *Nihon eiga no kyoshotachi.* 3 vols. Tokyo: Gakuyo Shobo, 1996.

———. *Nihon eiga rironshi.* Tokyo: Hyoronsha, 1977.

————. *Nihon eigashi.* 4 vols. Tokyo: Iwanami Shoten, 1995.

————. *Nihon eiga shisoshi.* Tokyo: San'ichi Shobo, 1970.

————. *Obake entotsu no sekai: Eiga kantoku Gosho Heinosuke no hito to shigoto.* Tokyo: Noberu Shobo, 1977.

————. *Ozu Yasujiro no geijutsu.* 2 vols. Tokyo: Asahi Shinbunsha, 1978–1979.

Sawamura Tsutomu. *Gendai eigaron.* Tokyo: Toukei Shobo, 1941.

Schatz, Thomas. *Hollywood Genres: Formulas, Filmmaking and the Studio System.* New York: Random House, 1981.

Schermann, Susanne. *Naruse Mikio: Nichijo no kirameki.* Tokyo: Kinema Junposha, 1997.

Schilling, Mark. *The Yakuza Movie Book: A Guide to Japanese Gangster Films.* Berkeley: Stone Bridge Press, 2003.

Seidensticker, Edward. *Tokyo Rising: The City since the Great Earthquake.* New York: Knopf, 1990.

Shimaji Takamaro et al., eds. *Nihon eigashi.* Tokyo: Kinema Junposha, 1976.

Shimizu Takashi. *Ryosai kinbo no tanjo.* Tokyo: Chikuma Shobo, 1995.

Shimokawa Shuji. *Showa Heisei kateishi nenpyo 1926–1995.* Tokyo: Kawade Shobosha, 1997.

Shinba Akihiko. *Meisaku no eizo o saguru: "Izu no odoriko," Showa 8-nen, Gosho Heinosuke sakuhin.* Shizuoka: Shinba Akihiko, n.d.

Shochiku Eizo Honbu Eiga Hogai Shitsu, ed. *Kinema no seiki: Eiga no 100-nen, Shochiku no 100-nen.* Tokyo: Firumu Artsha, 1995.

Shochiku Kabushiki Gaisha, ed. *Shochiku 100-nenshi: Eizo shiryo kakushu siryo nenpyo.* Tokyo: Shochiku Kabushiki Gaisha, 1996.

Showa Nyusu Jiten Henshu Iinkai and Mainichi Komyunikeshonzu, eds. *Showa nyusu jiten,* vol. 1. Tokyo: Mainichi Komyunikeshonzu, 1990.

Silberman, Bernard S., and H. D. Harootunian, eds. *Japan in Crisis: Essays on Taisho Democracy.* Princeton: Princeton University Press, 1974.

Silverberg, Miriam. "The Cafe Waitress Serving Modern Japan." In Vlastos, *Mirror of Modernity,* 208–225.

————. *Changing Song: The Marxist Manifestos of Nakano Shigeharu.* Princeton: Princeton University Press, 1990.

————. "Constructing the Japanese Ethnography of Modernity." *Journal of Asian Studies* 51 (1992): 30–54.

————. "Remembering Pearl Harbor, Forgetting Charlie Chaplin, and the Case of the Disappearing Western Woman: A Picture Story." *Positions* 1 (1993): 24–76.

————. *Male Subjectivity at the Margins.* New York: Routledge, 1992.

Singer, Ben. *Melodrama and Modernity: Early Sensational Cinema and Its Contexts.* New York: Columbia University Press, 2001.

————. "Modernity, Hyperstimulus, and the Rise of Popular Sensationalism." In Charney and Schwartz, *Cinema and the Invention of Modern Life,* 72–99.

Sorlin, Pierre. "Cinema: An Undiscoverable History?" *Paragraph* 15 (1992): 1–18.

————. *The Film in History: Restaging the Past.* Oxford: Blackwell, 1980.

Staiger, Janet. *Bad Women: Regulating Sexuality in Early American Cinema.* Minneapolis: University of Minnesota Press, 1995.

Suga Hidemi. *Shosetsuteki kyodo.* Tokyo: Fukutake Shoten, 1990.

Suzuki Sadami, ed. *Modan toshi bungaku: Toshi no shishu,* vol. 10. Tokyo: Heibonsha, 1991.

———. *Nihon no "bungaku" o kangaeru.* Tokyo: Kadokawa Shoten, 1994.

Takeuchi Yoshimi. *Nihon to Ajia.* Tokyo: Chikuma Shobo, 1993.

Tanaka, Jun'ichiro. *Katsudo shashin ga yattekita.* Tokyo: Chuo Koronsha, 1985.

———. *Nihon eiga hattatsushi.* Tokyo: 5 vols. Chuo Koronsha, 1975–1976.

———. *Nihon eigashi hakkutsu.* Tokyo: Tojusha, 1980.

———. *Otani Takejiro.* Tokyo: Jiji Tsushinsha, 1961.

Tanaka Kinuyo. "Watashi no rirekisho." In *Watashi no rirekisho: Bunkajin 13.* Tokyo: Nihon Keizai Shinbunsha, 1984, 173–243.

Tanaka Masumi. "Jidaigeki eigashi no tame no yobiteki shokousatsu, sengo-hen." Tsutsui and Kato, In *Jidaigeki eiga to wa nani ka,* 17–44.

———, ed. "Ozu Yasujiro kantoku no Tokyo no yado o kataru." In *Ozu Yasujiro zen hatsugen 1933–1945.* Tokyo: Tairyusha, 1987, 67–70.

Tanaka, Stefan. *Japan's Orient: Reading Past into History.* Berkeley: University of California Press, 1993.

Tanemura Naoki. "Chotokkyu Tubamego hasshin suru: Supido appu sakusen no tenkai." In *Tokyo koshinkyoku no jidai,* vol. 1 of *Shogen no Showashi.* Tokyo: Gakushu Kenkyusha, 1983, 166–171.

Tanizaki Jun'ichiro. *Naomi.* Trans. Anthony H. Chambers. San Francisco: North Point Press, 1990.

Thompson, Kristin, and David Bordwell. *Film History: An Introduction.* New York: McGraw-Hill, 1994.

———. "Space and Narrative in the Films of Ozu." *Screen* 17, no. 2 (1976): 41–73.

Tierney, Dolores. "Silver Silk-Backs and Mexican Melodrama: Salón México and Danzón." *Screen* 38, no. 4 (1997): 360–371.

Tipton, Elise K., and John Clark, eds. *Being Modern in Japan: Culture and Society from the 1910s to the 1930s.* Honolulu: University of Hawai'i Press, 2000.

Tokyo Kokuritsu Kindai Bijutsukan Firumu Senta, ed. *Tokyo kokuritsu kindai bijutsukan firumu senta shozo eiga mokuroku, Nihon gekieiga.* Tokyo: Tokyo Kokuritsu Kindai Bijutsukan, 1986.

Tominaga Ken'ichi. *Nihon no kindaika to shakai hendo.* Tokyo: Kodansha, 1990.

Toyama Shizuo, ed. *Toho 10-nenshi.* Tokyo: Kabushiki Gaisha Toho Gekijyo, 1943.

Tsukada Yoshinobu. *Nyujozei to eiga no nyujo ryokin no hensen.* Tokyo: Tsukamoto Yoshinobu, 1985.

Tsumura Hideo. *Eiga no bi.* Tokyo: Koufukan, 1947.

———. *Eiga seisakuron.* Tokyo: Chuo Koronsha, 1943.

———. *Eiga to kansho.* Tokyo: Rodo Bunkasha, 1947.

Tsurumi, Shunsuke. *An Intellectual History of Wartime Japan 1931–1945.* New York: Routledge and Kegan Paul, 1986.

——. *Tsurumi shunsukeshu: Gendai Nihon shisoshi*, vol. 5. Tokyo: Chikuma Shobo, 1991.

Tsutsui Kiyotada. *Showaki Nihon no kozo*. Tokyo: Kodansha, 1996.

Tsutsui Kiyotada and Kato Mikiro, eds. *Jidaigeki to wa nani ka*. Kyoto: Jinbun Shoin, 1997.

Tsuzuki Masaaki. *Shinema ga yattekita: Nihon eiga kotohajime*. Tokyo: Shogakkan, 1995.

Ueno Chizuko. *Kindai kazoku no seiritsu to shuen*. Tokyo: Iwanami Shoten, 1994.

——. "Modern Patriarchy and the Formation of the Japanese Nation State." In *Multicultural Japan: Palaeolithic to Postmodern*. Ed. Donald Denoon, Mark Hudson, Gavan McCormack, and Tessa Morris-Suzuki. Cambridge: Cambridge University Press, 1996.

——. *Nashonarizumu to jenda*. Tokyo: Seidosha, 1998.

Un'no Hiroshi. "Kawabata Yasunari no toshi hoko." *Kokubungaku* 32, no. 15 (1987).

——, ed. *Modan toshi bungaku: Modan Tokyo an'nai*, vol. 1. Tokyo: Heibonsha, 1989.

——. *Modan toshi Tokyo: Nihon no 1920-nendai*. Tokyo: Chuokoronsha, 1983.

Ushihara Kiyohiko. *Eiga mangekyo*. Tokyo: Chuobijutsusha, 1927.

Vincendeau, Ginette. "Community, Nostalgia and the Spectacle of Masculinity: The Jean Gabin Persona in Film from the Popular Front Period." *Screen* 26, no. 6 (1985): 18–38.

Vlastos, Stephen, ed. *Mirror of Modernity: Invented Traditions of Modern Japan*. Berkeley: University of California Press, 1998.

Wahrman, Dror. *Imagining the Middle Class: The Political Representation of Class in Britain*. Cambridge: Cambridge University Press, 1995.

Wada-Marciano, Mitsuyo. "Imaging Modern Girls in Japanese Woman's Film." *Camera Obscura* 60 (2005): 14–55.

——. "Izu no odoriko." *National Film Center Newsletter* 22 (1998): 7–8.

——. "Modaniti, shinema, soshite nashonaru bodi no kochiku." In *Eiga to shintai/sei*. Ed. Ayako Saito. *Nihon eigashi shosho*, vol. 6. Tokyo: Shinwasha, 2006.

——. "Modernity, Cinema, and the Body: Analysis on the Shochiku Kamata Film 'Why Do the Youth Cry?' (1930)." *Review of Japanese Culture and Society* 10 (1998): 24–34.

——. "The Production of Modernity in Japanese National Cinema: Shochiku Kamata Style in the 1920s and 1930s." *Asian Cinema* 9, no. 2 (1998): 69–93.

——. "Shochiku eiga ni okeru kindaisei no shoshutsu: Shochiku Kamata eiga *Tonari no Yae-chan* (1934) bunseki." *Eizogaku* 60 (1998): 36–55.

——. "Shochiku Kamata eiga ni okeru 'josei eiga' no sozo: *Jinsei no onimotsu* (1935) bunseki." *Eizogaku* 61 (1998): 68–84.

Wakita Haruko and Susan B. Hanley, eds. *Jenda no Nihonshi*. 2 vols. Tokyo: Tokyo Daigaku Shippankai, 1994.

Wakiya Mitsunobu. *Otani Takejiro engeki 60-nen*. Tokyo: Dainihon Yubenkai Kodansha, 1951.

Williams, Alan. "Is a Radical Genre Criticism Possible?" *Quarterly Review of Film Studies* 9, no. 2 (1984): 121–125.

Williams, Linda. "Film Bodies: Gender, Genre, and Excess." In *Film and Theory: An Anthology.* Ed. Robert Stam and Toby Miller. Malden, Mass.: Blackwell Publishers, 2000, 207–221.

———, ed. *Viewing Positions: Ways of Seeing Film.* New Brunswick, N.J.: Rutgers University Press, 1997.

Yamamoto Kikuo. *Nihon eiga ni okeru gaikoku eiga no eikyo.* Tokyo: Waseda Daigaku Shuppanbu, 1983.

Yanagita Kunio. "Toshi to noson." *Teihon Yanagita Kunio shu,* vol. 16. Tokyo: Chikuma Shobo, 1962.

Yoda Yoshikata. *Mizoguchi Kenji no hito to geijutsu.* Tokyo: Eiga Geijutsusha, 1964.

Yoshida Yoshishige. *Ozu Yasujiro no han eiga.* Tokyo: Iwanami Shoten, 1998.

Yoshida Yoshishige, Yamaguchi Masao, and Kinoshita Naoyuki, eds. *Eiga denrai.* Tokyo: Iwanami Shoten, 1995.

Yoshimi Shun'ya. *Toshi no doramatsurugi: Tokyo, sakariba no shakaishi.* Tokyo: Kobundo, 1997.

Yoshimoto, Mitsuhiro. "The Difficulty of Being Radical: The Discipline of Film Studies and the Postcolonial World Order." *boundary 2* 18 (1991): 242–257.

———. *Kurosawa: Film Studies and Japanese Cinema.* Durham, N.C.: Duke University Press, 2000.

———. "Melodrama, Postmodernism, and Japanese Cinema." In Dissanayake, *Melodrama and Asian Cinema,* 101–123.

Zizek, Slavoj. *Looking Awry: An Introduction to Jacques Lacan through Popular Culture.* Cambridge, Mass.: MIT Press, 1991.

Index